LEARN TO DRAW
MANGA MEN

KYACHI

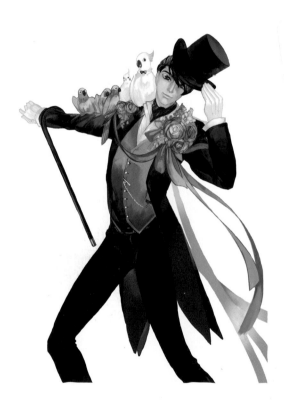

TUTTLE Publishing

Tokyo | Rutland, Vermont | Singapore

CONTENTS

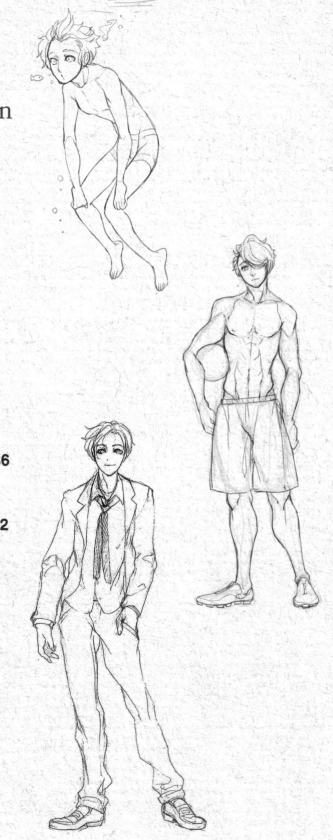

Why I Wrote This Book 4
KYACHI's Gallery 6

Introduction

Things to Know Before You Begin

The Basics of Contrapposto 13
Differences in Men's and Women's Bodies 14
Men's Body Structure 16
Drawing a Man's Muscles 18
Drawing an Appealing Male Character 20
Thinking about Silhouettes 24
Introducing Our Main Character 26
Practical Applications 28

PART 1

Standing Poses: The Basics

Drawing a Standing Pose 30
Warming Up 32
Drawing a Figure with the Weight on One Leg 36
Drawing a Figure Standing on One Leg 38
Drawing a Figure with an Arched Back 40
Drawing a Figure Looking over One Shoulder 42
Drawing a Slumped Figure 44
Drawing a Figure with Arms Folded 46
Drawing a Leaning Figure 48
Drawing a Bending Figure 50
Drawing Two Standing Figures 52
How-to Helpers Standing Poses
 Drawing a Rough Sketch 56
 Applying Color 58
Take a Closer Look How to Apply Color 60

PART 2

Sitting Poses: The Basics

Drawing a Sitting Pose 64

Warming Up 66

Drawing a Figure Sitting on the Ground 70

Drawing a Figure Sitting on a Chair 74

Drawing a Crouching Figure 78

Drawing Two Seated Figures 82

How-to Helpers **Sitting Poses**

 Drawing a Rough Sketch 86

 Applying Color 88

Take a Closer Look **Drawing Actions and Gestures 90**

PART 3

Reclining Poses: The Basics

Drawing a Reclining Pose 94

Warming Up 96

Drawing a Figure Lying Face Down 100

Drawing a Figure Lying on His Side 104

Drawing a Figure Lying on His Back 106

Drawing Two Reclining Figures 112

How-to Helpers **Reclining Poses**

 Drawing a Rough Sketch 116

 Applying Color 118

Take a Closer Look **Drawing Various Athletes 120**

PART 4

Poses in Motion

Drawing a Figure Playing Sports 124

Drawing a Fighting Figure 130

Drawing Two Fighting Figures 136

Take a Closer Look **Drawing Various Athletes 140**

Why I Wrote This Book

I know why you're here. You came for the basics, to learn how to realistically capture the male physique, how to create compelling scenes involving men in motion.

You're in the right place. I'll show you all you need to know in detailed drawings, labeled layouts and step-by-step progressions, harnessing the power and practicality of digital design and that other friendly format, paper.

With this practical guide, I've given you the men you seek, pages and pages of them, but so much more. Included throughout are a wealth of tips, expert advice and insider's insights applicable to drawing any subject or scene. How an object is drawn differently depending on the light source, how men and women's physiques differ, how to introduce movement and perspective. These are just some of the fundamentals and basic practices you will apply to create your characters and build your illustrations from the ground up.

From the first line to the last dash of color and shadow, I'll show you how to bring leaping, lying, running, fighting men to life on the page and screen. Your stories will come to life because your characters do. Happy drawing.

– kyachi

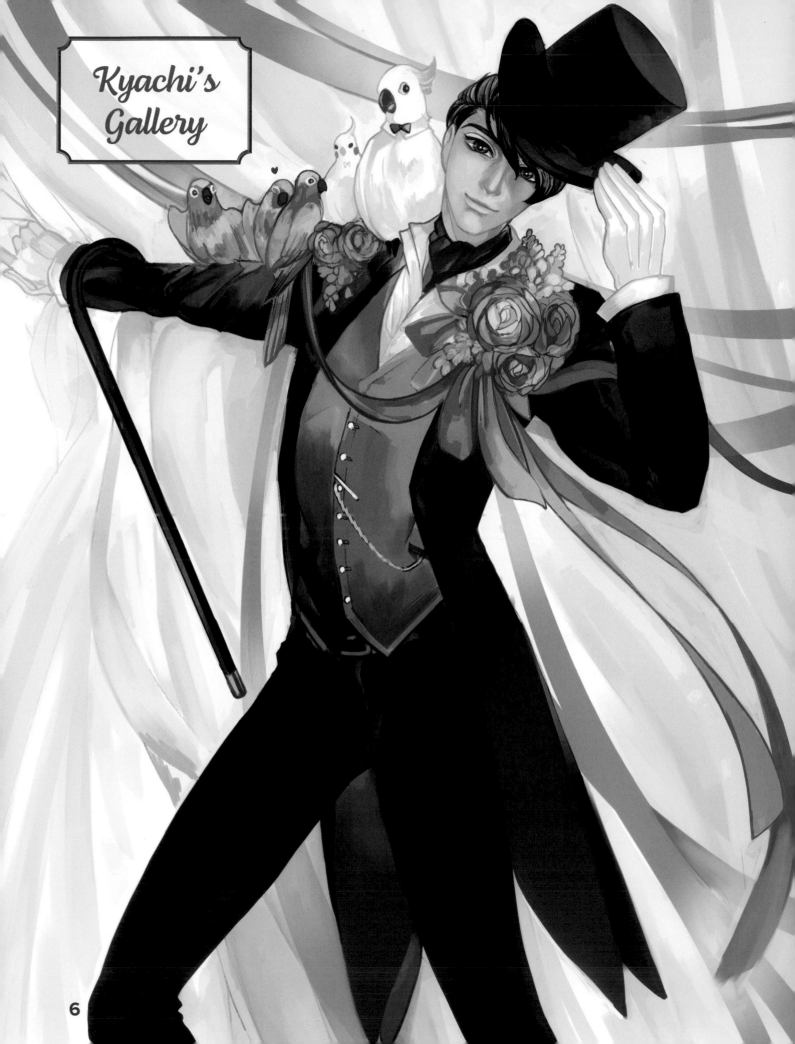

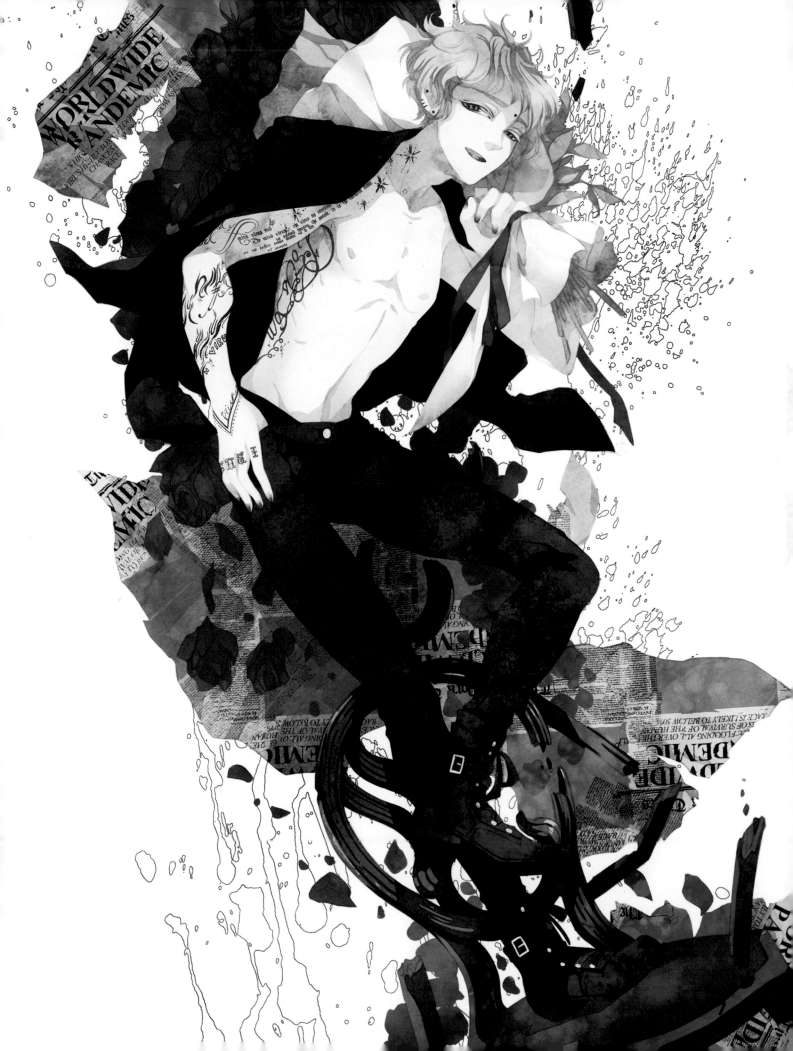

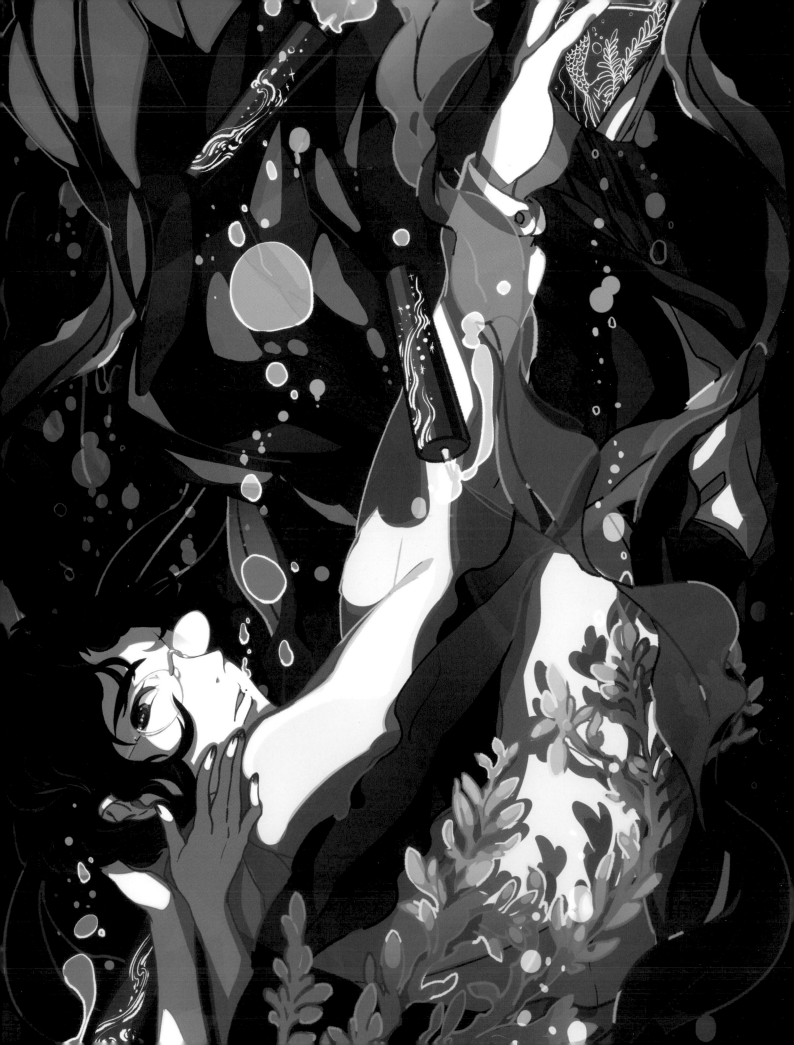

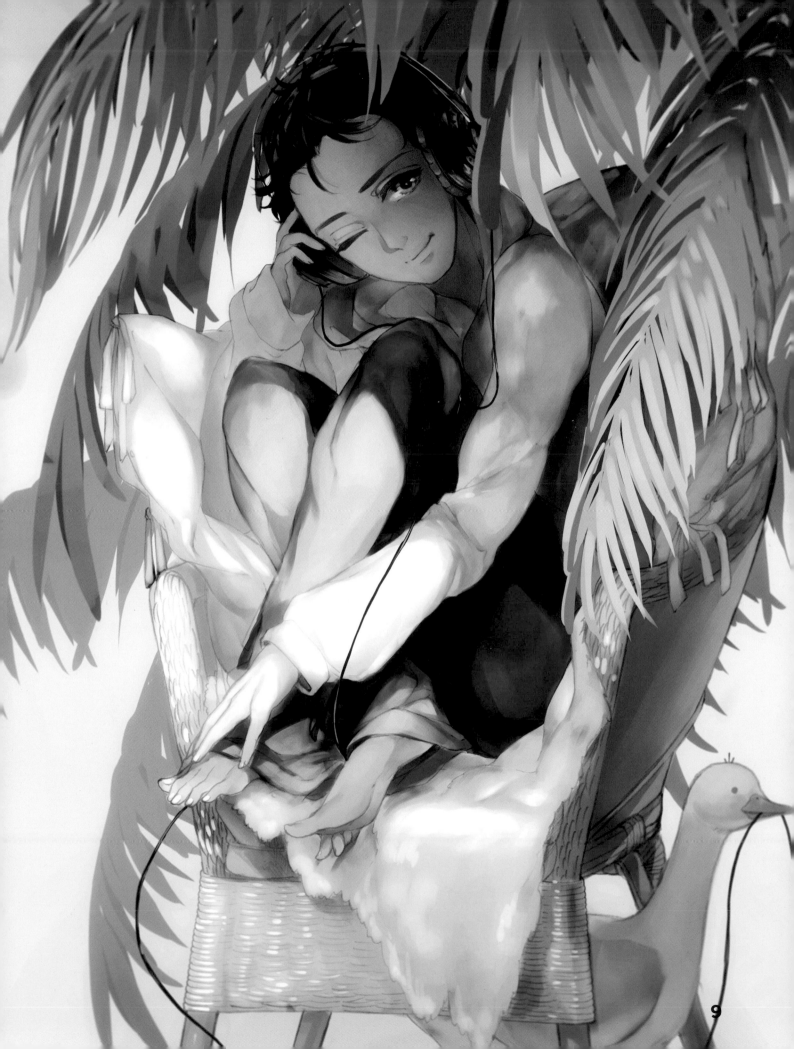

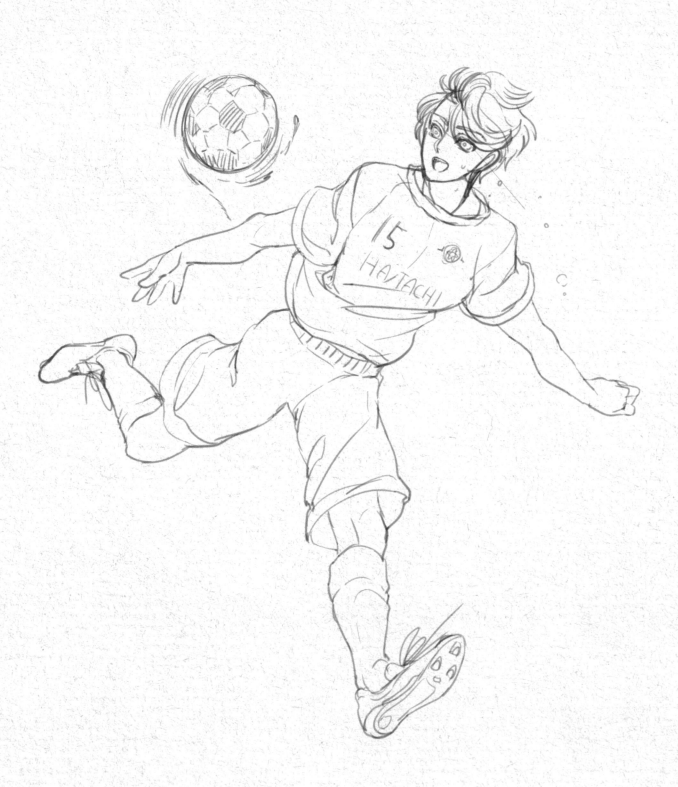

The Basics of Contrapposto

Contrapposto is a term used in art that indicates an asymmetrical standing pose achieved when the figure's center of gravity is shifted onto either the left or right leg.

Expert Tip

Applying contrapposto techniques is a must for creating stylish and eye-catching signature pose.

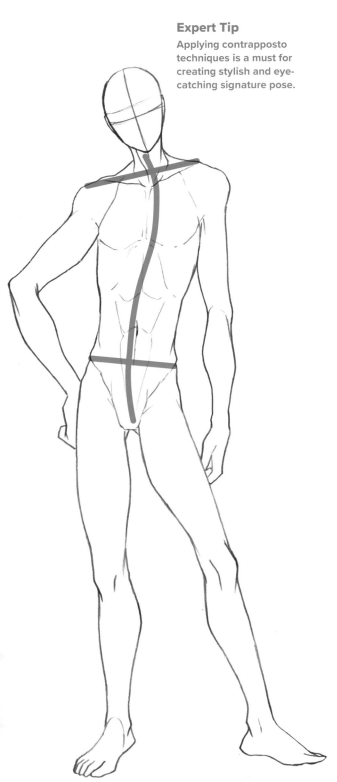

Features and Effects

The tilt of the shoulders in contrast to the bend or slant of the hips is the defining feature of contrapposto, the asymmetrical look achieved by shifting the central line of the body to a weight-bearing leg. This leg (the engaged or support leg) contrasts with the slightly bent free leg (the resting or transfer leg) adding movement and bringing out a dynamic sense of realism and complexity in the form. It also suggests psychological complexity, the presence of an "inner life." For this reason, in Western art, contrapposto is viewed as the go-to method for capturing or suggesting the mental state through the body's form and pose. Emphasizing a body's contrapposto position creates an S-shaped spine and brings out a sense of balance and flow in the line of the body, making for a more realistic character and a more appealing form.

Key Points

● **The shoulder and hip lines are in opposition.**
On the side of the body where the shoulder's lowered, the hip is raised, while the reverse is true. So the shoulders and hips are never parallel.

● **The knee and hip lines are parallel.**
The slant of the hips determines the position of the knee. The knee on the side of the raised hip is also raised, while the knee on the side of the lowered hip is also lowered, meaning the knees and hips are parallel.

● **The center of gravity is directly below the head.**
The center of gravity runs in a straight line from the head to the navel. In other words, it's the leg closest to the navel that carries the weight.

● **Create the eye line however you choose.**
The eyes can be drawn independent of the rest, as they're not affected by the rules of contrapposto.

● **The backbone forms an S.**
The opposing shoulder and hip lines result in an S-shaped backbone.

● **The ankle line changes depending on the knee line.**
The ankle on the weight-bearing leg lowers, while the ankle position of the leg stepping forward alters depending on the pose.

● **The line of the shoulders contrasts with the line of the hips.**
The shoulders form a line that tilts in the opposite direction to the hips. The hip rises on the side of the lowered shoulder and vice versa so that the shoulders and hips do not run parallel.

Differences in Men's and Women's Bodies

There are several differences in the distinguishing features of men's and women's bodies, so be sure to capture them clearly and accurately.

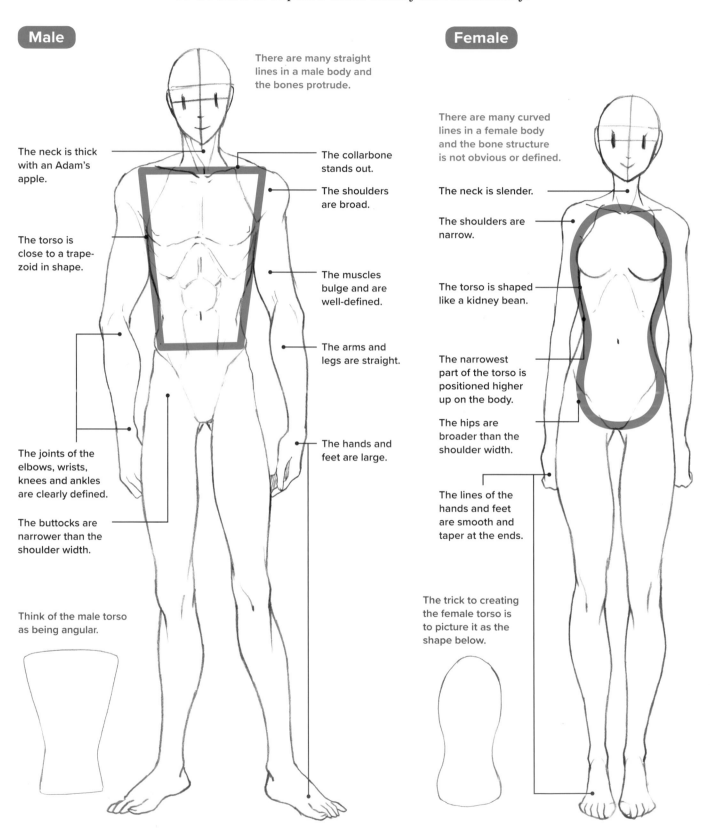

Male

There are many straight lines in a male body and the bones protrude.

The neck is thick with an Adam's apple.

The torso is close to a trapezoid in shape.

The joints of the elbows, wrists, knees and ankles are clearly defined.

The buttocks are narrower than the shoulder width.

Think of the male torso as being angular.

The collarbone stands out.

The shoulders are broad.

The muscles bulge and are well-defined.

The arms and legs are straight.

The hands and feet are large.

Female

There are many curved lines in a female body and the bone structure is not obvious or defined.

The neck is slender.

The shoulders are narrow.

The torso is shaped like a kidney bean.

The narrowest part of the torso is positioned higher up on the body.

The hips are broader than the shoulder width.

The lines of the hands and feet are smooth and taper at the ends.

The trick to creating the female torso is to picture it as the shape below.

14

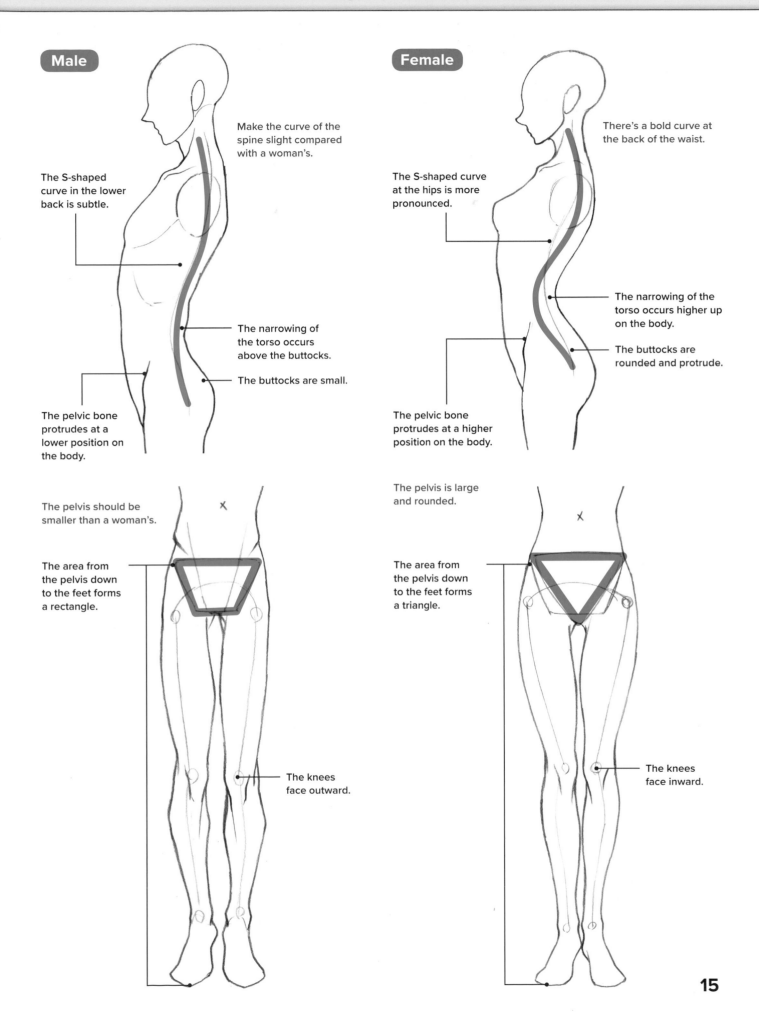

Male

Make the curve of the spine slight compared with a woman's.

The S-shaped curve in the lower back is subtle.

The narrowing of the torso occurs above the buttocks.

The buttocks are small.

The pelvic bone protrudes at a lower position on the body.

The pelvis should be smaller than a woman's.

The area from the pelvis down to the feet forms a rectangle.

The knees face outward.

Female

There's a bold curve at the back of the waist.

The S-shaped curve at the hips is more pronounced.

The narrowing of the torso occurs higher up on the body.

The buttocks are rounded and protrude.

The pelvic bone protrudes at a higher position on the body.

The pelvis is large and rounded.

The area from the pelvis down to the feet forms a triangle.

The knees face inward.

Men's Body Structure

Understanding the defining features of a male body is key not only for distinguishing between men and women as you're drawing, but for creating realistic and appealing male characters.

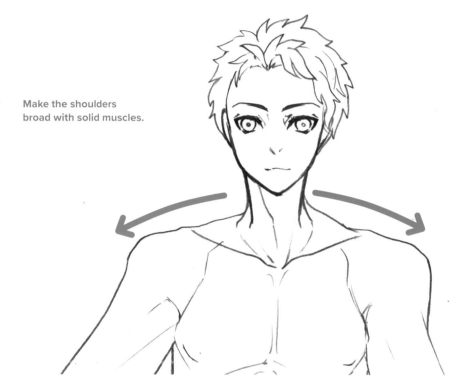

Make the shoulders broad with solid muscles.

The shoulders are exaggeratedly broad.

Using chibi techniques to create shoulders that seem too broad results in just the right effect. When creating a male character, keep in mind the trapezius, running from the back of the head to the collarbone and shoulder blades, along with the triangular form of the shoulder area.

The key is to make them broad!

The head is smaller than the shoulders.

Making the head smaller than the shoulder width yields a sharper, more defined look. Be aware of the trapezius as you draw, making the neck thick and firm and including the Adam's apple. The reason that women's necks look slender and their heads look larger in comparison with men's is that the female trapezius is less pronounced.

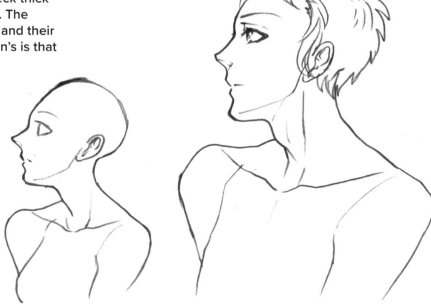

Make the neck thick and the head small for best results.

When drawing women, make the head large in comparison to the thickness of the neck.

Add in a slight protrusion to create the Adam's apple.

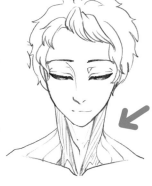

Be aware of the sterno-cleidomastoid muscle.

The Adam's apple is a key distinguishing feature of men's bodies.

The Adam's apple is the part that most defines an adult male. When drawing a figure viewed straight on, emphasizing the sternocleidomastoid muscle—which runs from the back of the neck through to the collarbone—automatically determines the shape of the Adam's apple.

There's little difference between the waist and hips.

As the stomach and back muscles are well-developed around the waist and hips, the waist does not narrow to the same extent as a woman's. The position of the waist on a man is also lower than on a woman. These are key points for distinguishing adult males and females when developing your characters.

Use muscles and joints to give legs a rugged look.

The muscles in men's legs tend to be well-developed, with quadriceps at the fronts of the thighs, biceps femoris muscles at the backs and triceps surae muscles in the calves. Where there's no muscle in the joints of the knees, ankles and toes, use chibi techniques to make them more pronounced for a rugged, angular look.

On a man, the waist is positioned in the lower third of the torso.

On a woman, the waist is positioned halfway down the torso.

Male

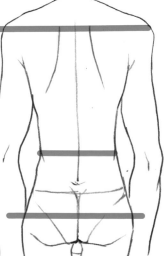

Female

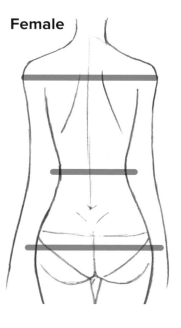

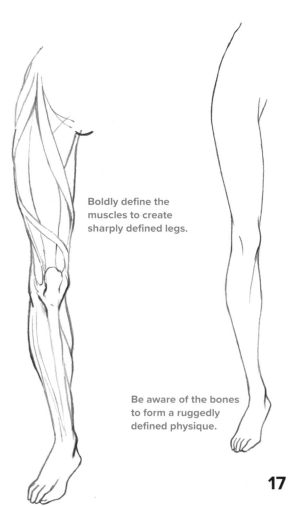

Boldly define the muscles to create sharply defined legs.

Be aware of the bones to form a ruggedly defined physique.

It's important to remember that men's and women's buttocks are shaped differently.

Drawing a Man's Muscles

In order to bring a male character to life, it's crucial to learn how the bones and muscles connect. I recommend studying the diagrams published in medical textbooks and exercise manuals!

Characteristics of Muscles

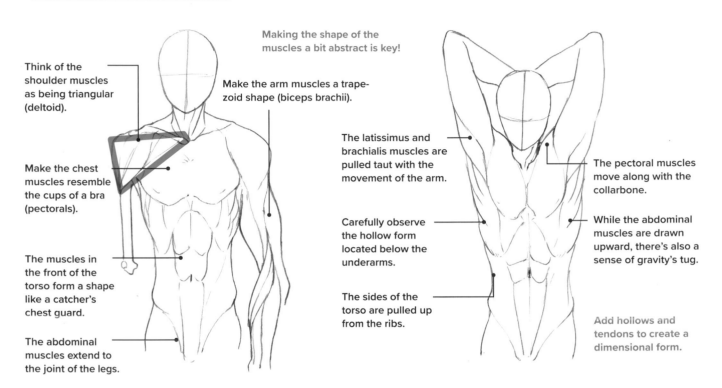

Think of the shoulder muscles as being triangular (deltoid).

Making the shape of the muscles a bit abstract is key!

Make the arm muscles a trapezoid shape (biceps brachii).

Make the chest muscles resemble the cups of a bra (pectorals).

The latissimus and brachialis muscles are pulled taut with the movement of the arm.

The pectoral muscles move along with the collarbone.

The muscles in the front of the torso form a shape like a catcher's chest guard.

Carefully observe the hollow form located below the underarms.

While the abdominal muscles are drawn upward, there's also a sense of gravity's tug.

The abdominal muscles extend to the joint of the legs.

The sides of the torso are pulled up from the ribs.

Add hollows and tendons to create a dimensional form.

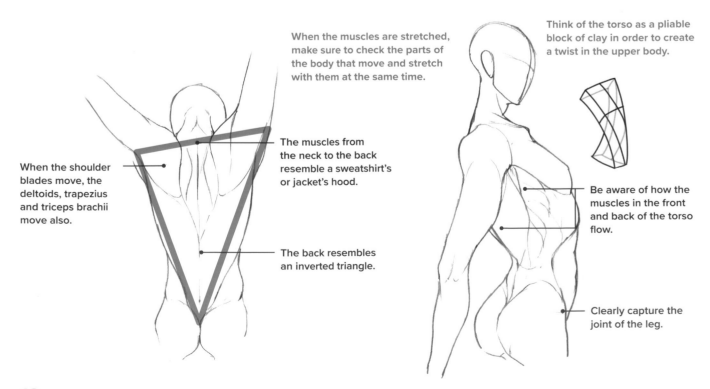

When the muscles are stretched, make sure to check the parts of the body that move and stretch with them at the same time.

Think of the torso as a pliable block of clay in order to create a twist in the upper body.

When the shoulder blades move, the deltoids, trapezius and triceps brachii move also.

The muscles from the neck to the back resemble a sweatshirt's or jacket's hood.

Be aware of how the muscles in the front and back of the torso flow.

The back resembles an inverted triangle.

Clearly capture the joint of the leg.

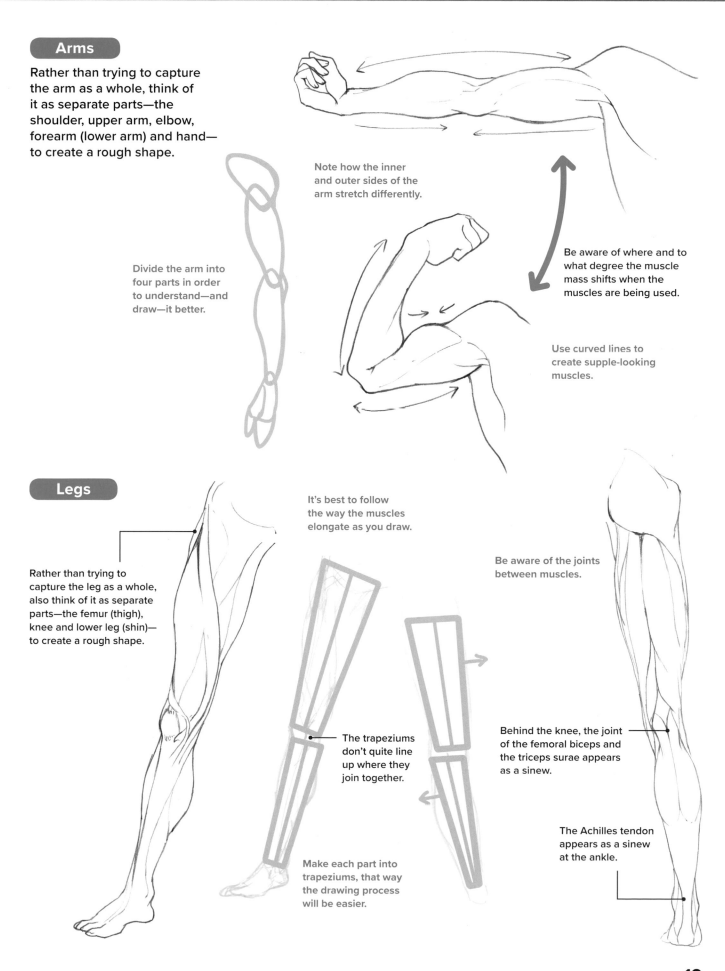

Arms

Rather than trying to capture the arm as a whole, think of it as separate parts—the shoulder, upper arm, elbow, forearm (lower arm) and hand—to create a rough shape.

Note how the inner and outer sides of the arm stretch differently.

Divide the arm into four parts in order to understand—and draw—it better.

Be aware of where and to what degree the muscle mass shifts when the muscles are being used.

Use curved lines to create supple-looking muscles.

Legs

It's best to follow the way the muscles elongate as you draw.

Rather than trying to capture the leg as a whole, also think of it as separate parts—the femur (thigh), knee and lower leg (shin)—to create a rough shape.

Be aware of the joints between muscles.

The trapeziums don't quite line up where they join together.

Behind the knee, the joint of the femoral biceps and the triceps surae appears as a sinew.

Make each part into trapeziums, that way the drawing process will be easier.

The Achilles tendon appears as a sinew at the ankle.

Drawing an Appealing Male Character

What's wonderful about illustration is being able to create figures suited to your own taste and style. Let's have a go at bringing your ideal man to life.

Drawing the Face

Perhaps more than any other part or area, it's the fact that most determines a character's appeal. So how do you become good at drawing this key area of focus? The answer is plenty of practice. Draw, draw and draw some more to find the technique that best suits you. First, collect the kinds of photos you want to use as model illustrations and pictures you want to draw, then start copying them. What's important is that you adapt your approach to create the face you want your character to have.

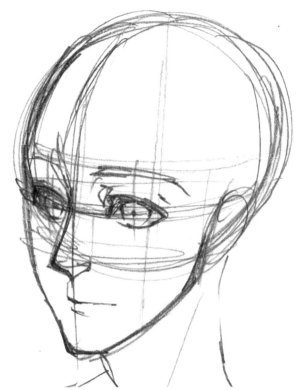

Decide on the Position of the Facial Parts

Symmetry is a must when bringing an appealing character to life. It's important that the eyes, nose, mouth and eyebrows are properly positioned. Ideally the eyes should sit symmetrically on the horizontal line formed when a cross is drawn in the center of the face. The nose is positioned in the equilateral triangle that's formed by drawing a line between the pupils and joining it with the point halfway down the vertical line from the pupils to the chin. The mouth is positioned around halfway between the nose and chin, and the eyebrows are about the height of one eye up from the actual eyes' location. The ears are the same length from the eyebrows to the nose.

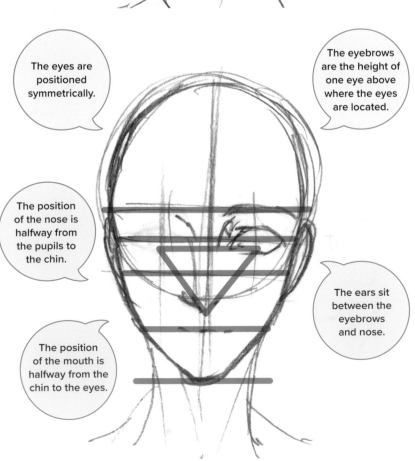

The eyes are positioned symmetrically.

The eyebrows are the height of one eye above where the eyes are located.

The position of the nose is halfway from the pupils to the chin.

The ears sit between the eyebrows and nose.

The position of the mouth is halfway from the chin to the eyes.

How to Sketch a Face

❶ Draw a perfect circle.

Draw a circle with barely any distortion. The diameter will form the length of the face from the top of the head to below the nose.

❷ Add a vertical line.

Draw in a vertical line that will act as a guide line when determining the tilt of the head. As here the head isn't tilted, make the line through the center.

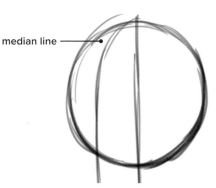

median line

❸ Add in the median line.

Thinking of the circle as a sphere, add in a vertical guide line (the median line) to determine the center of the face. This will be the line that runs through the nose. As the face is directed slightly to the viewer's left, add the line to the left of the circle's center.

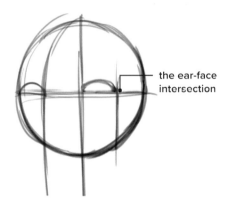

the ear-face intersection

❹ Decide on the position of the ears.

Measure the length from the median line to the left edge of the circle. Then make a mark at that distance from the line at the center out to the right. This indicates where the ear joins the face.

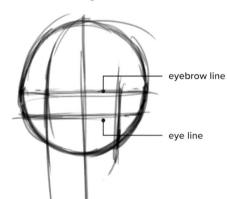

eyebrow line

eye line

❺ Decide on the position of the eyes and eyebrows.

Make a horizontal line to equally divide the upper and lower sections of the sphere. Make another horizontal line halfway between the first line and the bottom of the circle. The upper line forms the position for the eyebrows while the lower line forms the position for the eyes.

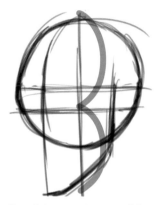

❻ Decide on the position of the chin.

Measure from the lower horizontal line to the top edge of the circle. Then make a mark at that length down from the lower horizontal line. This will form part of the jaw's outline.

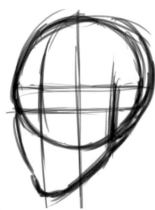

❼ Draw the outline.

The point where the jaw mark from Step 6 intersects the median line forms the tip of the chin. Once the jawline is decided, draw in the entire facial outline.

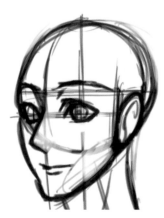

❽ Draw the eyes, nose and ears.

Draw in the facial parts. Mark in the eye closest to the viewer halfway between where the ear meets the median line, and make the other eye halfway between the median line and the left edge of the circle.

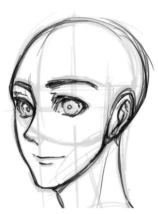

❾ Completion!

The face is complete. Alter the curve of the eyebrows, the size of the eyes, the position of the pupils and the expression of the mouth to create a smug or troubled face.

How to Draw Eyes

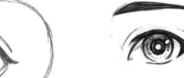

Think of the eyes as being stuck onto spheres.

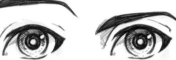

Use the eyebrows to capture and express your character's personality.

Draw the pupils clearly.

Eyeballs are spherical

As you draw them, keep in mind that eyes are ball-shaped. Look at a guide to human anatomy to draw the irises and other parts of the eye.

Eyelids cover the sphere

The eyes' spherical shape means that they have a sense of depth to them. Be aware that the eyelid covers a spherical form.

Differentiate when drawing eyebrows

Asians and Westerners can be differentiated based on the distance between their eyes and eyebrows. Reducing the distance creates a Western look, so try this for yourself.

Eye variations

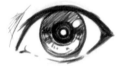

Normal

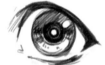

Droopy

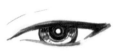

Slanted

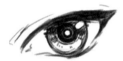

Narrowed

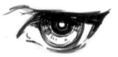

Glaring

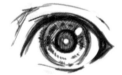

Wide

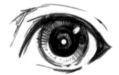

Large pupils

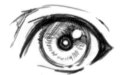

Small pupils

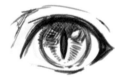

Cat's eye

Eyes with visible white around the iris

Double fold

Deep double fold

Single fold

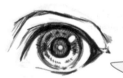

Change the width of the fold depending on the character's personality. Choose whichever color you like for the eye.

Eyebrow variations

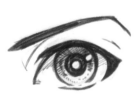

Defined brow

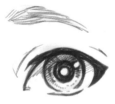

Unassuming brow

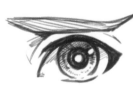

Western-style brow

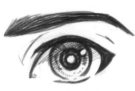

Asian-style brow

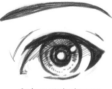

Hot-blooded or impassioned brow

Changing the Eyes and Eyebrows

Once called the windows to the soul, your character's personality can be captured through his eyes. The brows, too, are parts of the face that reveal the full spectrum of emotions. Except in particular situations, they're always drawn together with the eyes to form a set. By mixing and matching the expressions of eyes and eyebrows, various characters or types can be created. Even if the tilt of the head, facial outline, nose and mouth are exactly the same, changing the size of the eyes and pupils and the thickness and shape of the eyebrows allows you to draw a completely different character.

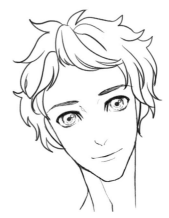
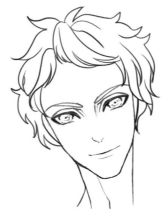

Cool type

Thin eyebrows/slanted eyes/ small pupils/smaller distance between brows and eyes

Calm type

Thick eyebrows/round eyes/ normal pupils/larger distance between brows and eyes

Drawing an Appealing Man's Face

To make a man's face appealing, the face must appear symmetrical. Define the outline of the face, eyes, nose and mouth, but don't draw in any wrinkles or other fine details. When just starting out in illustration, people often end up making the face feminine when trying to draw a man. This can be avoided by clearly drawing in the bridge of the nose, jaw and cheekbones and making sure the face doesn't become too long and narrow.

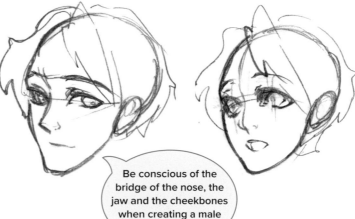

Man's face **Woman's face**

Be conscious of the bridge of the nose, the jaw and the cheekbones when creating a male character's face.

Various Types of Men's Faces

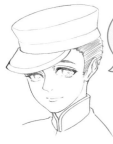

fine eyebrows/ droopy eyes/normal pupils/brows and eyes are far apart

Attractive youth

thick eyebrows/ brows and eyes are close together/bone structure is well-defined/each facial feature is large

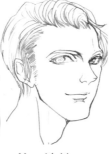

More highly defined features

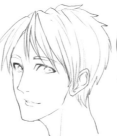

thick eyebrows/ small eyes/ well-defined bone structure

Narrow-eyed, straight nose, long and thin face

Eyes are narrow/ brows and eyes are far apart/each facial feature is small

Flatter face with thin eyes

Androgynous

Thick eyebrows/ brows and eyes are close together/small face/droopy eyes

Thinking about Silhouettes

Thinking too much about the differences between men's and women's bodies can lead to a character who's less cohesive or sharply defined. If you find yourself stuck, substitute a silhouette into the drawing.

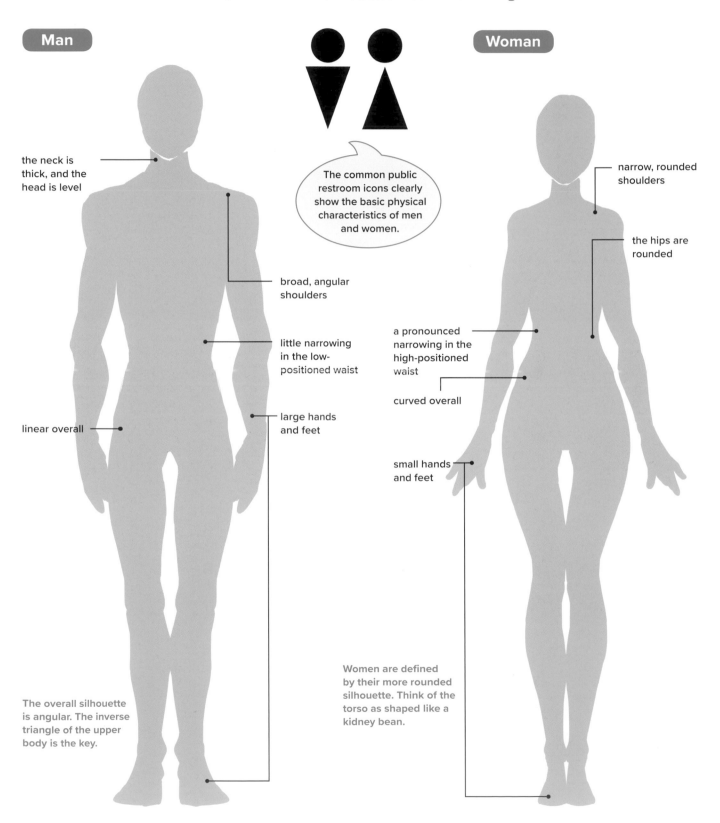

Man

Woman

The common public restroom icons clearly show the basic physical characteristics of men and women.

the neck is thick, and the head is level

broad, angular shoulders

little narrowing in the low-positioned waist

linear overall

large hands and feet

The overall silhouette is angular. The inverse triangle of the upper body is the key.

narrow, rounded shoulders

the hips are rounded

a pronounced narrowing in the high-positioned waist

curved overall

small hands and feet

Women are defined by their more rounded silhouette. Think of the torso as shaped like a kidney bean.

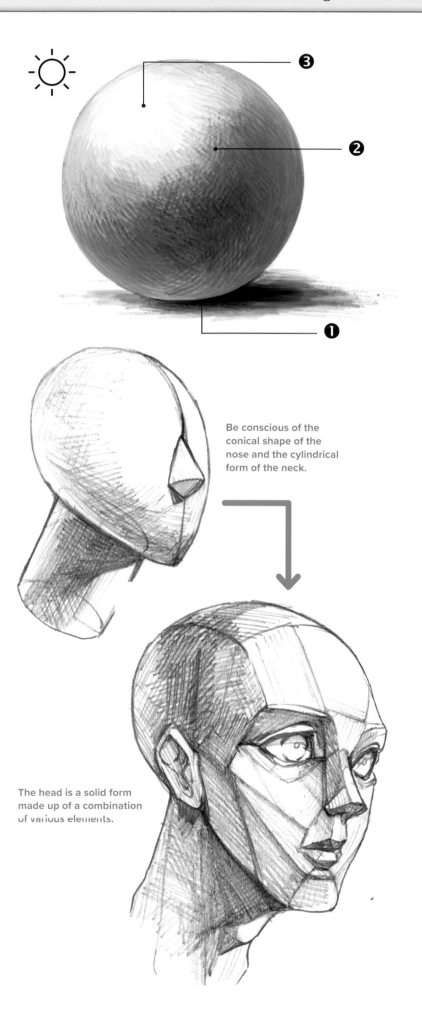

Capturing the Face's Shadows

The key to giving an object a solid look lies in the interplay of light and shadow. When light hits an object from one direction, the area on the object farthest from the source is darkest. It's the section in shadow. Parts and areas of the object are brighter in this order, from dark to light: ❶ Areas in contact with shadow. ❷ Areas in contact with shadow and with the light source.
❸ Areas in contact with the light source.

Grasping Dimension

Close to the light source = bright, far from the light source = dark. Based on this, try adding light and shadow to various elements. Whether cubes, pyramids, prisms, cylinders or spheres, think about which part of the object will be brightest and which parts will form shadows, depending on the shape. Make practice sketches over and over to create a sense of solidity.

Combining Forms

Once you're able to draw various elements that appear solid, try putting them together. Combine a sphere and cylinder to make a form resembling a head. Inside complicated forms lie basic shapes. If you're stuck, substitute a silhouette instead and make each part a simple shape to improve your ability at drawing solid forms.

Be conscious of the conical shape of the nose and the cylindrical form of the neck.

The head is a solid form made up of a combination of various elements.

25

Introducing Our Main Character

It's time to meet the character who will be doing most of the posing for us,
our artist's model. He can travel freely through space and time, so will appear before
you as a boy, a high school student and an adult.

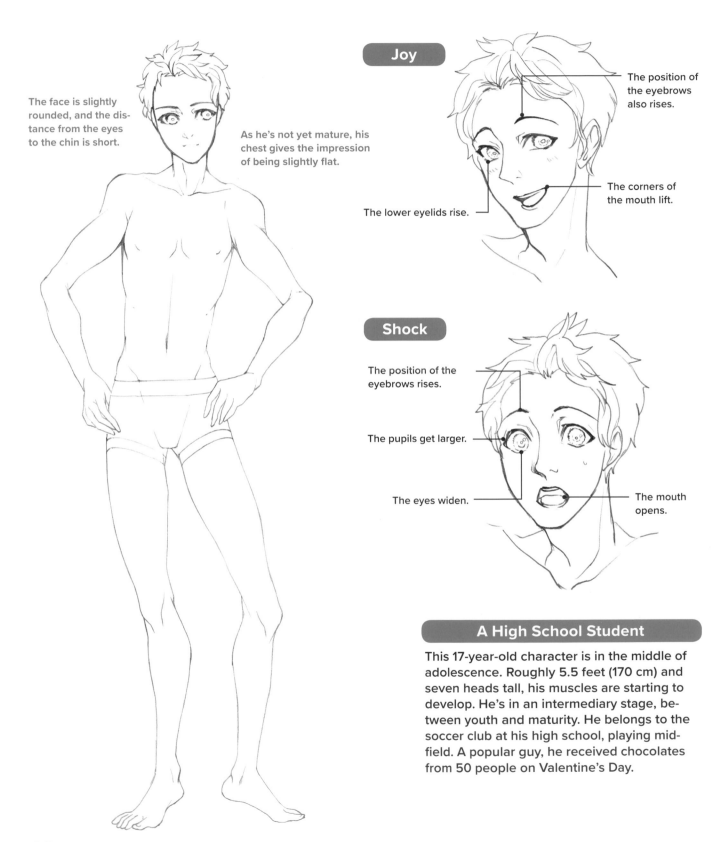

The face is slightly rounded, and the distance from the eyes to the chin is short.

As he's not yet mature, his chest gives the impression of being slightly flat.

Joy

The position of the eyebrows also rises.

The lower eyelids rise.

The corners of the mouth lift.

Shock

The position of the eyebrows rises.

The pupils get larger.

The eyes widen.

The mouth opens.

A High School Student

This **17-year-old** character is in the middle of adolescence. Roughly 5.5 feet (170 cm) and seven heads tall, his muscles are starting to develop. He's in an intermediary stage, between youth and maturity. He belongs to the soccer club at his high school, playing midfield. A popular guy, he received chocolates from **50 people** on Valentine's Day.

A Boy

A mischievous 10-year-old character. Just under 5 feet (145 cm) and 5.5 heads tall, he's defined by his large eyes and round face. His favorite food is hamburgers. He has a sister three years older and a pet turtle named Kamejiro.

An Adult

It's been three years since this 25-year-old completed his education and started working. He's just under 6 feet (175 cm) and 7.5 heads tall. His muscular structure is completely developed. The bridge of his nose is clearly defined, and he has the facial features of an adult. Regardless of how busy he gets at work, he never misses a weekly weight-training session.

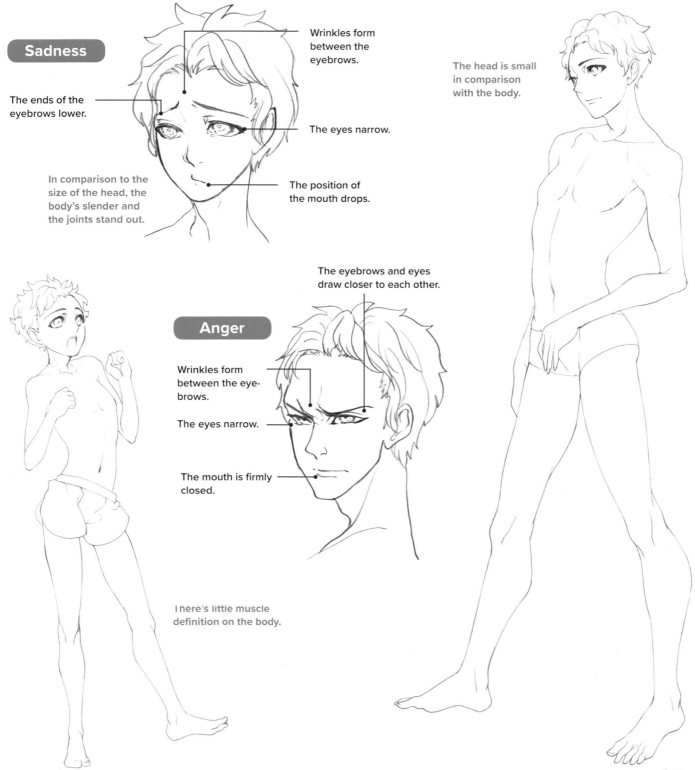

Sadness

Wrinkles form between the eyebrows.

The ends of the eyebrows lower.

The eyes narrow.

In comparison to the size of the head, the body's slender and the joints stand out.

The position of the mouth drops.

The head is small in comparison with the body.

The eyebrows and eyes draw closer to each other.

Anger

Wrinkles form between the eyebrows.

The eyes narrow.

The mouth is firmly closed.

There's little muscle definition on the body.

27

Practical Applications

Use this guide to improve your powers of observation and drawing skills when creating characters of various guises and formats.

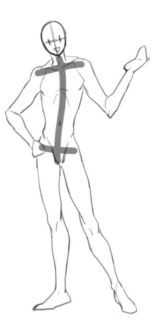

Situation 1

When Drawing Characters

Incorporating contrapposto techniques into poses yields a dynamic body line, creating a vibrant impression and an appealing illustration.

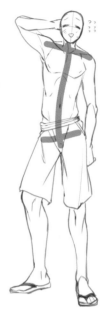

Situation 2

When Posing Someone Else

A knowledge of contrapposto allows you to give accurate, detailed orders when posing another person, resulting in the exact pose you're after.

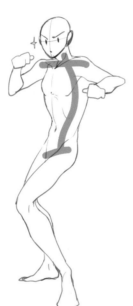

Situation 3

When Posing Yourself

A knowledge of contrapposto when posing yourself leads to a deeper understanding of which body parts rise or lower and to what degree depending on the position of the center of gravity.

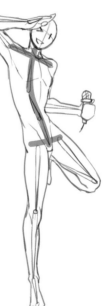

Situation 4

When Making a Figure or 3D Model

When creating a three-dimensional character, a knowledge of contrapposto allows you to achieve a pose with a balanced center of gravity and to model muscle movement accurately.

Situation 5

When Looking through a Book of Poses

A knowledge of contrapposto makes it easier to understand mechanisms and muscle movements in the human body. This means you'll be able to study references for poses from various viewpoints, thus improving your sketching ability.

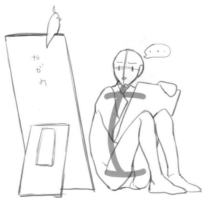

Standing Poses: The Basics

In order to create memorable and appealing standing poses, the raising and lowering of each body part plays a key role. Let's learn the basics so you can get it right.

Drawing a Standing Pose

Contrapposto is an invaluable tool for drawing striking standing poses.
Be conscious of the raising or lowering of of each body part,
making sure it's reflected in your illustration.

A Basic Standing Pose

The leg taking the weight extends straight down, and the body is lowered on that side. The hip also rises on that side, and the knees and hips form a parallel line. The leg on the other side extends out, and the heel lifts off the ground.

Standing Poses Check List

☐ The line of the shoulders contrasts with that of the hips.

☐ The backbone forms an S shape.

☐ The leg closest to the position of the navel is the pivoting leg.

☐ Placing a hand on the raised hip makes for a stable pose.

Make sure to properly learn which parts lift, which ones lower and where the center of gravity is located!

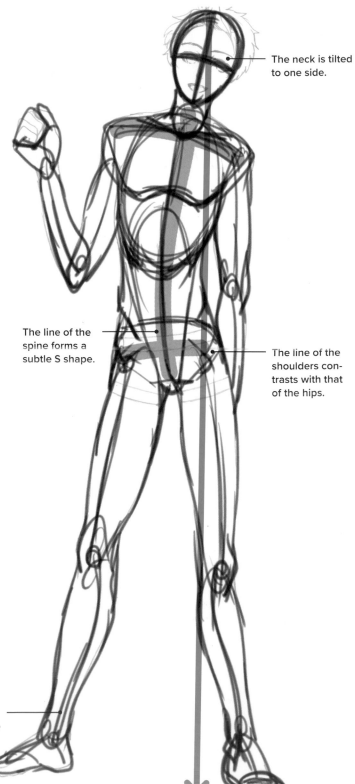

The neck is tilted to one side.

The line of the spine forms a subtle S shape.

The line of the shoulders contrasts with that of the hips.

Show the side of the leg to give the pose stability.

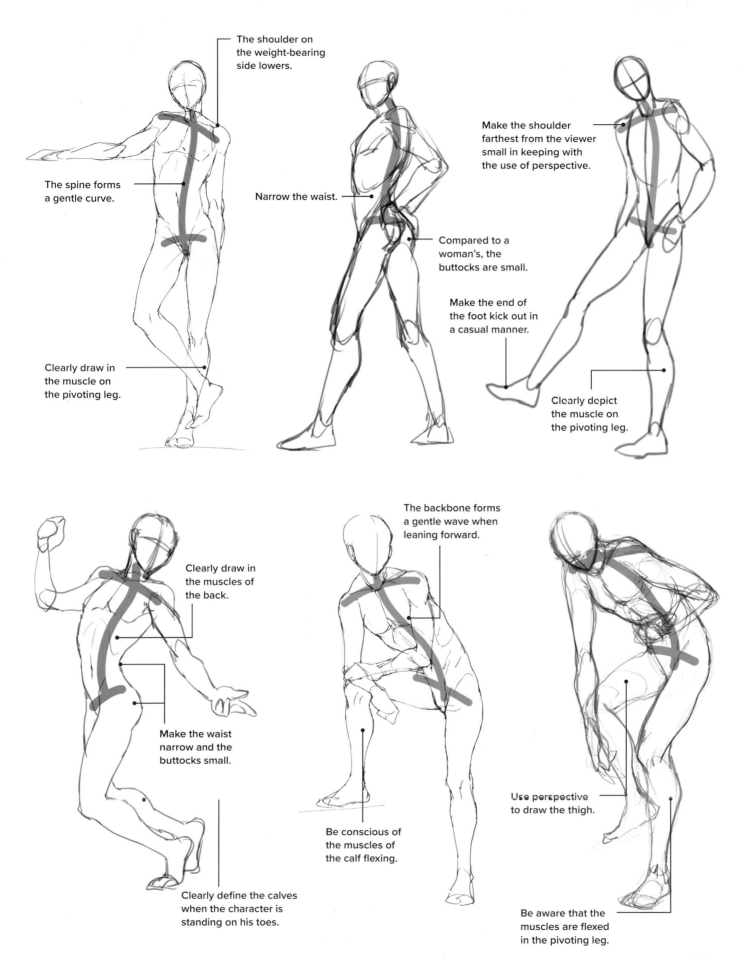

The shoulder on the weight-bearing side lowers.

The spine forms a gentle curve.

Clearly draw in the muscle on the pivoting leg.

Narrow the waist.

Make the shoulder farthest from the viewer small in keeping with the use of perspective.

Compared to a woman's, the buttocks are small.

Make the end of the foot kick out in a casual manner.

Clearly depict the muscle on the pivoting leg.

Clearly draw in the muscles of the back.

Make the waist narrow and the buttocks small.

Clearly define the calves when the character is standing on his toes.

The backbone forms a gentle wave when leaning forward.

Be conscious of the muscles of the calf flexing.

Use perspective to draw the thigh.

Be aware that the muscles are flexed in the pivoting leg.

31

Warming Up

In standing poses, the lines of the skeleton, such as the shoulders, hips and spine, are important. While maintaining the lines of these three key points, let's block-in the figure step by step.

Blocking-In

First, block-in the figure (blocking-in means to roughly sketch the form and position of the figure). Rather than the body's muscles, picture drawing the skeleton. Draw the shoulders, hips and the S-shaped line of the spine, adding the head, hands and feet.

At this stage, it's fine to simply use a circle to show the position of the head.

Decide on the position of the shoulders.

Be conscious of the S shape of the backbone; don't make it straight.

Roughly decide on the movement of the hands.

Decide on the position of the pelvis.

At this stage, draw in the feet just to make it clear which direction they're facing.

Don't forget to draw in the neck between the head and shoulders at the blocking-in stage.

Draw the arms around the blocked-in lines.

Decide on the position of the knee joints and the calves extending from them.

Draw the feet facing in the direction determined from blocking-in.

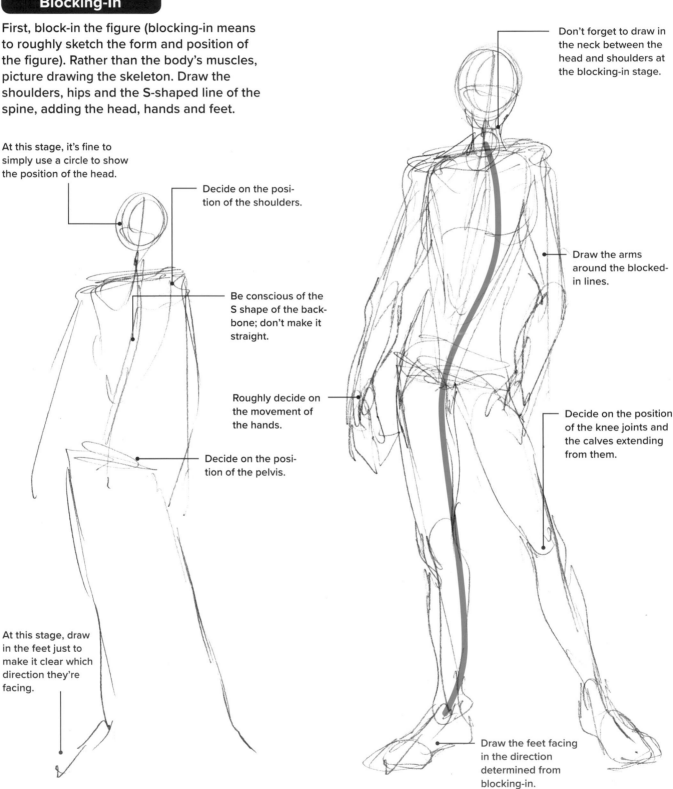

Flesh Out the Form

Add in flesh over the blocked-in skeleton. Don't start by drawing the clothes. First, draw the muscles beneath the clothing. Be aware of the movement of the arm and leg joints along with the muscles as you draw.

Be aware of the center of gravity as you draw the S-shaped spine!

Select the best line from the multiple lines sketched in and trace over it strongly to create a rough outline.

Following the outline created in the previous step, add in the basic face and clothing.

Draw in the basic facial features, such as the position of the eyes and mouth and the bridge of the nose.

Be conscious of the muscles in the chest and stomach as you fill in the body.

Draw in the clothing little by little.

Roughly decide on the angle of the wrists and joints, but don't add in details such as the fingers yet.

Keep in mind the direction of the knees as you draw.

Consider how the hem of the pants will move in relation to the movement of the leg.

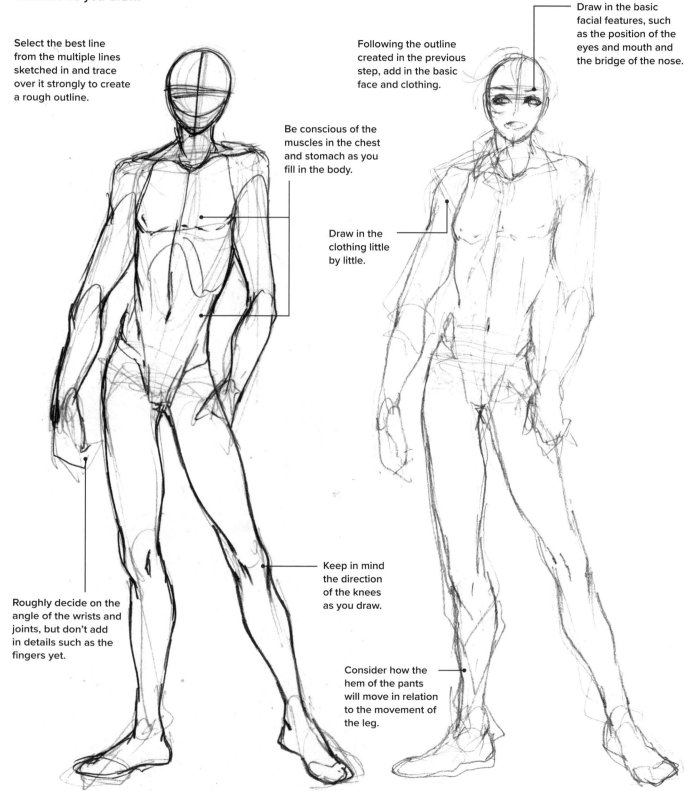

Fill in the Details

Draw in the details of the clothing, face and limbs over the fleshed-out line drawing, keeping in mind the way creases form in the clothing. Add other details such as the tie and shoes too.

Always look for the best line as you draw!

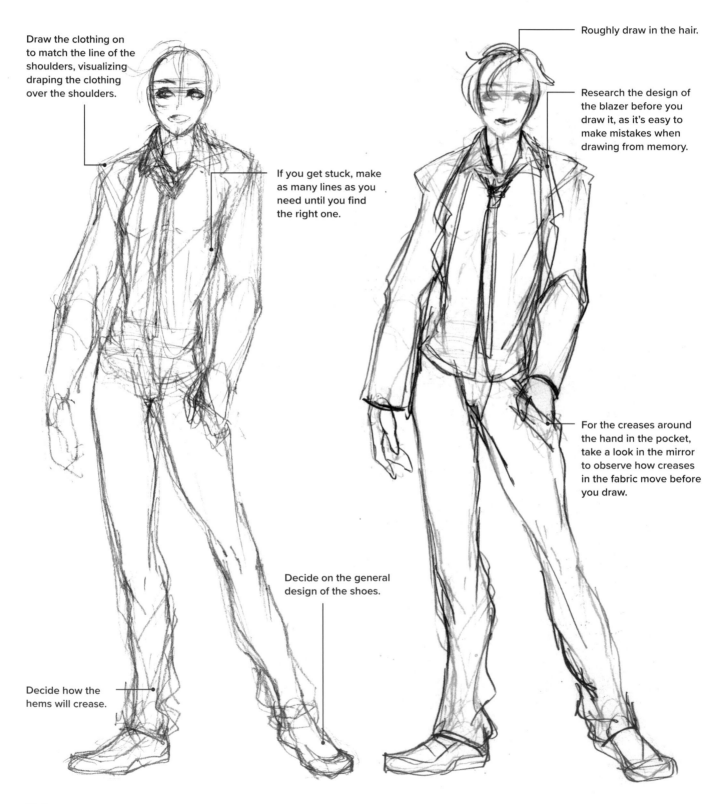

Draw the clothing on to match the line of the shoulders, visualizing draping the clothing over the shoulders.

If you get stuck, make as many lines as you need until you find the right one.

Decide how the hems will crease.

Decide on the general design of the shoes.

Roughly draw in the hair.

Research the design of the blazer before you draw it, as it's easy to make mistakes when drawing from memory.

For the creases around the hand in the pocket, take a look in the mirror to observe how creases in the fabric move before you draw.

Completing the Line Drawing

Erase the unnecessary lines from the sketch and complete the details for the clothing and facial expression. If you don't pay attention to the creases in clothing as you draw, the dimension achieved by drawing the figure from the skeleton upward will be lost.

Carefully add in the facial expression and hairstyle to bring out the character's personality

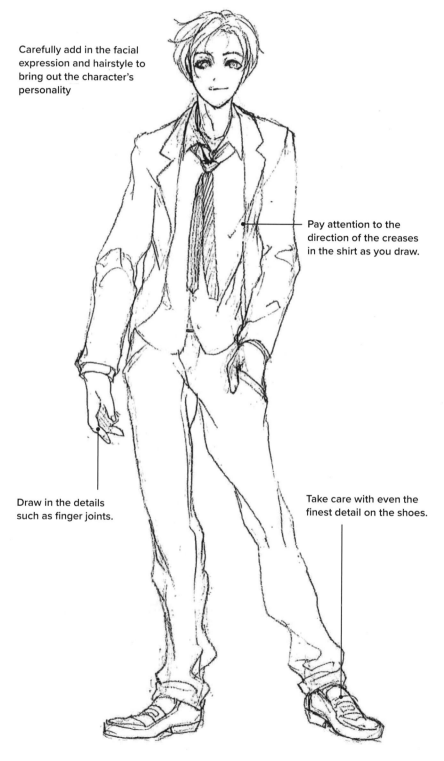

Pay attention to the direction of the creases in the shirt as you draw.

Draw in the details such as finger joints.

Take care with even the finest detail on the shoes.

Key points when blocking-in the figure for this standing pose.

POINT 1

Even when adding movement, first draw the skeleton and then add the flesh.

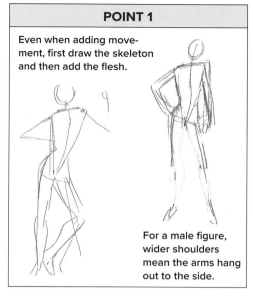

For a male figure, wider shoulders mean the arms hang out to the side.

POINT 2

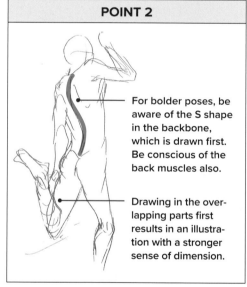

For bolder poses, be aware of the S shape in the backbone, which is drawn first. Be conscious of the back muscles also.

Drawing in the overlapping parts first results in an illustration with a stronger sense of dimension.

POINT 3

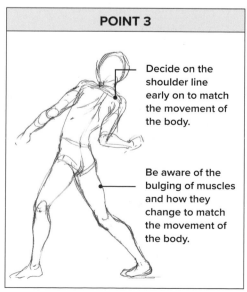

Decide on the shoulder line early on to match the movement of the body.

Be aware of the bulging of muscles and how they change to match the movement of the body.

01 | Drawing a Figure with the Weight on One Leg

Let's learn how each part of the body rises or lowers when standing with the weight resting on only one leg.

The One-Legged Pose

The shoulder lowers and the hip rises on the side of the weight-bearing leg. This is the same for both men and women. The leg where the center of gravity is located extends straight, while the other leg moves freely. Distancing the heel of the free-moving leg from the ground yields a stronger result.

Tilt the head however you like.

When gravity is centered on the left leg, raise the right shoulder and lower the left.

In a pose expressing boredom or listlessness, limit the amount of movement in the arm by keeping it close to the torso.

Place the ankle of the weight-bearing foot directly below the head.

Be conscious of the S shape that runs from the head to the toes to create a balanced figure.

If it's difficult to locate the center of gravity in a pose, use the direction of the shoulders to guide you.

When weight's resting on the left leg, the left hip rises and the left side of the waist narrows.

The sole of the left foot is firmly planted on the ground.

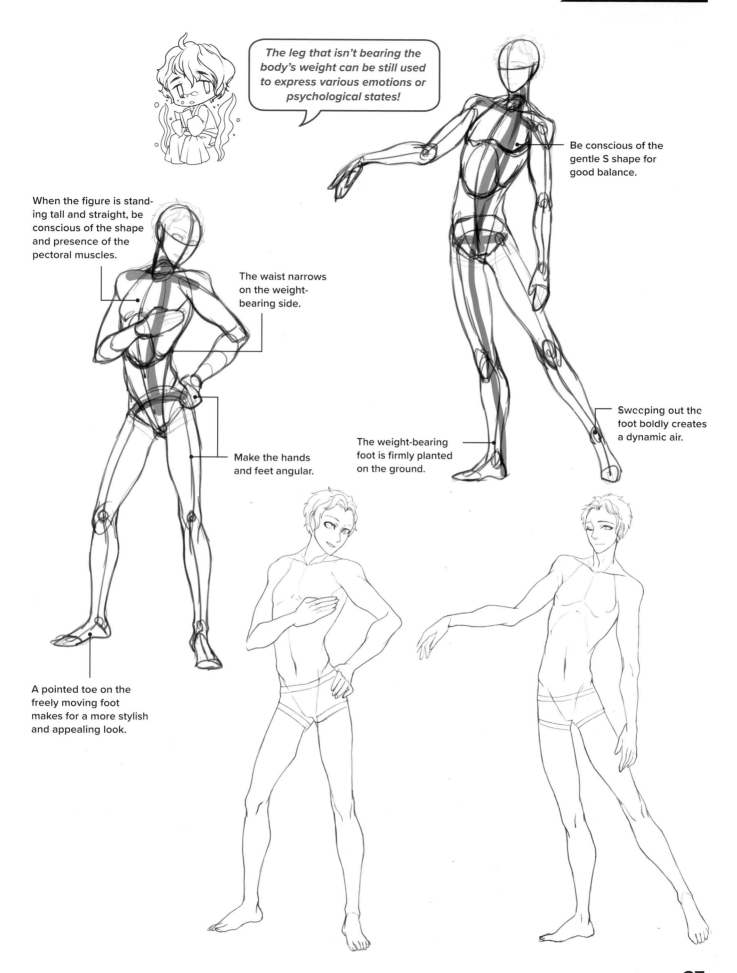

The leg that isn't bearing the body's weight can be still used to express various emotions or psychological states!

When the figure is standing tall and straight, be conscious of the shape and presence of the pectoral muscles.

The waist narrows on the weight-bearing side.

Make the hands and feet angular.

A pointed toe on the freely moving foot makes for a more stylish and appealing look.

Be conscious of the gentle S shape for good balance.

Sweeping out the foot boldly creates a dynamic air.

The weight-bearing foot is firmly planted on the ground.

Drawing a Figure Standing on One Leg

When wanting to create a more dynamic pose for the character, draw your character balanced on one leg.

Standing on One Leg

Gravity is centered on the foot planted on the ground. On that side of the body, the hip lowers and the shoulder rises. Keeping the ankle on the weight-bearing side directly below the head creates a balanced, stable look that appears more natural and realistic.

On the weight-bearing side of the body, the shoulder rises and the hip lowers.

The line of the backbone curves in an S shape.

Be aware that every single part of the body is flexed or engaged.

When the figure is moving only a little, keep the arm close to the torso.

The hip lowers on the side where the shoulder rises.

Clearly define the calf of the leg planted on the ground.

The knees face outward.

Lifting the Leg Up High

In a pose where the knee is raised high and the figure's standing on one leg, such as in fighting poses, a sense of stability is key. Keeping the ankle of the weight-bearing leg directly below the head lends reality to the pose.

Shifting the center of gravity to the direction that the face is heading creates a sense of momentum.

The shoulder on the weight-bearing side moves in contrast with the hip.

Bring out the sense of dynamism in the thigh in the moment before a kick.

Clearly define the mass of muscle in the pivoting leg.

The waist area is torqued and activated.

Be conscious of the fullness of the thigh muscles.

Position the pivoting leg directly below the head to create a sense of stability.

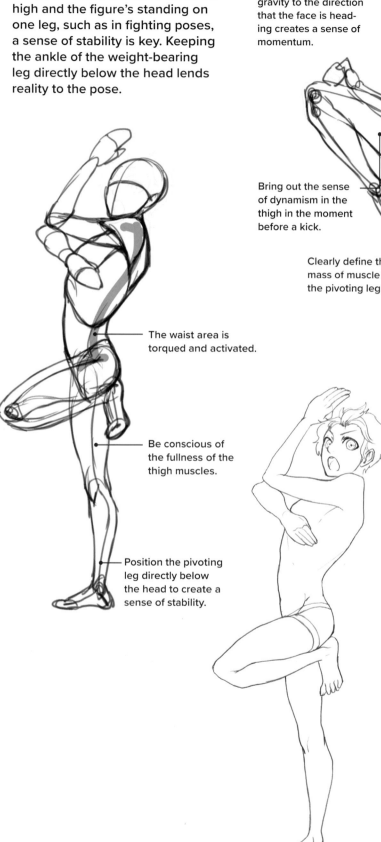

A Bit of Advice

Be conscious of the muscle when the leg's raised.

In a one-legged standing pose, the depiction of the raised leg is important. Be aware of the muscles in that leg being flexed and engaged all the way to the tips of the toes. Make sure to clearly show the bulk in the muscle.

03

Drawing a Figure with an Arched Back

When drawing a body in an arching pose, depicting a sense of movement is crucial. Be conscious of the curve of the back to create an active and engaged pose.

The Basics of an Arched Pose

Be conscious of the structure of the backbone to guide the curved line from the middle of the back down to the hips. With the typical musculature of a man's back, the arch is not as pronounced as it is for women.

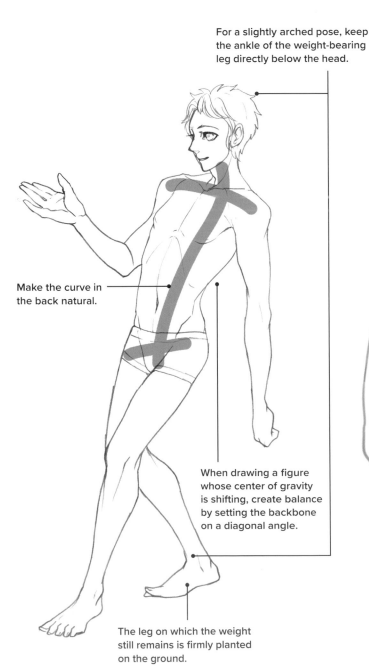

For a slightly arched pose, keep the ankle of the weight-bearing leg directly below the head.

Make the curve in the back natural.

When drawing a figure whose center of gravity is shifting, create balance by setting the backbone on a diagonal angle.

The leg on which the weight still remains is firmly planted on the ground.

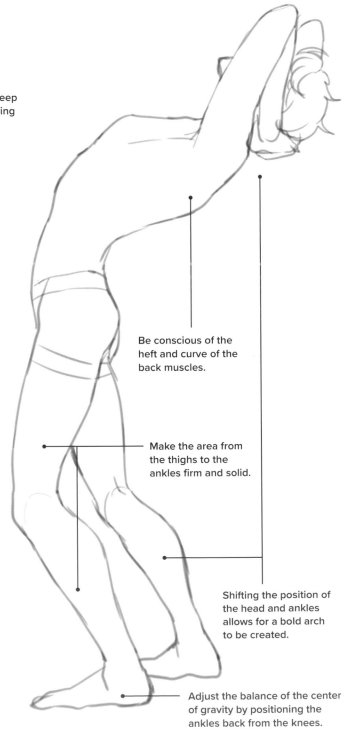

Be conscious of the heft and curve of the back muscles.

Make the area from the thighs to the ankles firm and solid.

Shifting the position of the head and ankles allows for a bold arch to be created.

Adjust the balance of the center of gravity by positioning the ankles back from the knees.

Arching and Twisting

The trick to making this pose look natural is to be aware of the point at which muscles protrude or engage. A dynamic movement won't be conveyed in a drawing that isn't properly finished.

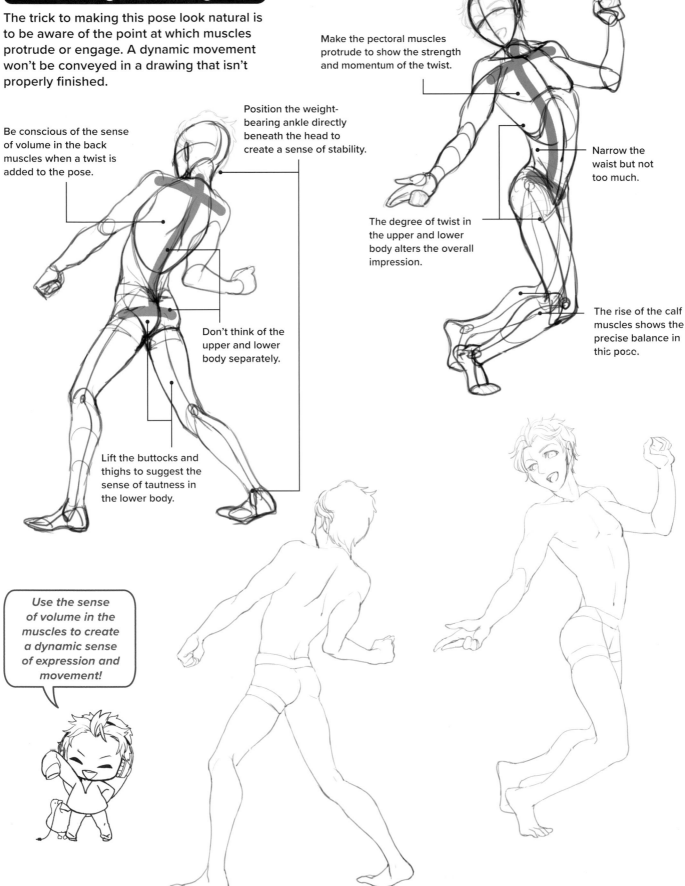

Be conscious of the sense of volume in the back muscles when a twist is added to the pose.

Position the weight-bearing ankle directly beneath the head to create a sense of stability.

Make the pectoral muscles protrude to show the strength and momentum of the twist.

Narrow the waist but not too much.

The degree of twist in the upper and lower body alters the overall impression.

Don't think of the upper and lower body separately.

The rise of the calf muscles shows the precise balance in this pose.

Lift the buttocks and thighs to suggest the sense of tautness in the lower body.

Use the sense of volume in the muscles to create a dynamic sense of expression and movement!

04

Drawing a Figure Looking Over One Shoulder

Twisting around or looking back over a shoulder is a distinctive pose that sets your character apart.

Twisting the Neck

The trick to depicting turning around and twisting the upper body is to think of the torso as a solid form. Picture it as a twisted piece of licorice.

Imagine your character's being photographed, his picture taken the moment he turns toward the camera.

Directing the face to follow the weight-bearing leg adds momentum to the swinging motion.

If only the head turns, it'll look unnatural, so make the shoulders move also.

Make the entire body linear for a more strikingly defined standing pose.

Avoid large movements in the hands and feet and keep the arms close to the torso.

Make sure that the body twists from the waist.

Spreading the legs wide makes for a sharper, more memorable drawing.

Position the leg bearing the center of gravity directly beneath the head.

42

Twisting the Upper Body

The twisted, backward glance can be one of your character's signature poses. Start by drawing a well-defined standing pose, then rotate the upper body of the figure.

If the figure is turning considerably, create a noticeable bulge in the back and brachial muscles.

Make sure the turn starts at the waist.

Elevating the buttocks and thighs emphasizes the movement of the upper body.

Keep the bulk of the trapezius to a minimum.

If the figure is only slightly turning, make the movement minimal in the upper body.

While making the chest stick out, don't emphasize the curve in the back.

Let the arm fall in a straight, linear fashion.

Spread the legs wide for a more defined pose.

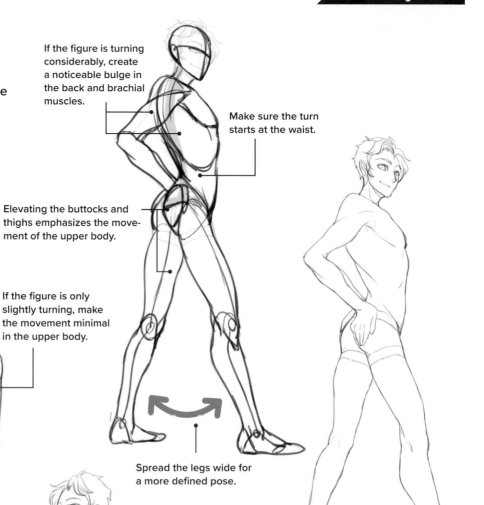

A Bit of Advice

Think of the upper body and torso as a piece of licorice.

Have a strong image in mind of the torso in order to draw it, considering how the back moves when the body twists or leans in one direction. Don't forget to include what happens with the position of the hips when the chest is pushed out.

Drawing a Slumping Figure

The movement of the shoulders and the line of the back are key points
for creating a believably listless pose.

A Slight Lack of Energy

Drop the shoulders to express
the lack of power and create a
gentle curve in the spine. Place
the weight-bearing ankle im-
mediately below the drooping
head to maintain balance.

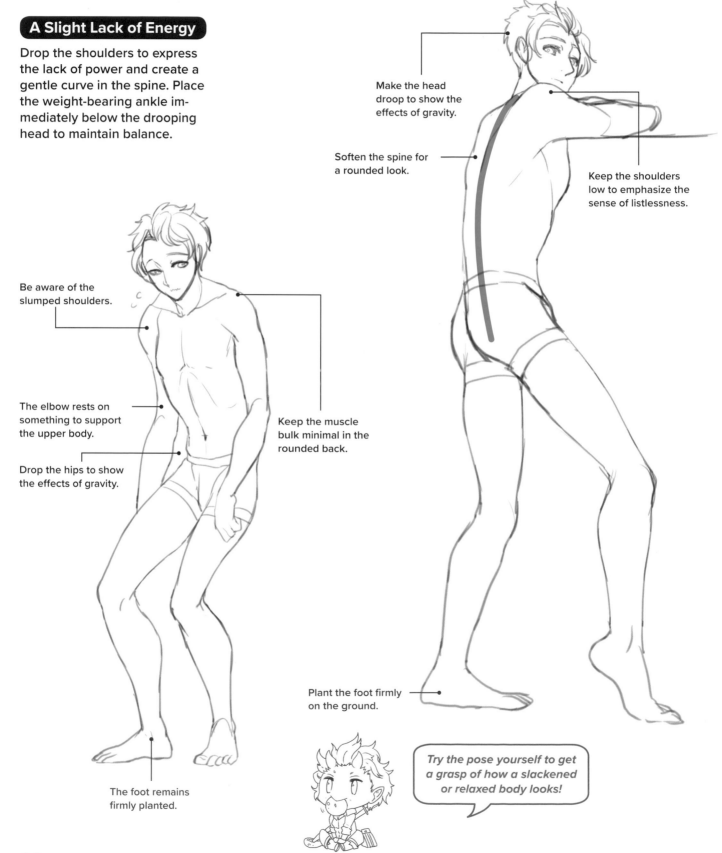

Make the head
droop to show the
effects of gravity.

Soften the spine for
a rounded look.

Keep the shoulders
low to emphasize the
sense of listlessness.

Be aware of the
slumped shoulders.

The elbow rests on
something to support
the upper body.

Drop the hips to show
the effects of gravity.

Keep the muscle
bulk minimal in the
rounded back.

Plant the foot firmly
on the ground.

The foot remains
firmly planted.

*Try the pose yourself to get
a grasp of how a slackened
or relaxed body looks!*

Limp or Floating

In scenes where the character is just about to lose consciousness, is floating in water or is otherwise relaxed or limp, emphasizing the looseness and slackness in the lower body is the key. Loose limbs and unflexed muscles are the clinchers.

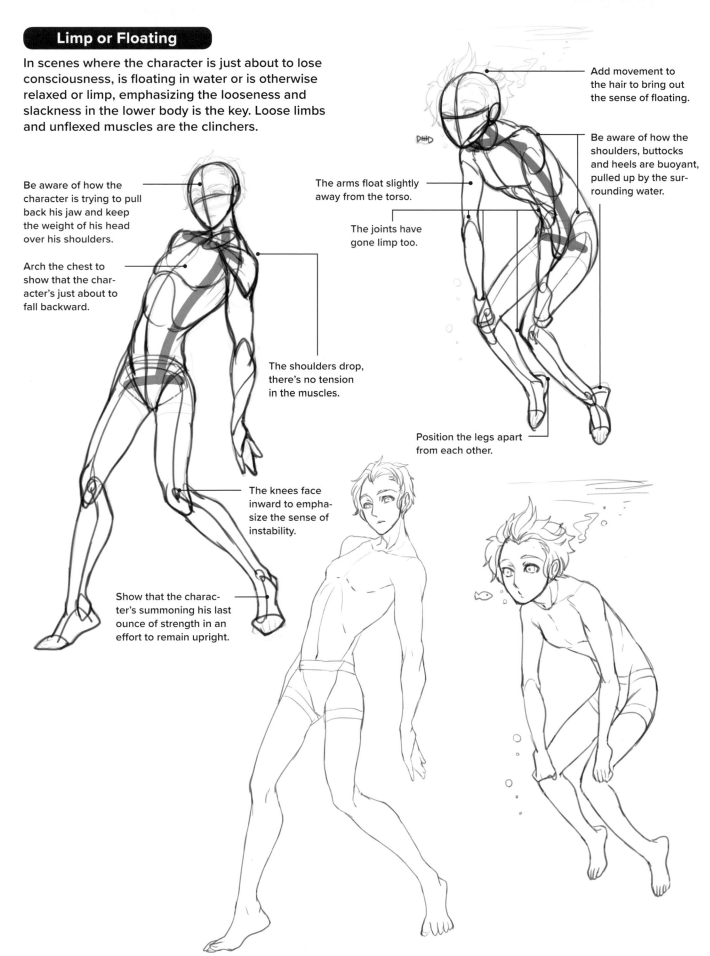

Add movement to the hair to bring out the sense of floating.

Be aware of how the shoulders, buttocks and heels are buoyant, pulled up by the surrounding water.

The arms float slightly away from the torso.

The joints have gone limp too.

Be aware of how the character is trying to pull back his jaw and keep the weight of his head over his shoulders.

Arch the chest to show that the character's just about to fall backward.

The shoulders drop, there's no tension in the muscles.

Position the legs apart from each other.

The knees face inward to emphasize the sense of instability.

Show that the character's summoning his last ounce of strength in an effort to remain upright.

06

Drawing a Figure with Arms Folded

The arms can always be used to add emphasis and definition to your pose.
Folded arms only increase this appeal.

The Folded Arms Basics

Positioning the shoulders, nipples and elbows parallel to one another yields a crisply defined folded-arms pose. Making the upper arms sit out wide, away from the torso, creates a sense of stability, while pulling them in gives the pose a bit more subtlety.

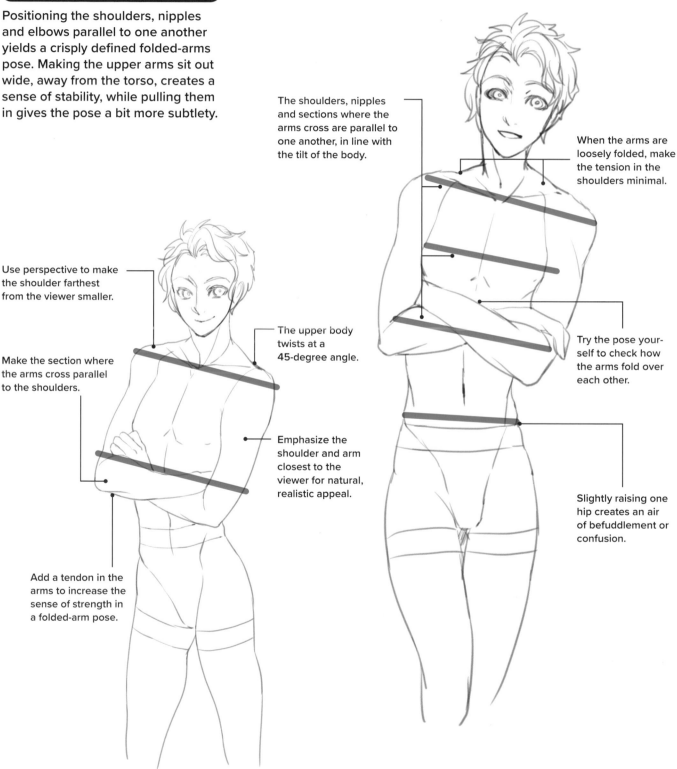

The shoulders, nipples and sections where the arms cross are parallel to one another, in line with the tilt of the body.

When the arms are loosely folded, make the tension in the shoulders minimal.

Use perspective to make the shoulder farthest from the viewer smaller.

Make the section where the arms cross parallel to the shoulders.

The upper body twists at a 45-degree angle.

Try the pose yourself to check how the arms fold over each other.

Emphasize the shoulder and arm closest to the viewer for natural, realistic appeal.

Add a tendon in the arms to increase the sense of strength in a folded-arm pose.

Slightly raising one hip creates an air of befuddlement or confusion.

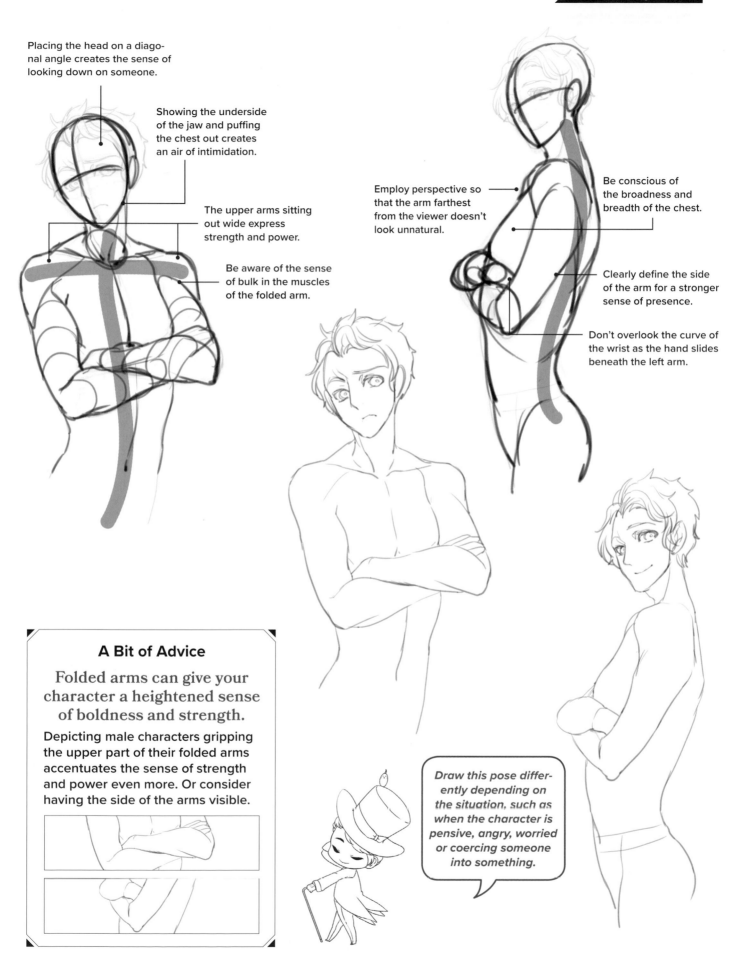

Placing the head on a diagonal angle creates the sense of looking down on someone.

Showing the underside of the jaw and puffing the chest out creates an air of intimidation.

The upper arms sitting out wide express strength and power.

Be aware of the sense of bulk in the muscles of the folded arm.

Employ perspective so that the arm farthest from the viewer doesn't look unnatural.

Be conscious of the broadness and breadth of the chest.

Clearly define the side of the arm for a stronger sense of presence.

Don't overlook the curve of the wrist as the hand slides beneath the left arm.

A Bit of Advice

Folded arms can give your character a heightened sense of boldness and strength.

Depicting male characters gripping the upper part of their folded arms accentuates the sense of strength and power even more. Or consider having the side of the arms visible.

Draw this pose differently depending on the situation, such as when the character is pensive, angry, worried or coercing someone into something.

47

Drawing a Leaning Figure

In a leaning pose, the positioning of the parts of the body touching the
wall is key. If they protrude or blend too seamlessly into the wall,
the drawing will look unnatural.

Leaning on a Wall

When leaning against a vertical
service, the back becomes the
center of gravity and the body's
axis moves, shifting tension to
the back of the head. The wall is
perpendicular to the ground, so
maintain that line through the
positioning of the head and back.

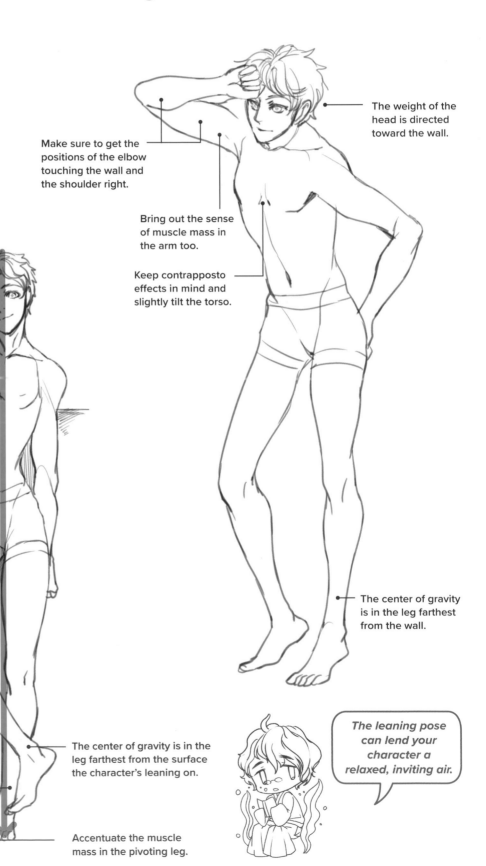

Make sure to get the
positions of the elbow
touching the wall and
the shoulder right.

The weight of the
head is directed
toward the wall.

Bring out the sense
of muscle mass in
the arm too.

Keep contrapposto
effects in mind and
slightly tilt the torso.

Carefully draw in the parts
of the arm and side of the
stomach that are in contact
with the surface.

The center of gravity
is in the leg farthest
from the wall.

Keep the free leg
loose and relaxed.

The center of gravity is in the
leg farthest from the surface
the character's leaning on.

Keep the ankle at the
center of gravity directly
below the head.

Accentuate the muscle
mass in the pivoting leg.

*The leaning pose
can lend your
character a
relaxed, inviting air.*

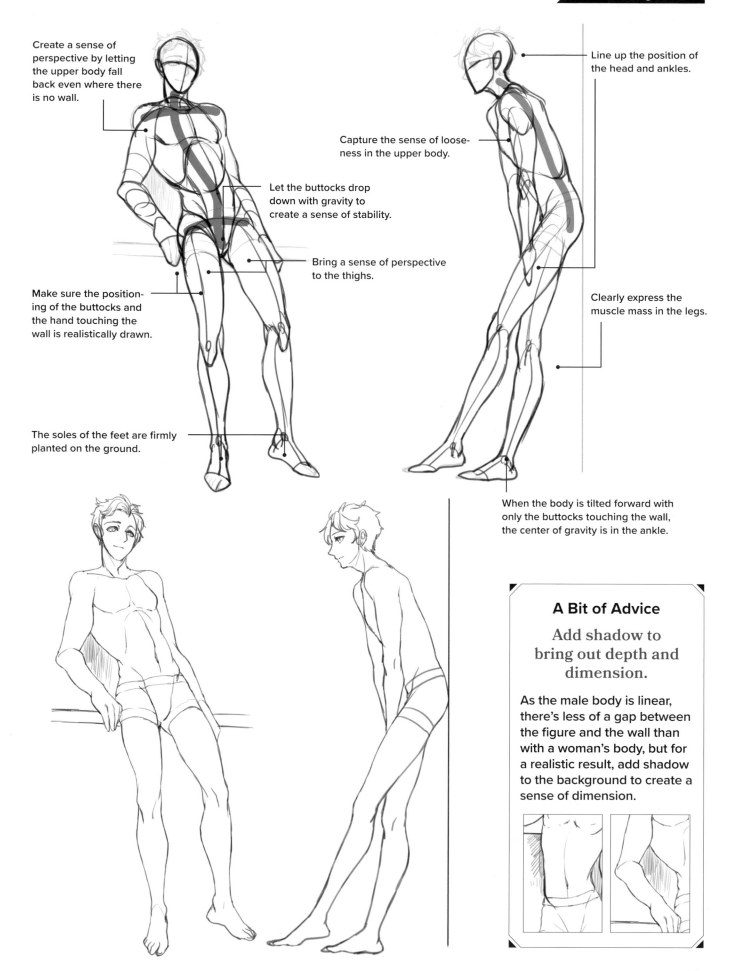

Create a sense of perspective by letting the upper body fall back even where there is no wall.

Line up the position of the head and ankles.

Capture the sense of looseness in the upper body.

Let the buttocks drop down with gravity to create a sense of stability.

Bring a sense of perspective to the thighs.

Make sure the positioning of the buttocks and the hand touching the wall is realistically drawn.

Clearly express the muscle mass in the legs.

The soles of the feet are firmly planted on the ground.

When the body is tilted forward with only the buttocks touching the wall, the center of gravity is in the ankle.

A Bit of Advice

Add shadow to bring out depth and dimension.

As the male body is linear, there's less of a gap between the figure and the wall than with a woman's body, but for a realistic result, add shadow to the background to create a sense of dimension.

Drawing a Bending Figure

Bending over is a common pose, but getting it right can be tricky.
The position of the waist and knees is key.

Bending Slightly

Keeping the structure of the backbone in mind, draw the upper body on a diagonal. Raise the hip on the side where the center of gravity is located and direct both knees outward for a more pronounced, defined look. Bring the shoulder and arm toward the knee on the weight-bearing side.

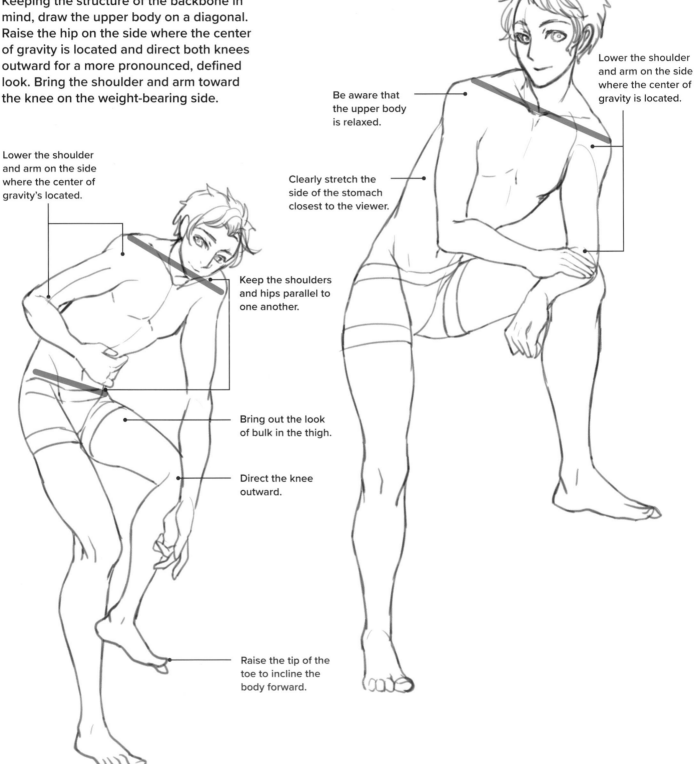

Be aware that the upper body is relaxed.

Lower the shoulder and arm on the side where the center of gravity is located.

Clearly stretch the side of the stomach closest to the viewer.

Lower the shoulder and arm on the side where the center of gravity's located.

Keep the shoulders and hips parallel to one another.

Bring out the look of bulk in the thigh.

Direct the knee outward.

Raise the tip of the toe to incline the body forward.

Bending All the Way Over

Draw the upper body significantly bent over
with the stomach approaching the thighs.
Whether the knees are straight or the hips are
dropped, in a pose where the body's bent, the
sense of bulk in the calves is important.

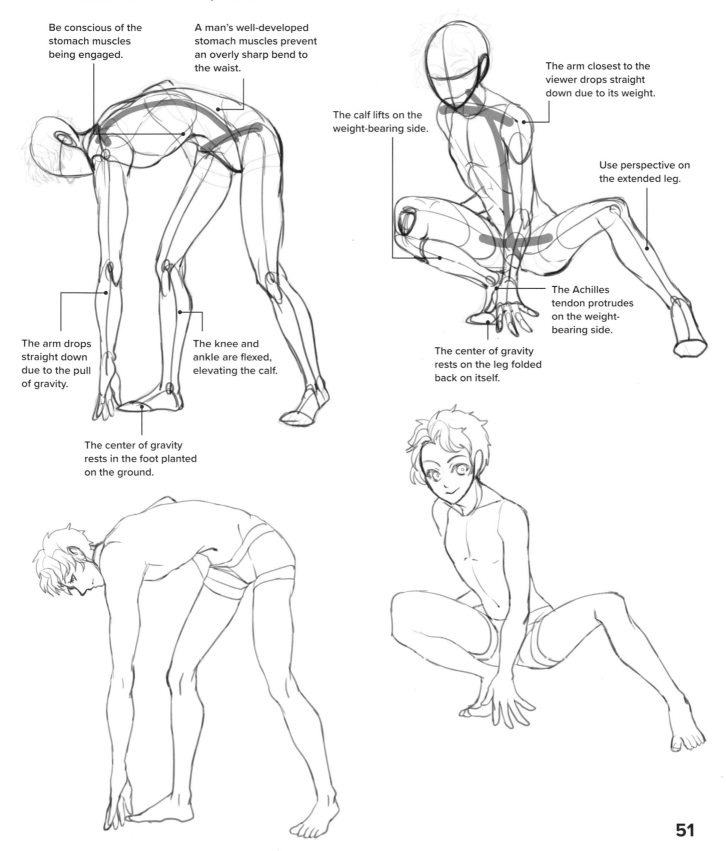

Be conscious of the
stomach muscles
being engaged.

A man's well-developed
stomach muscles prevent
an overly sharp bend to
the waist.

The calf lifts on the
weight-bearing side.

The arm closest to the
viewer drops straight
down due to its weight.

Use perspective on
the extended leg.

The arm drops
straight down
due to the pull
of gravity.

The knee and
ankle are flexed,
elevating the calf.

The Achilles
tendon protrudes
on the weight-
bearing side.

The center of gravity
rests in the foot planted
on the ground.

The center of gravity
rests on the leg folded
back on itself.

Drawing Two Standing Figures

When drawing two figures physically interacting, pay attention to each figure's movement and be sure you get the centers of gravity balanced.

Grabbing the Arm

In this scene, one character grabs the arm of the other in an effort to stop him as he tries to run away. There's a twist in the upper body of the figure on the right. The balance of the figure on the left shifts slightly forward.

Make sure the gazes and the directions of the body align.

The torso is twisted so be conscious of the sense of bulk in the back muscles.

Make the parts contacting one another clear and neatly defined.

Make the muscle of the grabbing arm well-defined.

Tilt the upper body forward to add momentum.

The weight rests on the foot stepping forward.

A Bit of Advice

Draw the overlapping parts first.

If you want to connect the two figures but are having trouble creating a sense of continuity and cohesion, start by drawing the parts that are touching. In the illustration above, it's the hands. Another good tip: use images and photos of posing as references and practice drawing them.

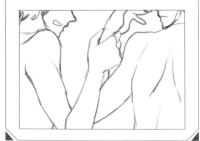

Clinging to Each Other

When drawing two figures in close contact and gazing into each other's eyes, the first thing to consider is the height difference. In order to reduce the difference and create balance, put one character on tiptoes or draw him bending down.

Make sure to check each character's position on the ground as you draw!

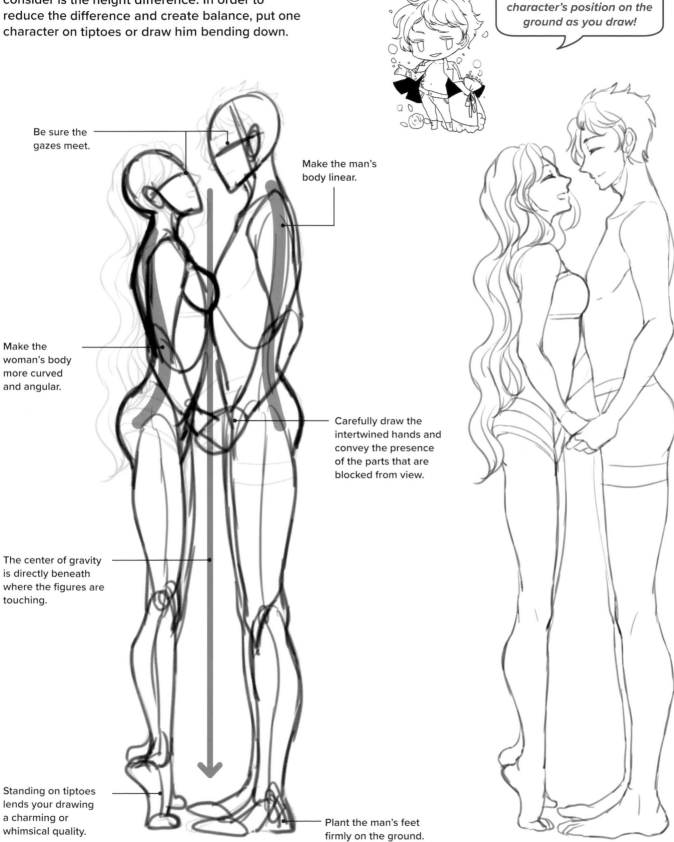

Be sure the gazes meet.

Make the man's body linear.

Make the woman's body more curved and angular.

Carefully draw the intertwined hands and convey the presence of the parts that are blocked from view.

The center of gravity is directly beneath where the figures are touching.

Standing on tiptoes lends your drawing a charming or whimsical quality.

Plant the man's feet firmly on the ground.

Cuddling an Animal

In a pose where a figure's holding a pet or where there's a marked difference in size between the two connected figures, starting the drawing with the larger character makes it easy to adjust overall balance.

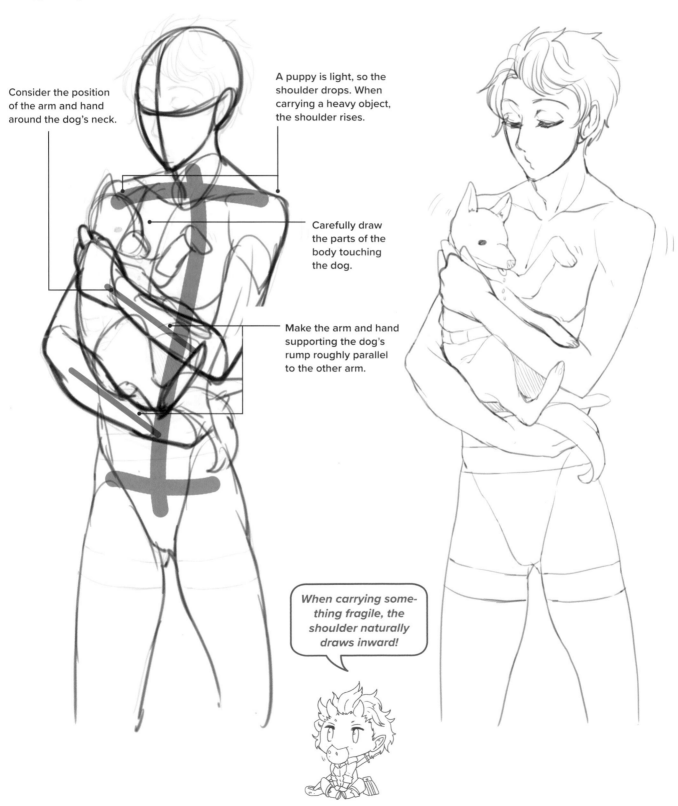

Consider the position of the arm and hand around the dog's neck.

A puppy is light, so the shoulder drops. When carrying a heavy object, the shoulder rises.

Carefully draw the parts of the body touching the dog.

Make the arm and hand supporting the dog's rump roughly parallel to the other arm.

When carrying something fragile, the shoulder naturally draws inward!

Grabbing Each Other

In poses where two figures are close together, such as when play fighting with one character grabbing the other from behind, make sure to check where the center of gravity is to prevent the composition from becoming messy.

When you're having trouble drawing, try using stick figures and silhouettes to simulate the movement!

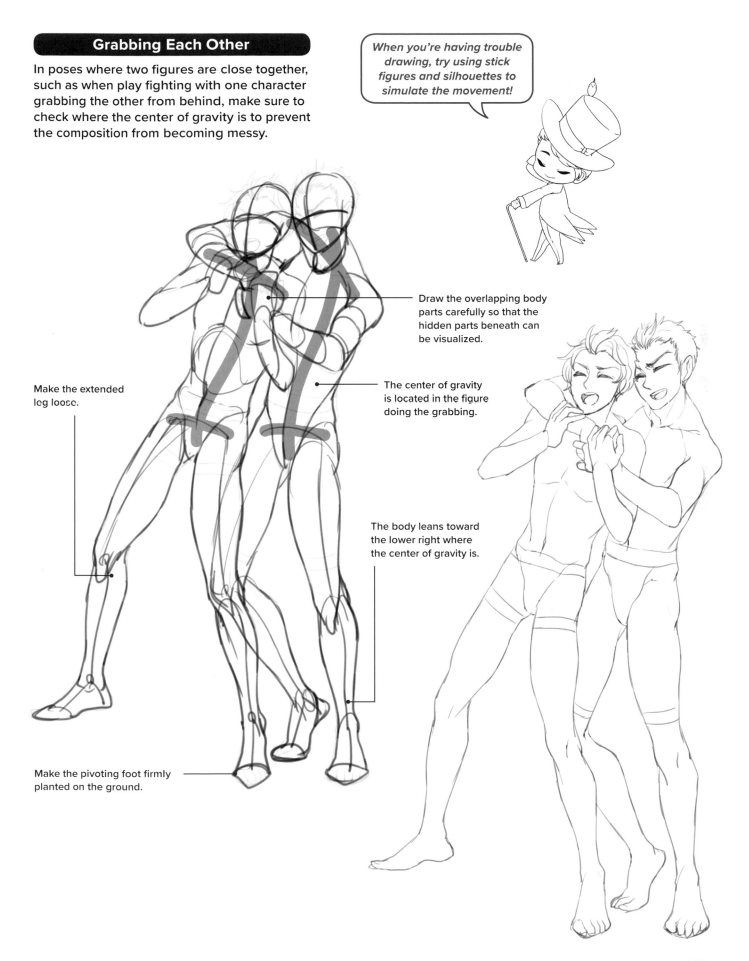

Make the extended leg loose.

Draw the overlapping body parts carefully so that the hidden parts beneath can be visualized.

The center of gravity is located in the figure doing the grabbing.

The body leans toward the lower right where the center of gravity is.

Make the pivoting foot firmly planted on the ground.

Applying Color

Add color in a thick layer to complete
the drawing.

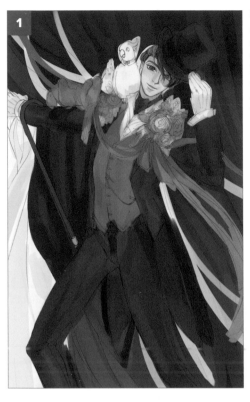

Use your preferred digital-design software for applying color, and Photoshop for correcting it. Let's start by applying a temporary coat. Use a normal brush to achieve a color application that resembles oil paint.

First, use the normal brush to place color on the illustration a little at a time.

Oil pastels work well for smudging and blending effects.

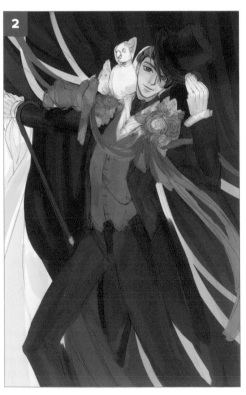

Digital-design software allows you to focus on layers limited to drawing, line drawing, applying color and developing the background. It's easy to make corrections as everything is added on one layer.

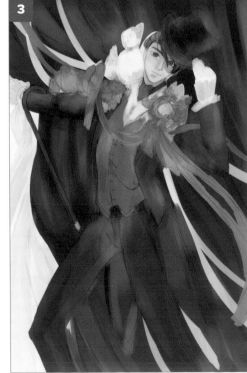

Match the color of the line drawing to the color of the paint. Adding color to the lines allows the hues to blend better. Replicate the layers of paint and combine them, then move them over the top of the line-drawing layer.

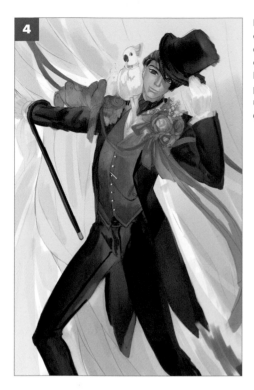

Here, the red background has been changed. Keep adding color over the line drawing. Try various ways of applying color such as using the eyedropper or Photoshop's posterization effects. Using posterization removes mottling or irregular color, so use it when color has been quickly placed onto the illustration.

Try using the eyedropper to blend the surrounding colors!

Make use of posterization to smoothly erase mottling!

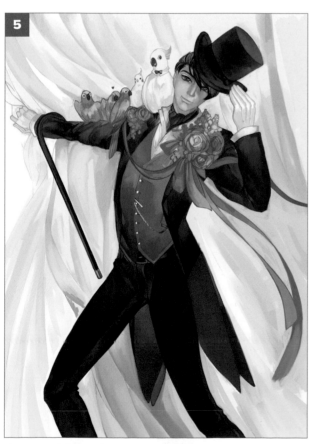

Use your digital-design software to further apply color and complete the work. It's fun to use various filters to discover your favorite color scheme!

A Bit of Advice

Normal brush vs. Oil pastel

There are various types of brushes available for use when creating illustrations on a computer. If you're not sure which one to start with, try two types: the normal brush and the oil pastel. Use the normal brush to draw the base, then use the oil pastel version to smudge and blend color and create nuance. Oil pastel is characterized by its resemblance to oil paint. Once you're used to it, try making your own original brush!

How to Apply Color

Pay attention to the balance of color as you go!

There are various methods for applying color. Here, two methods of color application are explored: Photoshop and your preferred digital-design software.

▶ Cel Shading

Often seen in traditional animation, it's the simplified use of color that appeals in this type of painting method. As the method itself is simple, matching the colors and finding an overall balance require serious consideration. Apply color using mainly the default brush in Photoshop.

Line drawing prior to the application of color.

Applying a soft-focus effect to particular sections diffuses the outline of the glass, creating the appearance of light being reflected.

Make the shadow on the face green and the shadow on the shirt blue. The key here is to create the appearance of the blue in the background being reflected.

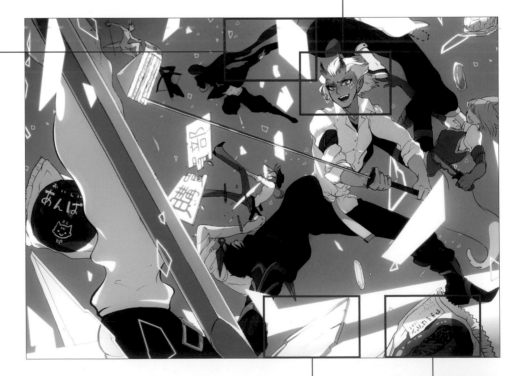

The parts reflecting light stand out and appear to glow.

Make the snack packaging reflective too. This has the added effect of making the package seem more solid.

▶ Gray-Scale Techniques

This technique involves first using shades of gray to create density, then adding color. Most of the work is done using digital-design software, with Photoshop used to make fine adjustments to the color.

If you're not good at coloring, give this type of painting a try!

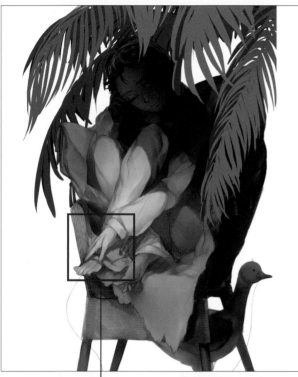

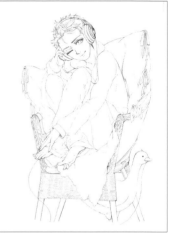

Line drawing prior to the application of color: In many cases, it's O.K. not to make the line drawing too neat.

Using a separate layer to sweep color over the image, creating the look of warm sunlight.

Add shadow to the illustration using basic layering techniques. This is an easy way to apply color if you're not yet proficient at putting colors together, if you like layering your preferred colors or if you're unsure which colors to use.

It's fine not to be too precise with shading, so start by adding color to create a rough overall impression.

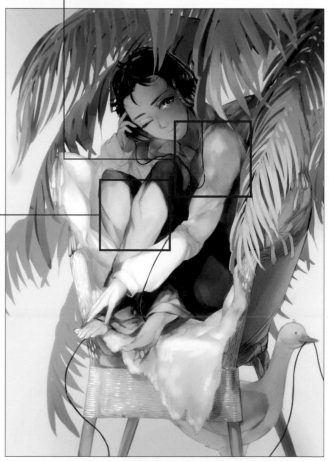

Areas that aren't shaded appear to be in direct sunlight. If this suits the look you're going for, it's a sign that the method of shading has worked.

Add color in separate layers. Place suitable shades of color in layers over the illustration and integrate those that you like best, using layering techniques to add color.

▶ Other Ways of Applying Color

There are various ways of adding and applying color. Layer painting refers to the process of applying color and texture in stages. Additionally, just as when using paint, the feel of an illustration can alter significantly depending on whether the colors are blended together and whether texture and artistic effect and being integrated.

Layer painting (with no shadow)

No shadow has been applied to this layer painting. Because of that, this is a more difficult method of arranging colors than anime painting. Texture is applied in layers to create a prism effect at the same time as unifying the colors into a cohesive whole.

Layer painting

This illustration is colored in a similar way to that of the loose pose on page 118. Over all, the tones are subdued and low key in this picture. When creating an illustration, considering the tones to be used while planning the composition is key.

Anime painting

This illustration has been colored using anime painting techniques. In contrast to regular anime painting, many textures have been incorporated, resulting in an illustration with depth and dimension. Use gradation and other tools as a way of evolving the illustration.

Analog painting

Here, transparent watercolor and color ink have been applied to drawing paper. If you're not skilled at applying color on a computer, try coloring by hand first and then scanning your work into a computer.

PART 2

Sitting Poses: The Basics

The movement of the legs and the application of perspective are essential for creating compellingly complex sitting poses. Make sure you pay close attention to the object the character's sitting on.

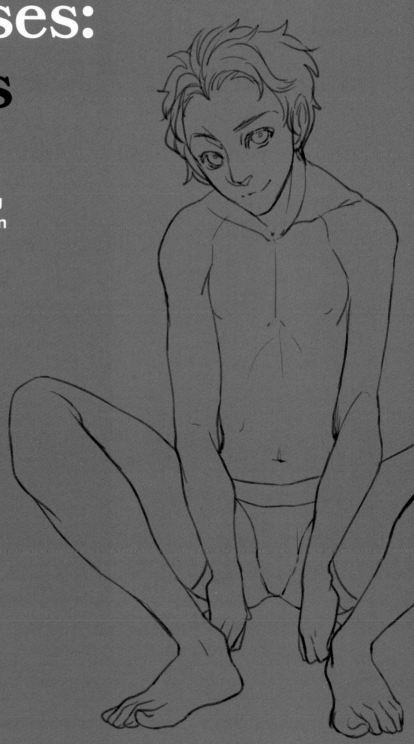

Drawing a Sitting Pose

The best approach to a sitting pose depends on the item your character's sitting on. Furthermore, having the figure leaning against the seat back is an easy way of introducing contrapposto complexity to the pose.

Take a Seat

The arm rises on the side of the body where the weight is centered, while the opposite shoulder lowers. Think of the chair or object the figure is sitting on as a solid and don't forget to apply perspective. Be aware of the ground, so the feet don't appear to hover above it.

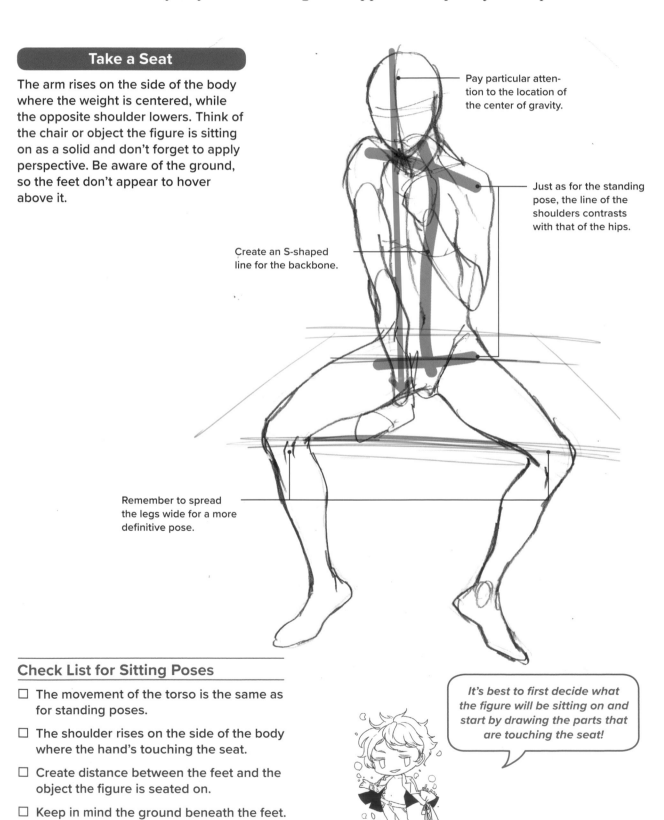

Pay particular attention to the location of the center of gravity.

Just as for the standing pose, the line of the shoulders contrasts with that of the hips.

Create an S-shaped line for the backbone.

Remember to spread the legs wide for a more definitive pose.

Check List for Sitting Poses

☐ The movement of the torso is the same as for standing poses.

☐ The shoulder rises on the side of the body where the hand's touching the seat.

☐ Create distance between the feet and the object the figure is seated on.

☐ Keep in mind the ground beneath the feet.

It's best to first decide what the figure will be sitting on and start by drawing the parts that are touching the seat!

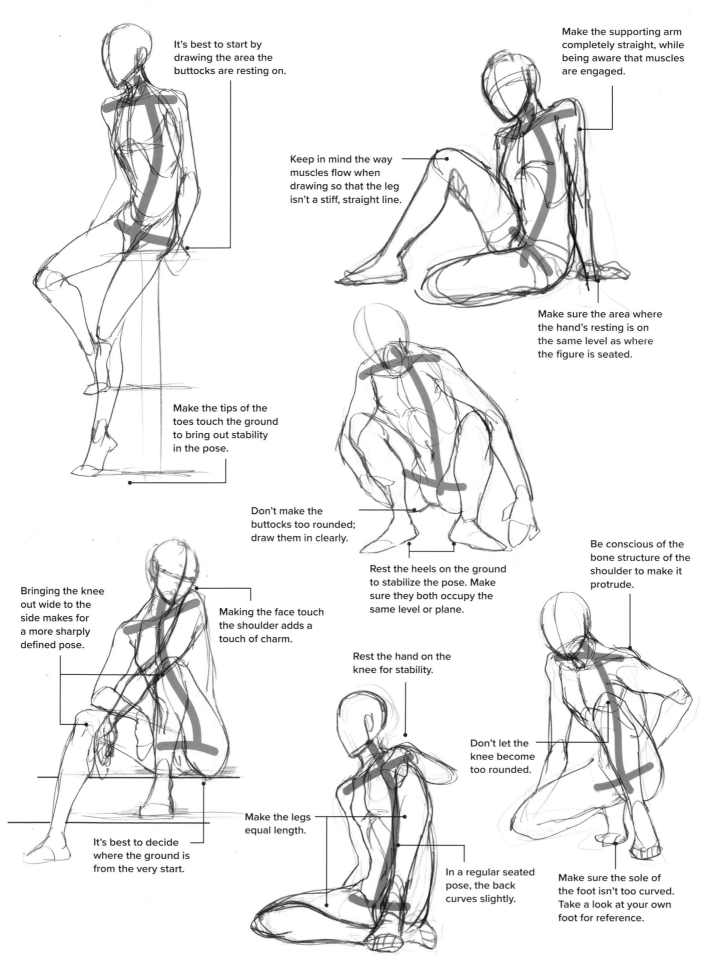

It's best to start by drawing the area the buttocks are resting on.

Make the supporting arm completely straight, while being aware that muscles are engaged.

Keep in mind the way muscles flow when drawing so that the leg isn't a stiff, straight line.

Make sure the area where the hand's resting is on the same level as where the figure is seated.

Make the tips of the toes touch the ground to bring out stability in the pose.

Don't make the buttocks too rounded; draw them in clearly.

Be conscious of the bone structure of the shoulder to make it protrude.

Bringing the knee out wide to the side makes for a more sharply defined pose.

Making the face touch the shoulder adds a touch of charm.

Rest the heels on the ground to stabilize the pose. Make sure they both occupy the same level or plane.

Rest the hand on the knee for stability.

Don't let the knee become too rounded.

It's best to decide where the ground is from the very start.

Make the legs equal length.

In a regular seated pose, the back curves slightly.

Make sure the sole of the foot isn't too curved. Take a look at your own foot for reference.

65

Warming Up

The body moves in different ways depending on the object it's perched on. Decide the position of the lower body and pay attention to how the upper body twists or moves.

Blocking-In

First, roughly sketch in the object the character's sitting on. The figure will move differently depending on the object's height and shape, so it's important to draw in the overall movement at the blocking-in stage.

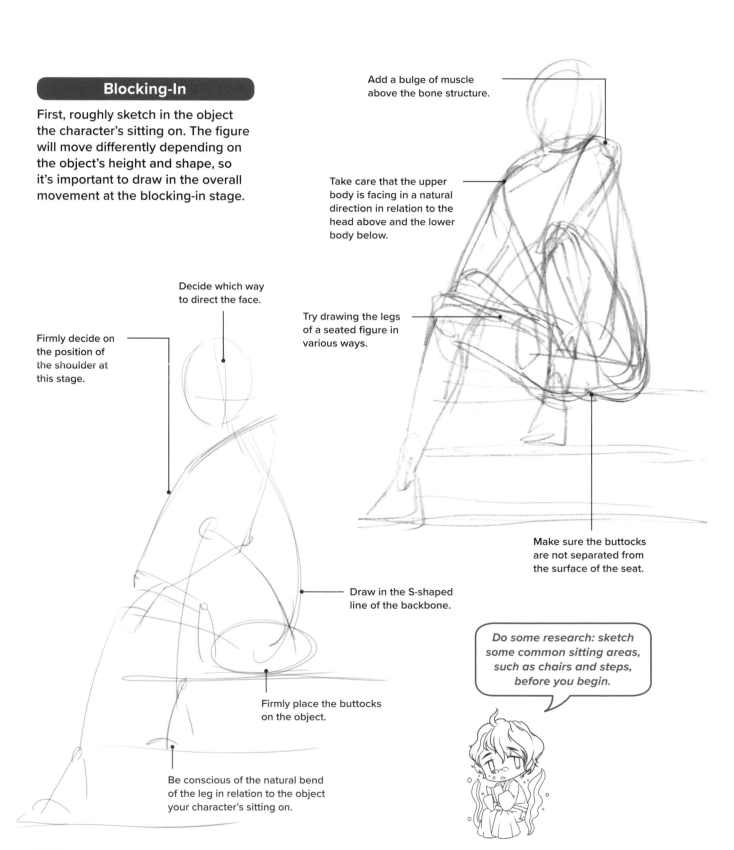

Add a bulge of muscle above the bone structure.

Take care that the upper body is facing in a natural direction in relation to the head above and the lower body below.

Try drawing the legs of a seated figure in various ways.

Decide which way to direct the face.

Firmly decide on the position of the shoulder at this stage.

Draw in the S-shaped line of the backbone.

Firmly place the buttocks on the object.

Be conscious of the natural bend of the leg in relation to the object your character's sitting on.

Make sure the buttocks are not separated from the surface of the seat.

Do some research: sketch some common sitting areas, such as chairs and steps, before you begin.

Flesh Out the Form

Add flesh to the bone structure. Muscle movement alters significantly depending on how the figure's seated, so add flesh carefully to the lower body. It's a good idea to check movements by looking in a mirror.

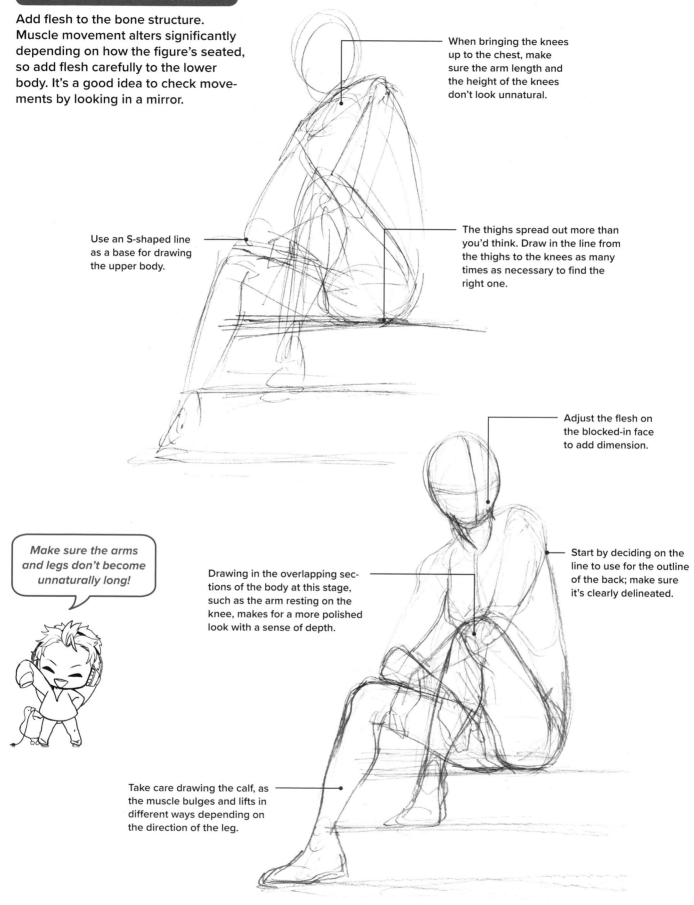

When bringing the knees up to the chest, make sure the arm length and the height of the knees don't look unnatural.

Use an S-shaped line as a base for drawing the upper body.

The thighs spread out more than you'd think. Draw in the line from the thighs to the knees as many times as necessary to find the right one.

Adjust the flesh on the blocked-in face to add dimension.

Make sure the arms and legs don't become unnaturally long!

Drawing in the overlapping sections of the body at this stage, such as the arm resting on the knee, makes for a more polished look with a sense of depth.

Start by deciding on the line to use for the outline of the back; make sure it's clearly delineated.

Take care drawing the calf, as the muscle bulges and lifts in different ways depending on the direction of the leg.

Drafting the Details

Add details such as the clothing and face over the fleshed-out figure. Here, too, make as many lines as necessary until you find the right one.

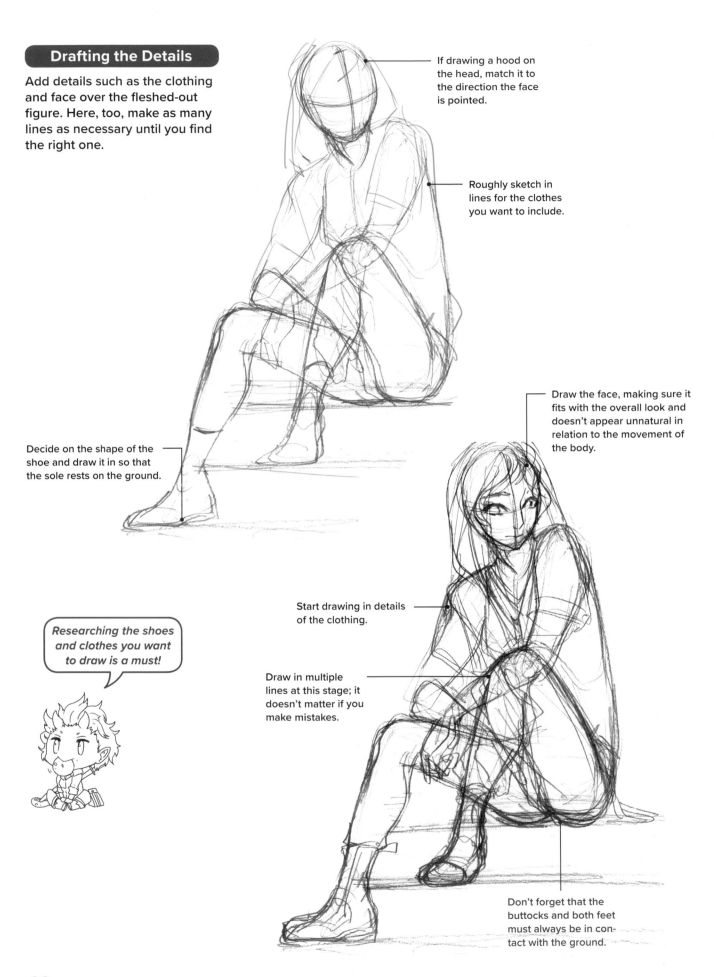

If drawing a hood on the head, match it to the direction the face is pointed.

Roughly sketch in lines for the clothes you want to include.

Decide on the shape of the shoe and draw it in so that the sole rests on the ground.

Researching the shoes and clothes you want to draw is a must!

Draw the face, making sure it fits with the overall look and doesn't appear unnatural in relation to the movement of the body.

Start drawing in details of the clothing.

Draw in multiple lines at this stage; it doesn't matter if you make mistakes.

Don't forget that the buttocks and both feet must always be in contact with the ground.

Completing the Line Drawing

From the multiple lines you've drawn, choose the best and draw in details such as the creases in clothing, fingers and facial features to complete the line drawing. Look over the entire drawing to check that nothing appears unnatural.

Three-Point Plan When Blocking-In a Sitting Pose

POINT 1

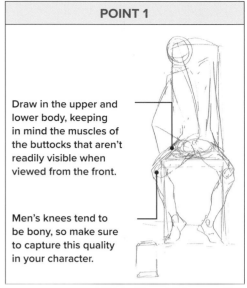

Draw in the upper and lower body, keeping in mind the muscles of the buttocks that aren't readily visible when viewed from the front.

Men's knees tend to be bony, so make sure to capture this quality in your character.

Don't forget to draw in the creases created from sitting.

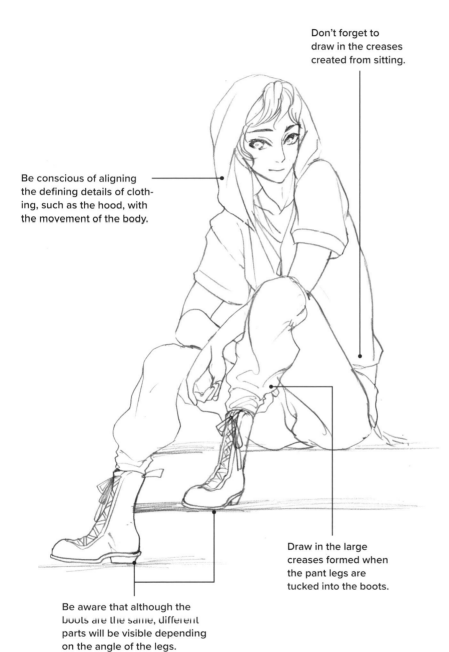

Be conscious of aligning the defining details of clothing, such as the hood, with the movement of the body.

Be aware that although the boots are the same, different parts will be visible depending on the angle of the legs.

Draw in the large creases formed when the pant legs are tucked into the boots.

POINT 2

When wanting to efficiently capture the thickness of your figure, think of a licorice stick. Picture the long, pliable licorice whip as you draw an elongated cube. This will not only add dimension to your character but allow you to draw a natural-looking twist in the body.

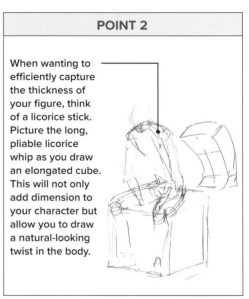

POINT 3

Draw the right shoulder so it's clear that it's pulled back slightly due to the movement in the arm.

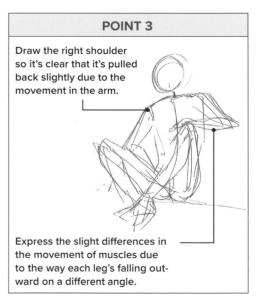

Express the slight differences in the movement of muscles due to the way each leg's falling outward on a different angle.

Drawing a Figure Sitting on the Ground

Sitting on the ground includes such poses as kneeling with the buttocks resting on the heels, sitting with the knees drawn up to the chest or kneeling with the legs out to the sides.

Sitting

When seating a male character on the ground, it's common to direct the knees outward. Making them face inward creates a softer look, so unless it fits the particular pose you're going for, draw the knees facing outward.

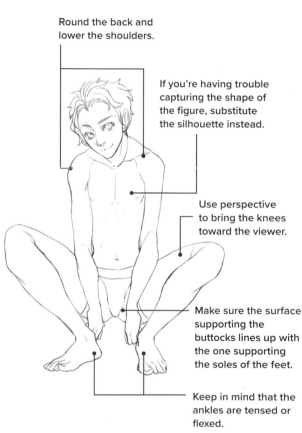

Round the back and lower the shoulders.

If you're having trouble capturing the shape of the figure, substitute the silhouette instead.

Use perspective to bring the knees toward the viewer.

Make sure the surface supporting the buttocks lines up with the one supporting the soles of the feet.

Keep in mind that the ankles are tensed or flexed.

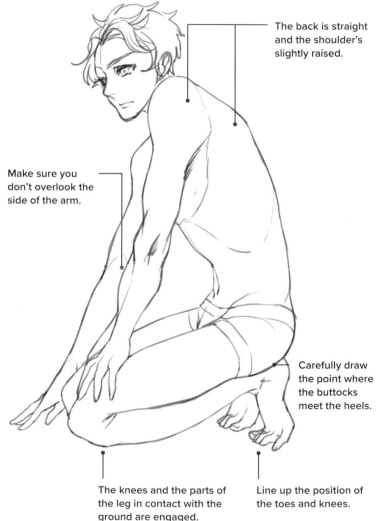

The back is straight and the shoulder's slightly raised.

Make sure you don't overlook the side of the arm.

Carefully draw the point where the buttocks meet the heels.

The knees and the parts of the leg in contact with the ground are engaged.

Line up the position of the toes and knees.

A Bit of Advice

Be aware of the kneecaps to prevent an unnatural look.

To create variation in a sitting pose, it's necessary to move the joints of the hip. Be aware of the bend in the legs to create a natural look for the direction of the knees.

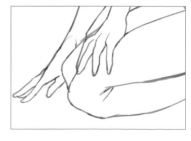

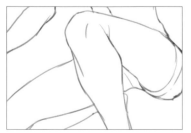

Kneeling While Resting on the Heels

This kneeling pose can be difficult for some men due to their pronounced leg muscles. Draw the bulk in the muscles, keeping in mind that they're not suited to folding the legs beneath the body.

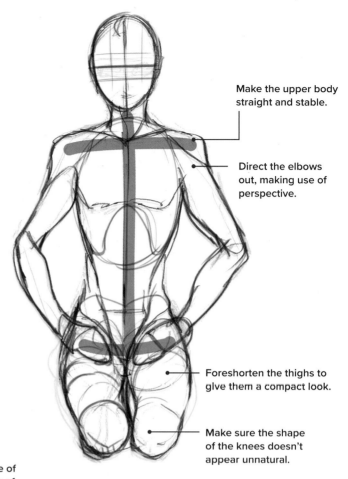

Make the upper body straight and stable.

Direct the elbows out, making use of perspective.

Foreshorten the thighs to give them a compact look.

Make sure the shape of the knees doesn't appear unnatural.

The center of gravity is directly beneath the head and buttocks.

Extend the torso straight up and be aware of the abdominal muscles.

Bring out the sense of bulk in the muscles of the thighs and calves.

Carefully draw where the top of the foot overlaps the other foot.

Make the parts touching the ground horizontal.

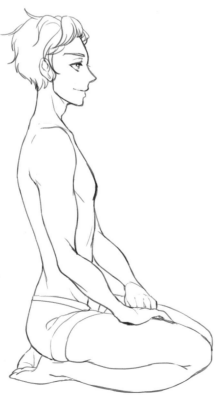

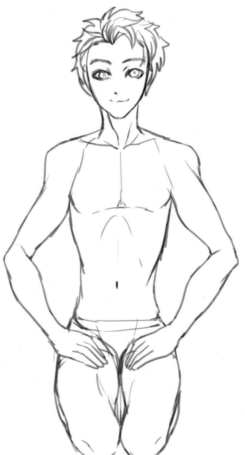

For a sitting pose where only one knee is raised, start by drawing the buttocks and legs. That makes it easier to create a sense of balance. Placing the hand on the raised knee or hugging the knee shifts the center of gravity to the leg on the ground.

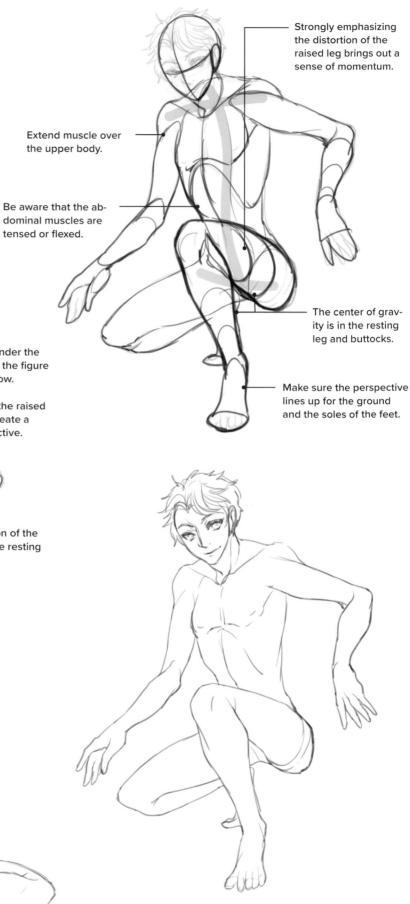

Strongly emphasizing the distortion of the raised leg brings out a sense of momentum.

Extend muscle over the upper body.

Be aware that the abdominal muscles are tensed or flexed.

The center of gravity is in the resting leg and buttocks.

Make sure the perspective lines up for the ground and the soles of the feet.

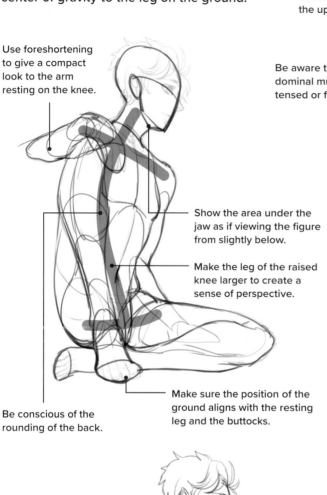

Use foreshortening to give a compact look to the arm resting on the knee.

Show the area under the jaw as if viewing the figure from slightly below.

Make the leg of the raised knee larger to create a sense of perspective.

Be conscious of the rounding of the back.

Make sure the position of the ground aligns with the resting leg and the buttocks.

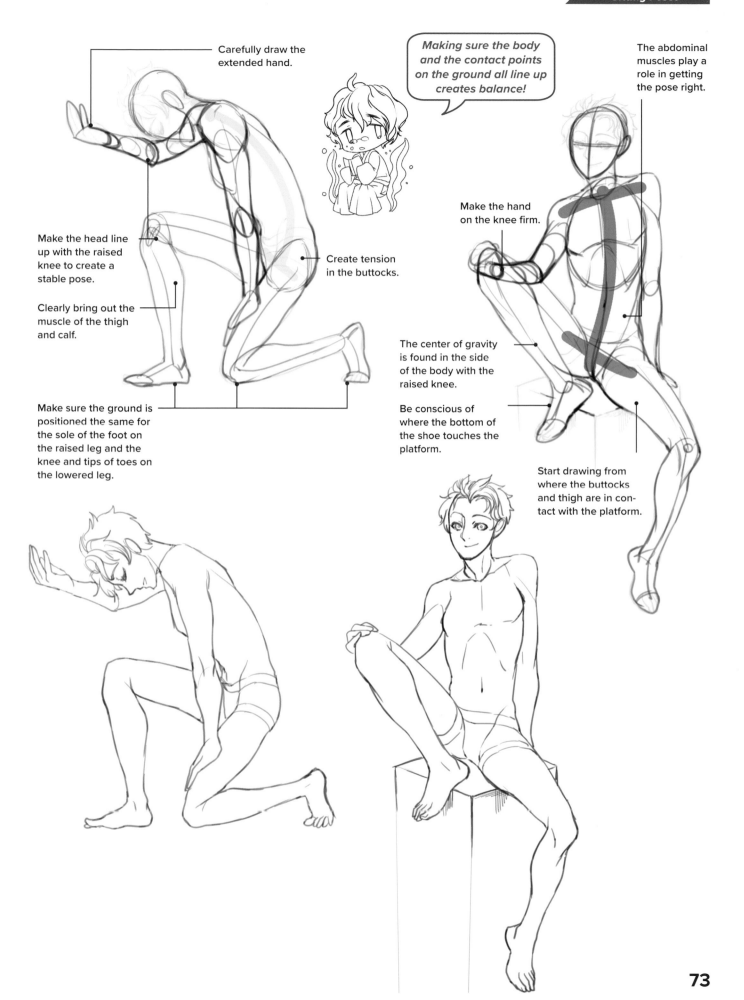

Carefully draw the extended hand.

Making sure the body and the contact points on the ground all line up creates balance!

The abdominal muscles play a role in getting the pose right.

Make the head line up with the raised knee to create a stable pose.

Clearly bring out the muscle of the thigh and calf.

Make the hand on the knee firm.

Create tension in the buttocks.

The center of gravity is found in the side of the body with the raised knee.

Make sure the ground is positioned the same for the sole of the foot on the raised leg and the knee and tips of toes on the lowered leg.

Be conscious of where the bottom of the shoe touches the platform.

Start drawing from where the buttocks and thigh are in contact with the platform.

Drawing a Figure Sitting on a Chair

When drawing a figure sitting on a chair, first carefully observe the parts of the body that are in direct contact with the seat.

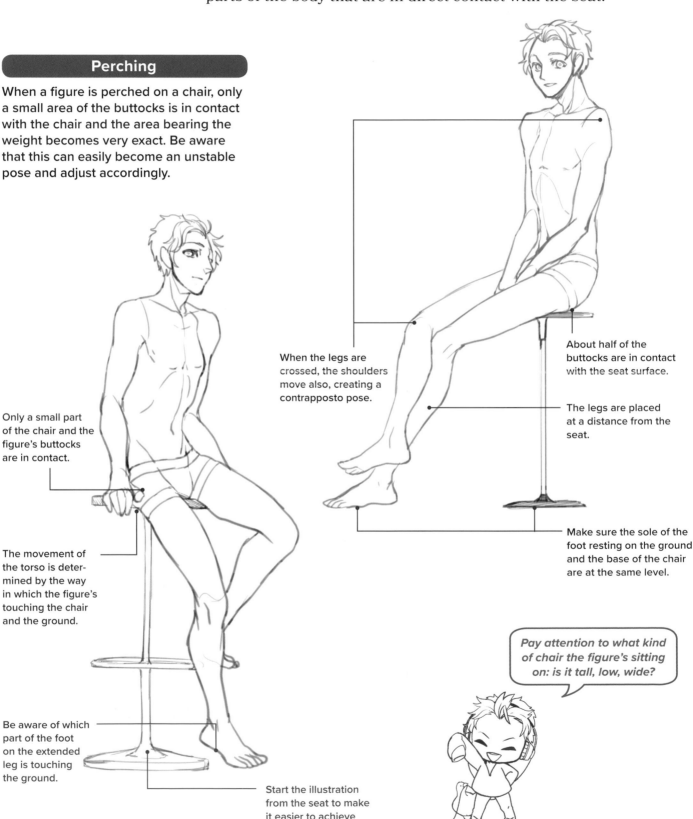

Perching

When a figure is perched on a chair, only a small area of the buttocks is in contact with the chair and the area bearing the weight becomes very exact. Be aware that this can easily become an unstable pose and adjust accordingly.

Only a small part of the chair and the figure's buttocks are in contact.

The movement of the torso is determined by the way in which the figure's touching the chair and the ground.

Be aware of which part of the foot on the extended leg is touching the ground.

When the legs are crossed, the shoulders move also, creating a contrapposto pose.

About half of the buttocks are in contact with the seat surface.

The legs are placed at a distance from the seat.

Make sure the sole of the foot resting on the ground and the base of the chair are at the same level.

Start the illustration from the seat to make it easier to achieve an overall balance.

Pay attention to what kind of chair the figure's sitting on: is it tall, low, wide?

Fully Seated

When seated deep in a chair, there's a large area of contact between the chair and the body. As a result, the weight's spread across a large area, allowing for a composition that's stable and balanced.

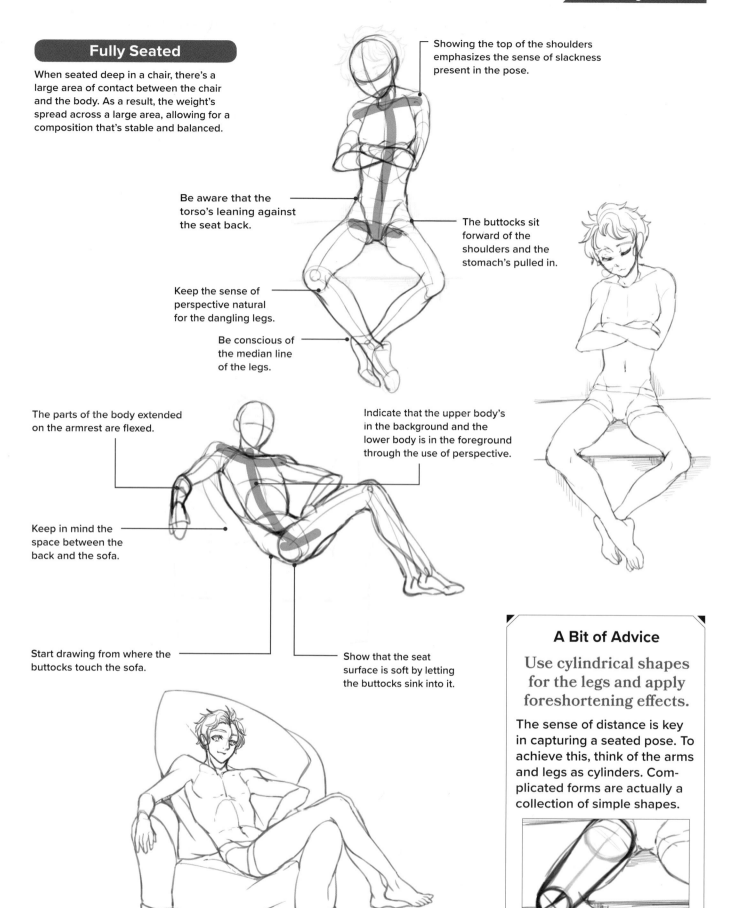

Showing the top of the shoulders emphasizes the sense of slackness present in the pose.

Be aware that the torso's leaning against the seat back.

The buttocks sit forward of the shoulders and the stomach's pulled in.

Keep the sense of perspective natural for the dangling legs.

Be conscious of the median line of the legs.

The parts of the body extended on the armrest are flexed.

Indicate that the upper body's in the background and the lower body is in the foreground through the use of perspective.

Keep in mind the space between the back and the sofa.

Start drawing from where the buttocks touch the sofa.

Show that the seat surface is soft by letting the buttocks sink into it.

A Bit of Advice

Use cylindrical shapes for the legs and apply foreshortening effects.

The sense of distance is key in capturing a seated pose. To achieve this, think of the arms and legs as cylinders. Complicated forms are actually a collection of simple shapes.

Other Seated Poses

Seated poses are created not only on a seat or sofa, but any time a character is resting his behind on something where there is a difference in levels (such as stairs). Adjust the balance of the body in line with the position of the knees and the difference in levels to achieve a natural pose.

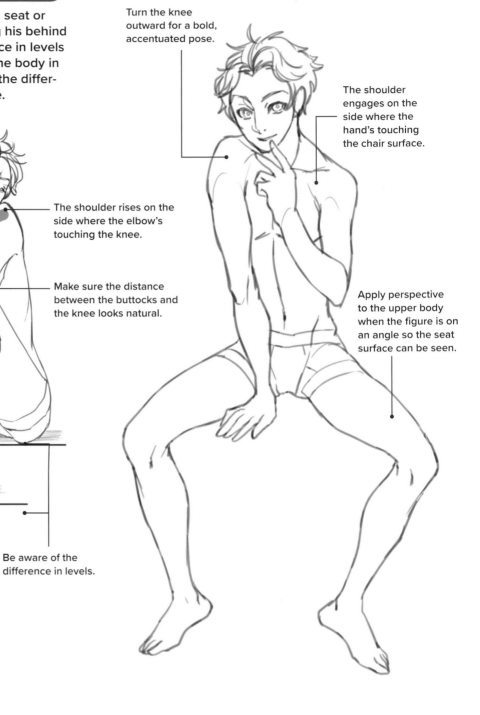

Turn the knee outward for a bold, accentuated pose.

The shoulder engages on the side where the hand's touching the chair surface.

The shoulder rises on the side where the elbow's touching the knee.

Make sure the distance between the buttocks and the knee looks natural.

Turn the knee outward.

Apply perspective to the upper body when the figure is on an angle so the seat surface can be seen.

Be aware of the difference in levels.

Make sure to clearly show the position where the buttocks are in contact with the step.

A Bit of Advice

Change the height of the knee depending on the chair or where the character's sitting.

For figures seated on steps or low chairs, the knee draws closer to the chest. Ascertain the correct position of the knee from where the buttocks come into contact with the surface of the chair in order to create a natural look.

Rear View

When drawing the rear view of a seated figure, pay attention to the back. Male characters, in particular, have pronounced back muscles and it's important to capture the sense of volume.

Be aware of the shape and bulk of the muscles in the back and along the shoulder blades.

Add movement to the shoulder to align with the way the face is pointing.

The center of gravity is where the body touches the seat surface.

Don't create movement in the lower body.

Take care with positioning where the soles of the feet meet the ground.

Accentuate your character's strength through the movement of the back muscles.

A Bit of Advice

Be aware of the muscles when the leg is raised.

In situations where the character's seated, the object he's sitting on may be a chair, sofa, stool or steps. If the shape, height and firmness of the material aren't taken into account, the pose won't look realistic.

Drawing a Crouching Figure

In a crouching pose, the back rounds and the body becomes compact.
Incorporating perspective is an important element.

Crouching

As crouching involves an extreme bending of the knees, it's a difficult posture for men with highly developed leg muscles. Unlike women, men's knees don't touch, so it's easy to distinguish between men and women when drawing this pose.

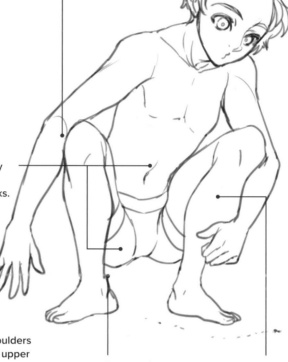

The extension of the arm determines the curve of the back.

The center of gravity is in the abdominal muscles and buttocks.

Be conscious of the flexing and muscular tension in the ankles.

Use perspective on the thighs and calves.

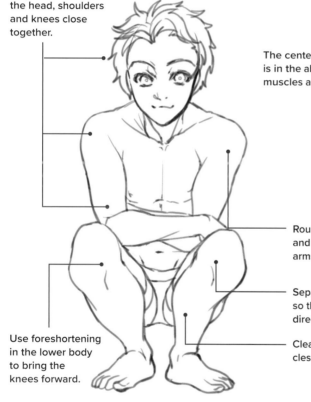

Bring the position of the head, shoulders and knees close together.

Use foreshortening in the lower body to bring the knees forward.

Round the shoulders and direct the upper arms inward.

Separate the knees so that they're directed outward.

Clearly show the muscles in the bent legs.

A Bit of Advice

Consider where to apply perspective for best effect.

Think of where perspective comes into play in order to create a natural crouching pose. If showing the figure from the front, it's needed in the legs, but this doesn't apply to a figure viewed from the side. Distant objects are fine and small, while closer objects are broad and large.

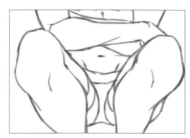
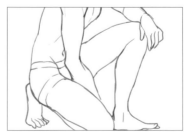

Crouching with One Knee Raised

In a pose where the figure's crouching with one leg raised, the center of gravity shifts, creating a contrapposto effect. The muscles are also more prominently on display, so it's an effective pose for a scene where you character's about to spring into action.

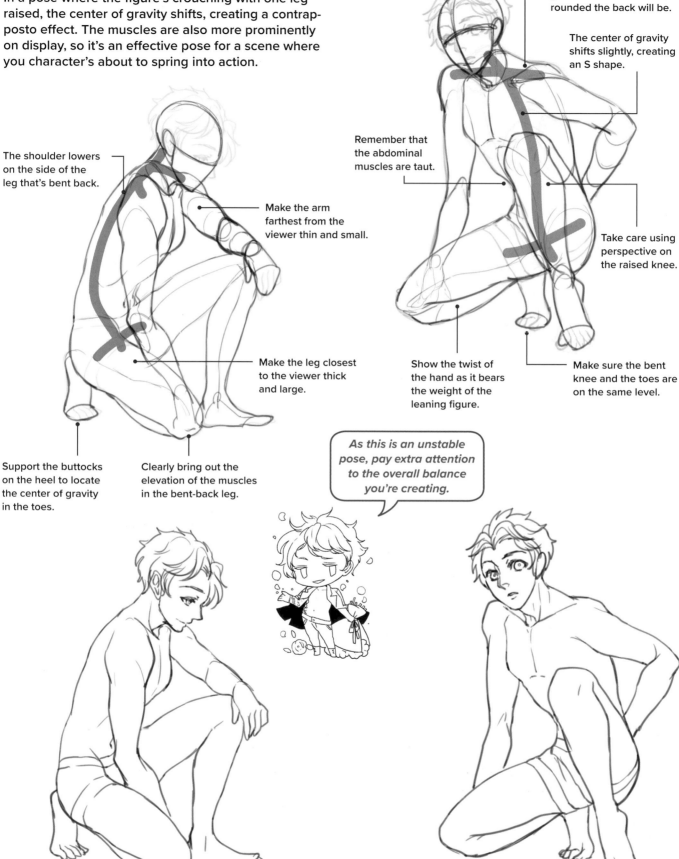

Use the distance between the shoulder and the ground to determine how rounded the back will be.

The center of gravity shifts slightly, creating an S shape.

The shoulder lowers on the side of the leg that's bent back.

Remember that the abdominal muscles are taut.

Make the arm farthest from the viewer thin and small.

Take care using perspective on the raised knee.

Make the leg closest to the viewer thick and large.

Support the buttocks on the heel to locate the center of gravity in the toes.

Clearly bring out the elevation of the muscles in the bent-back leg.

Show the twist of the hand as it bears the weight of the leaning figure.

Make sure the bent knee and the toes are on the same level.

As this is an unstable pose, pay extra attention to the overall balance you're creating.

Other Crouching Poses

Let's pose the figure to see what happens to the balance of the body when the upper body is leaning over, the arms are sweeping down dramatically or the figure is performing some other kind of action while squatting.

Make sure to draw the figure differently depending on the situation, whether your character is pensive or feeling angry, worried or intimidated.

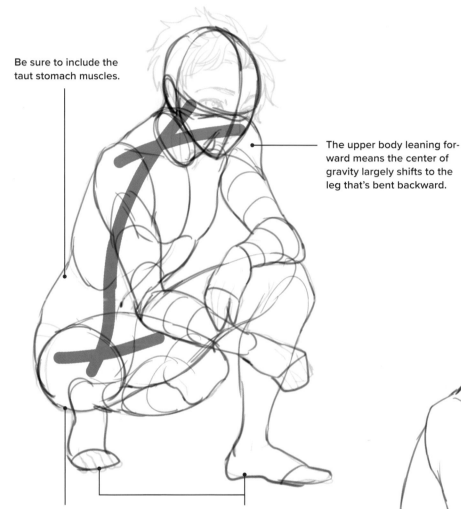

Be sure to include the taut stomach muscles.

The upper body leaning forward means the center of gravity largely shifts to the leg that's bent backward.

Corresponding with the tilt of the body, the heel supports the buttocks, with the nipples and the section where the arms cross running parallel to the heel.

Line up the positions where the feet touch the ground.

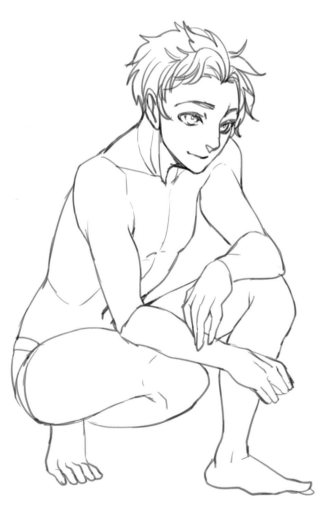

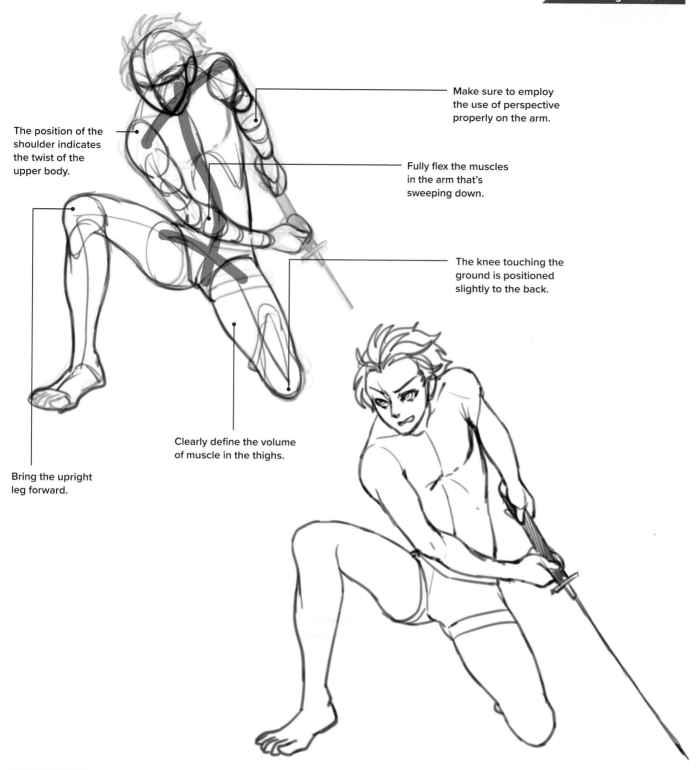

The position of the shoulder indicates the twist of the upper body.

Make sure to employ the use of perspective properly on the arm.

Fully flex the muscles in the arm that's sweeping down.

The knee touching the ground is positioned slightly to the back.

Clearly define the volume of muscle in the thighs.

Bring the upright leg forward.

A Bit of Advice

Shift the center of gravity to create a dramatic sense of movement.

Fast, dramatic actions can be expressed by shifting the shoulders and hips away from the center of gravity. Think of the click of a camera shutter and try to incorporate the moment that the weight shifts into the pose.

04

Drawing Two Seated Figures

When the bodies of two figures are connected, consider the distance
between them as well as the position of the ground.

Seated Side by Side

In order to make it clear that the figures are both
sitting on the same object, it's important that the
position of their buttocks and the sense of perspective
are in sync. Be sure also not to create an unnatural
disparity between their sizes.

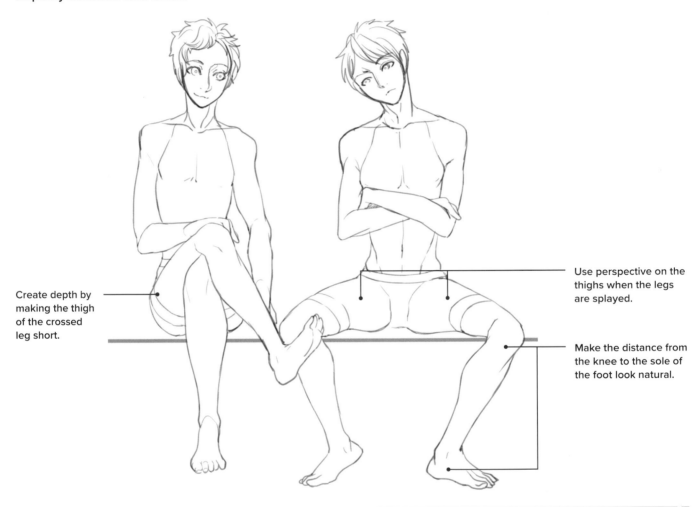

Create depth by
making the thigh
of the crossed
leg short.

Use perspective on the
thighs when the legs
are splayed.

Make the distance from
the knee to the sole of
the foot look natural.

A Bit of Advice

Maintain the proportions for the differences in the physiques to prevent inconsistencies.

When more than two characters appear in
a scene, differences in their size can create
disharmony in the illustration overall. If you
want to use characters with different phy-
siques, make sure their proportions are in
keeping with other elements present.

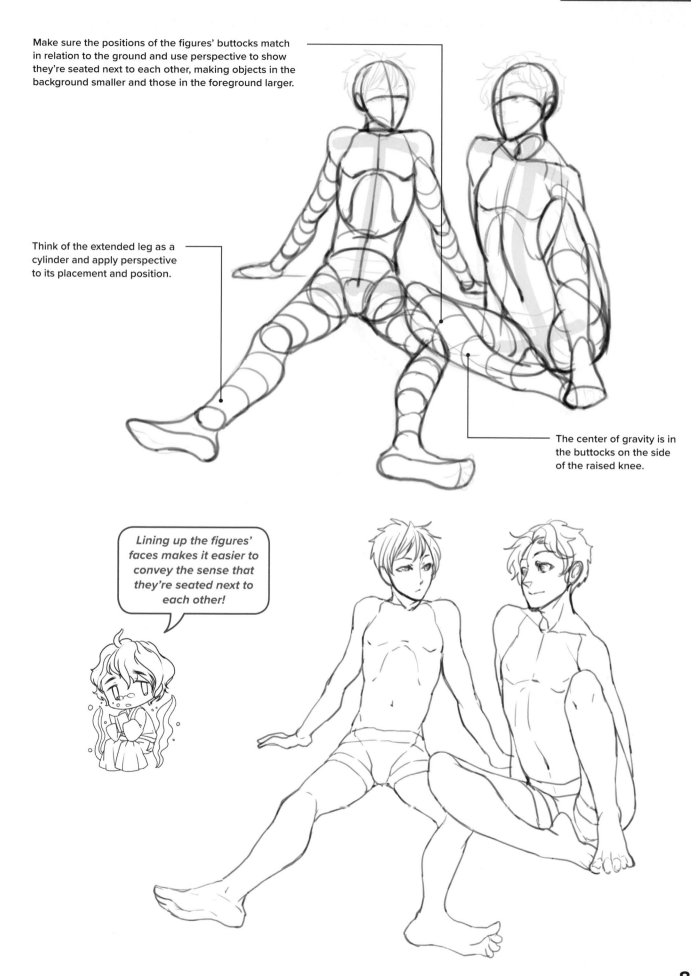

Make sure the positions of the figures' buttocks match in relation to the ground and use perspective to show they're seated next to each other, making objects in the background smaller and those in the foreground larger.

Think of the extended leg as a cylinder and apply perspective to its placement and position.

The center of gravity is in the buttocks on the side of the raised knee.

Lining up the figures' faces makes it easier to convey the sense that they're seated next to each other!

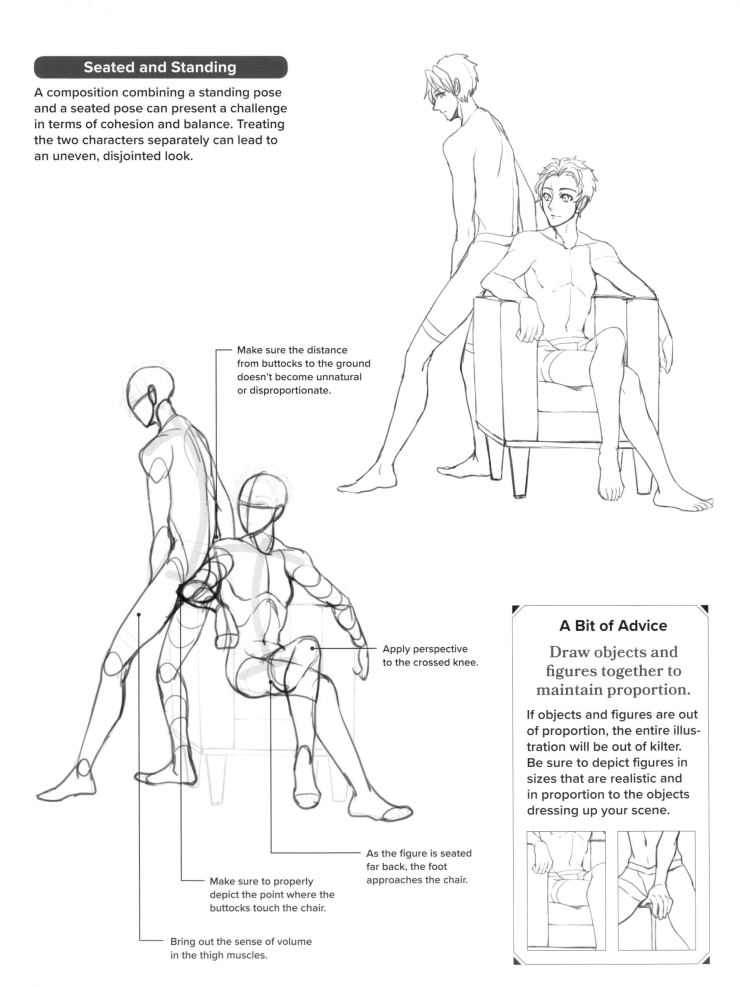

Seated and Standing

A composition combining a standing pose and a seated pose can present a challenge in terms of cohesion and balance. Treating the two characters separately can lead to an uneven, disjointed look.

Make sure the distance from buttocks to the ground doesn't become unnatural or disproportionate.

Apply perspective to the crossed knee.

Make sure to properly depict the point where the buttocks touch the chair.

As the figure is seated far back, the foot approaches the chair.

Bring out the sense of volume in the thigh muscles.

A Bit of Advice

Draw objects and figures together to maintain proportion.

If objects and figures are out of proportion, the entire illustration will be out of kilter. Be sure to depict figures in sizes that are realistic and in proportion to the objects dressing up your scene.

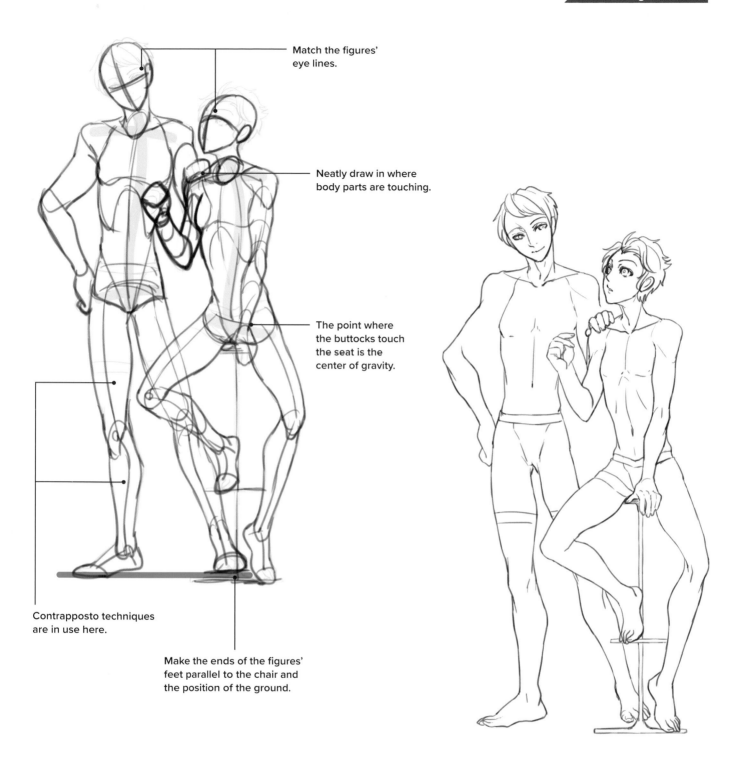

Match the figures' eye lines.

Neatly draw in where body parts are touching.

The point where the buttocks touch the seat is the center of gravity.

Contrapposto techniques are in use here.

Make the ends of the figures' feet parallel to the chair and the position of the ground.

A Bit of Advice

Position faces at different heights for an illustration that suggests a sense of movement.

Combining a standing and sitting pose or positioning faces at different heights within the one picture creates interest within the illustration. Altering the distance between the two figures or changing their poses is also a good idea.

Applying Color

Use the rough drawing to apply color on the computer. Reusing the background you've already processed saves you steps as well as adding detail and complexity to the story the illustration is telling.

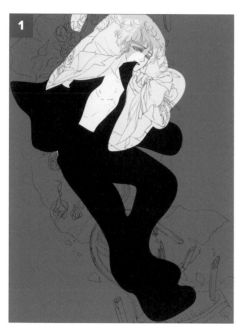

Use Photoshop to apply color. Start by layering color onto the flesh-toned sections and black sections of clothing.

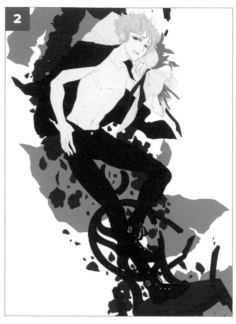

Continue using Photoshop to add color to large sections including the background. Placing color into the background, in addition to any other areas, at this early stage makes it easier to visualize the finished result.

Place color onto the background sections to reflect your overall vision for the illustration.

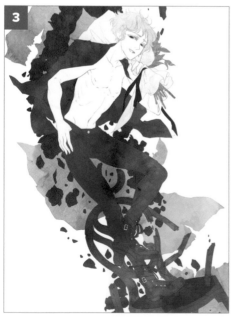

Use Photoshop to add texture to skin, clothing and the chair, keeping the characteristics of each in mind. This brings out the individual texture of the skin and the wood.

A Bit of Advice

Creating texture

It's possible to easily alter the atmosphere and the sense of design in an illustration by making use of texture through Photoshop. Rather than just using one layer of texture as it is, try combining multiple layers. Furthermore, if you can't find the texture you have in mind, try creating your own. Create several layers of texture that suit your vision and layer them to achieve the look and result you're going for.

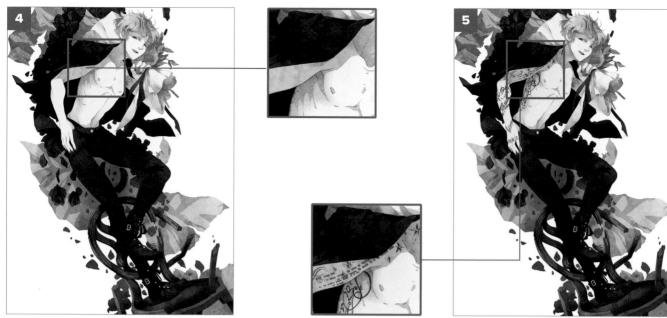

Use Photoshop to add shadow to the body and background to create a sense of depth and dimension. It's best to observe and note where shadow would naturally form before you apply color.

Use Photoshop to draw a tattoo. You'll need to edit it so it fits in with the curve of the arm.

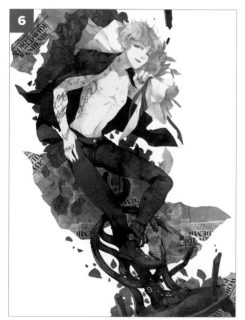

Use Photoshop to complete the design scheme for the background. Using elements you've created yourself provides the illustration with a fully realized, well-defined world that your character inhabits.

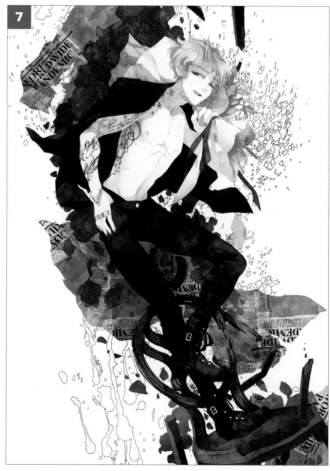

Once you've used Photoshop to apply the texture you've created to refine the background, boost the saturation levels. Now is a good time to experiment with tweaks and variations too.

Drawing Actions and Gestures

Now let's try drawing signature gestures and actions that will help define your character, such as smoking a cigarette, putting on a tie or putting on a pair of glasses.

▶ Smoking a Cigarette

When your character is smoking a cigarette, what's most important is the movement of the fingers. As it's necessary to draw the entire hand carefully, right down to the tips of the fingers, hold a cigarette or pen yourself to observe how the fingers move. Make sure to draw the bones running through the center of the hand. It's also important to show that in comparison with women's more supple, smooth fingers, men tend to have more angular, rugged fingers. Making their movements firmly and solidly defined, rather than fluid and supple, is key.

Check List

- ☐ Clearly define the hand right down to the fingertips.
- ☐ Use your own fingers to work out the shape and position.
- ☐ Draw the fingers so their movements appear firm and strong.
- ☐ Be aware of the bones and draw them in detail.

One of the options for drawing a smoking figure so that the cigarette is obvious is to use a slight side angle rather than showing him directly from the front.

Pay attention to the movement of the finger joints as you draw.

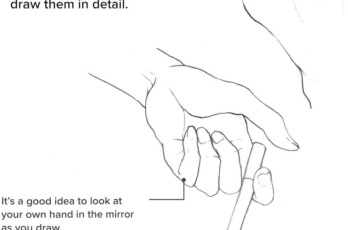

It's a good idea to look at your own hand in the mirror as you draw.

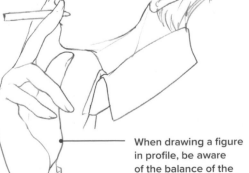

When drawing a figure in profile, be aware of the balance of the palm of the hand.

▶ Tying or Untying a Necktie

This is an action that's generally specific to or relegated only to men. Here, too, the way the hands are drawn is key. Stand in front of the mirror to see where each hand would naturally be placed on the tie. When putting a necktie on, the face naturally turns upward. Making sure not to bend the neck forward and emphasizing the Adam's apple also gives your illustration the realism and accuracy you're after.

Check List

- ☐ Be conscious of how the hands and fingers move.
- ☐ Clearly show the Adam's apple.
- ☐ Make sure not to draw the face directed downward.
- ☐ Decide on the design of the necktie.

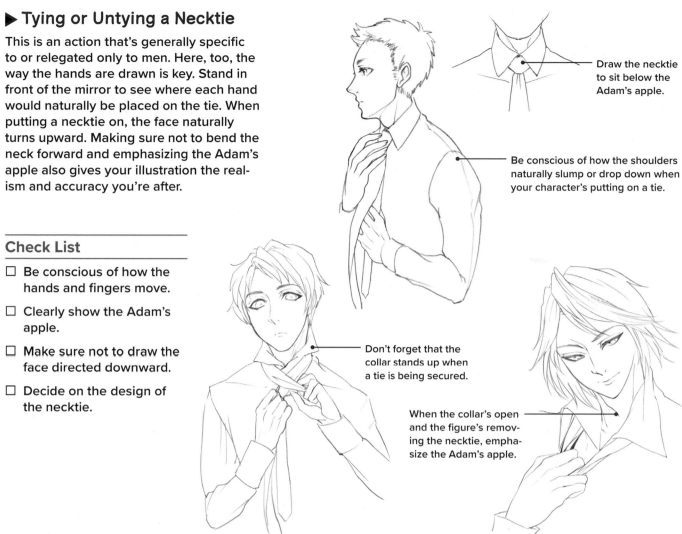

Draw the necktie to sit below the Adam's apple.

Be conscious of how the shoulders naturally slump or drop down when your character's putting on a tie.

Don't forget that the collar stands up when a tie is being secured.

When the collar's open and the figure's removing the necktie, emphasize the Adam's apple.

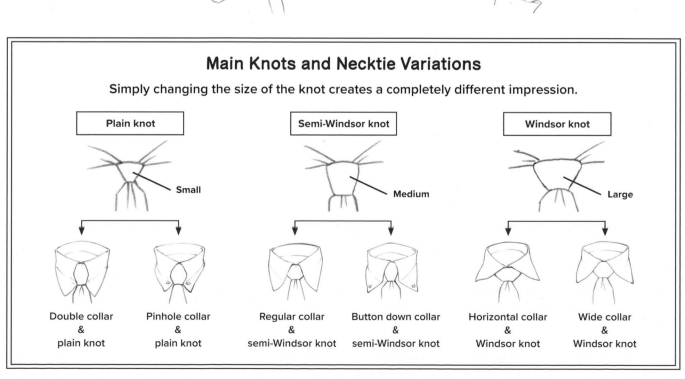

Main Knots and Necktie Variations

Simply changing the size of the knot creates a completely different impression.

Plain knot	Semi-Windsor knot	Windsor knot
Small	Medium	Large

Double collar & plain knot	Pinhole collar & plain knot	Regular collar & semi-Windsor knot	Button down collar & semi-Windsor knot	Horizontal collar & Windsor knot	Wide collar & Windsor knot

▶ Wearing Glasses

As long as the eyes fit within the lenses, it's easy to create the look of wearing glasses, so they're an invaluable item when it comes to creating different characters and looks. However, there's a pitfall when it comes to using them, as unless they match the movements of the face, the glasses will appear unnatural. It's important to draw them in parallel with facial movements. The design of the frames can also dramatically alter the impression a character makes. Devising designs for your characters to wear is part of the fun.

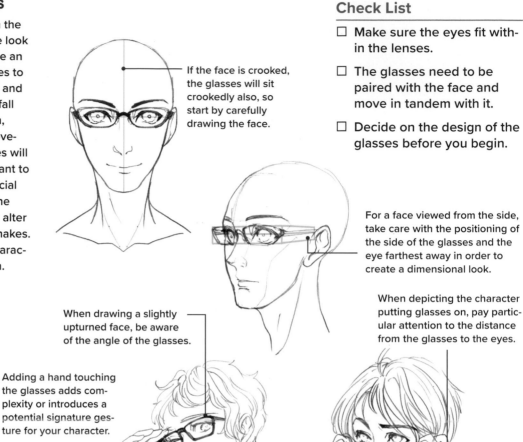

If the face is crooked, the glasses will sit crookedly also, so start by carefully drawing the face.

For a face viewed from the side, take care with the positioning of the side of the glasses and the eye farthest away in order to create a dimensional look.

When depicting the character putting glasses on, pay particular attention to the distance from the glasses to the eyes.

Check List

☐ Make sure the eyes fit within the lenses.

☐ The glasses need to be paired with the face and move in tandem with it.

☐ Decide on the design of the glasses before you begin.

When drawing a slightly upturned face, be aware of the angle of the glasses.

Adding a hand touching the glasses adds complexity or introduces a potential signature gesture for your character.

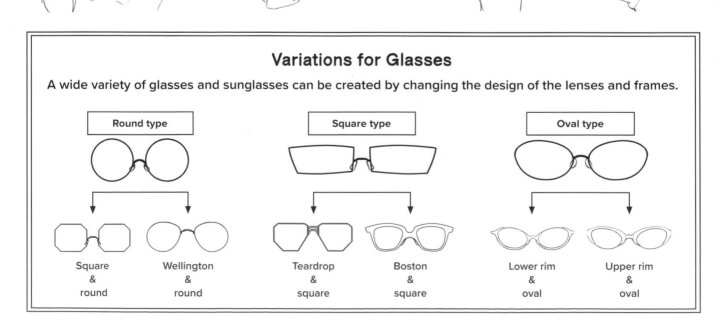

Variations for Glasses

A wide variety of glasses and sunglasses can be created by changing the design of the lenses and frames.

Round type — Square & round / Wellington & round

Square type — Teardrop & square / Boston & square

Oval type — Lower rim & oval / Upper rim & oval

Reclining Poses:
The Basics

The use of perspective is essential when creating reclining poses. Bring out movement in the pose by twisting the torso or shifting the position of the legs.

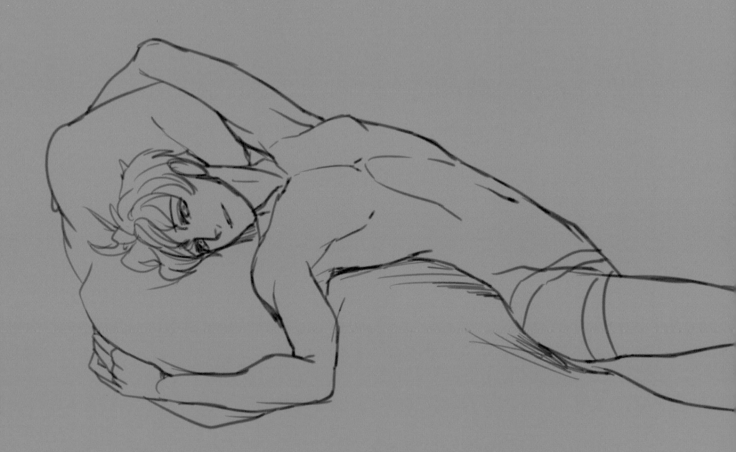

Drawing a Reclining Pose

In a reclining pose, it's important to be aware of where the body comes in contact with the ground. Additionally, reclining poses tend to require foreshortening or elongating parts of the body, so make sure to clearly apply and bring out a sense of perspective.

Basic Reclining Poses

When your character's facing upward, it's the back and buttocks that rest on the ground, while when facing down, it's the arms and hips. As the center of gravity is distributed across the entire body, there's little movement and the only parts that move freely are the legs.

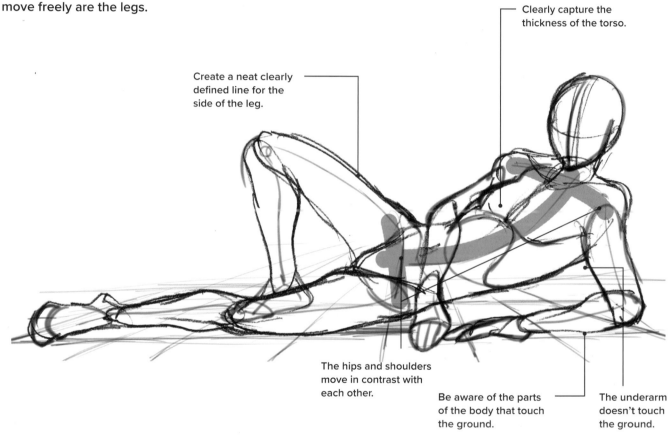

Clearly capture the thickness of the torso.

Create a neat clearly defined line for the side of the leg.

The hips and shoulders move in contrast with each other.

Be aware of the parts of the body that touch the ground.

The underarm doesn't touch the ground.

Check List

☐ Apply perspective before starting to draw.

☐ Make the line neat for the shoulders, hips and other parts at the side of the body.

☐ Clearly capture the broadness and breadth of the torso and the thickness of the arms.

☐ Determine which parts will be in contact with the ground and make sure they're consistently drawn.

Reclining poses tend to require the use of perspective, so take the time to draw in lines on the ground to guide you!

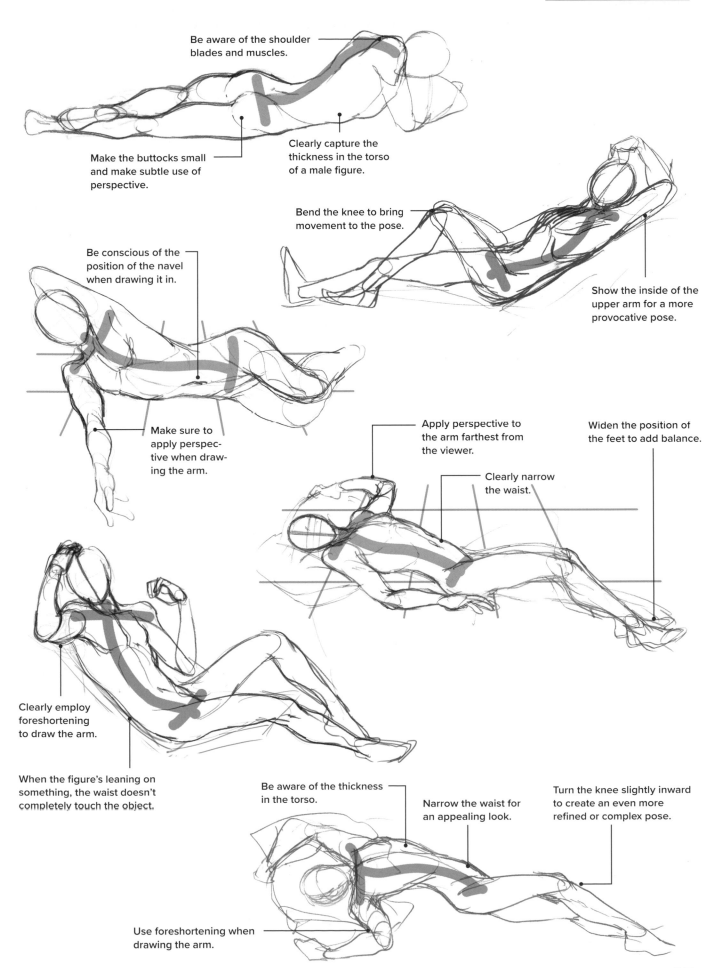

Be aware of the shoulder blades and muscles.

Make the buttocks small and make subtle use of perspective.

Clearly capture the thickness in the torso of a male figure.

Bend the knee to bring movement to the pose.

Be conscious of the position of the navel when drawing it in.

Show the inside of the upper arm for a more provocative pose.

Make sure to apply perspective when drawing the arm.

Apply perspective to the arm farthest from the viewer.

Widen the position of the feet to add balance.

Clearly narrow the waist.

Clearly employ foreshortening to draw the arm.

When the figure's leaning on something, the waist doesn't completely touch the object.

Be aware of the thickness in the torso.

Narrow the waist for an appealing look.

Turn the knee slightly inward to create an even more refined or complex pose.

Use foreshortening when drawing the arm.

95

Warming Up

There are many variations to the reclining pose. Decide how the figure will move, then keep the movements of the muscles in mind as you draw.

Blocking-In

First, determine the positions of the shoulders, back muscles and hips. Identify which parts of the body will be in contact with the ground. Keeping this in mind while drawing is key in order to end up with a striking and realistic pose.

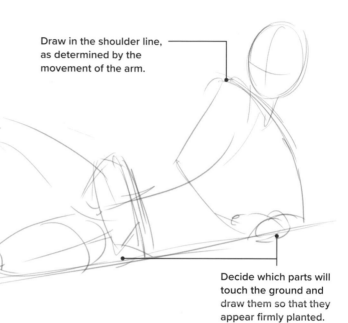

Draw in the shoulder line, as determined by the movement of the arm.

For joints that are moving, block them in at this stage.

Decide which parts will touch the ground and draw them so that they appear firmly planted.

Flesh Out the Form

In comparison to standing and sitting poses, reclining poses tend to be defined and solidified when the form is fleshed out, so take care when adding the flesh. Keep adding lines at this stage to find the right one to capture and express the figure's movement.

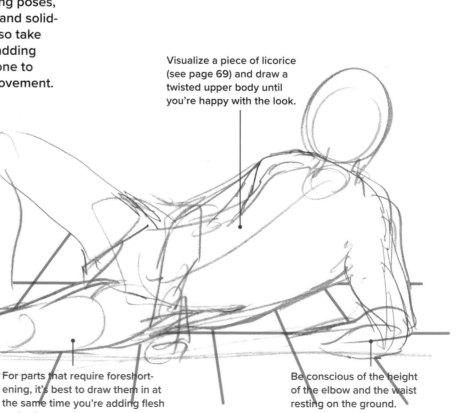

Visualize a piece of licorice (see page 69) and draw a twisted upper body until you're happy with the look.

Firmly block-in the joint that forms the knee.

For parts that require foreshortening, it's best to draw them in at the same time you're adding flesh to the form.

Be conscious of the height of the elbow and the waist resting on the ground.

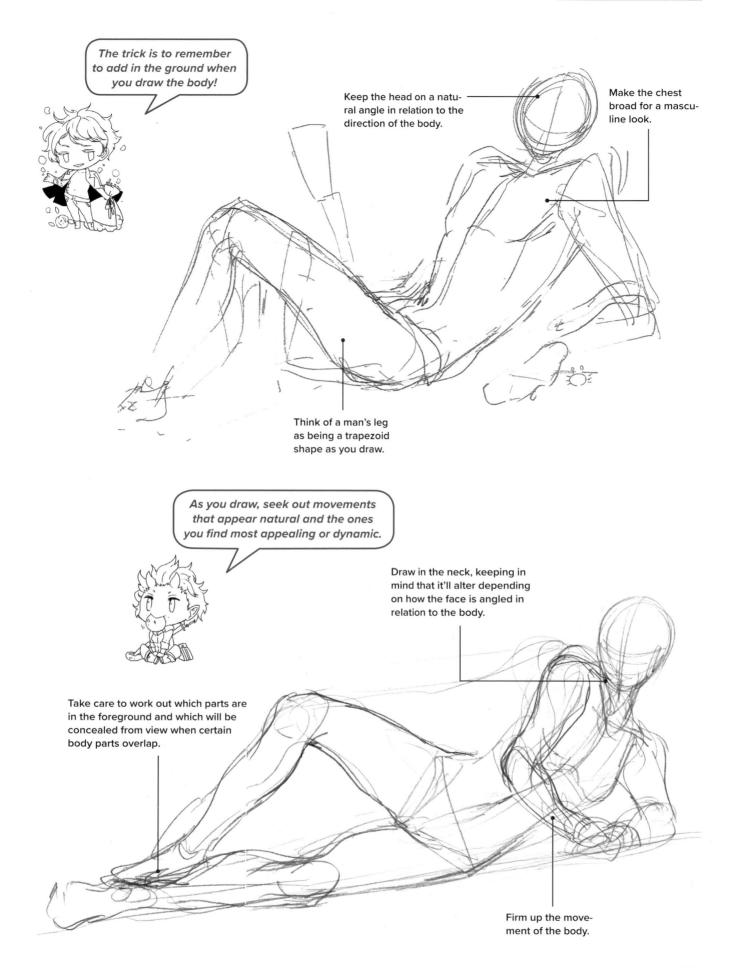

The trick is to remember to add in the ground when you draw the body!

Keep the head on a natural angle in relation to the direction of the body.

Make the chest broad for a masculine look.

Think of a man's leg as being a trapezoid shape as you draw.

As you draw, seek out movements that appear natural and the ones you find most appealing or dynamic.

Draw in the neck, keeping in mind that it'll alter depending on how the face is angled in relation to the body.

Take care to work out which parts are in the foreground and which will be concealed from view when certain body parts overlap.

Firm up the movement of the body.

Once the figure has been fleshed out, add in detailed sections such as the face and limbs. In the case of this illustration where the figure is near nude, also consider how muscular the character will be.

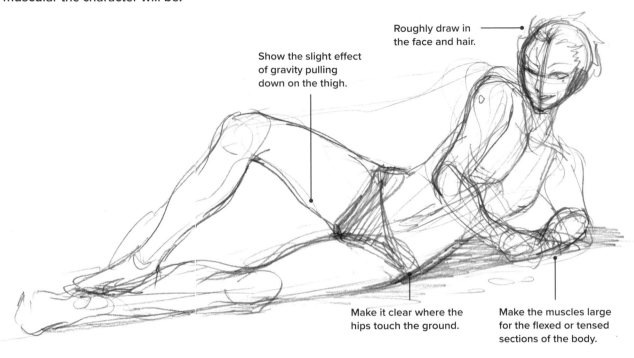

Roughly draw in the face and hair.

Show the slight effect of gravity pulling down on the thigh.

Make it clear where the hips touch the ground.

Make the muscles large for the flexed or tensed sections of the body.

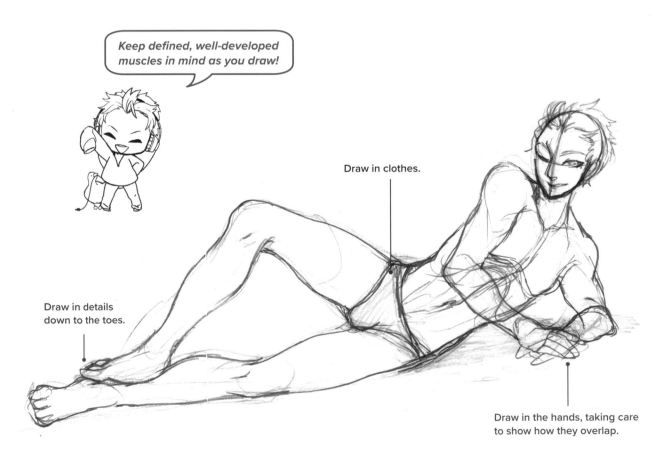

Keep defined, well-developed muscles in mind as you draw!

Draw in clothes.

Draw in details down to the toes.

Draw in the hands, taking care to show how they overlap.

Complete the line drawing

Erase unnecessary lines and add in detailed sections to complete the line drawing. Creating clearly defined or even somewhat bulging muscles makes for an appealing character.

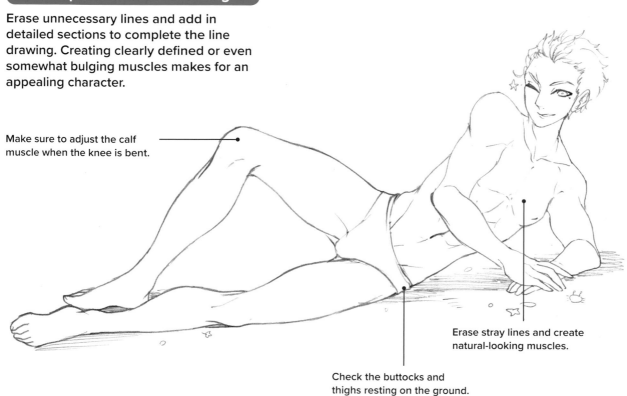

Make sure to adjust the calf muscle when the knee is bent.

Erase stray lines and create natural-looking muscles.

Check the buttocks and thighs resting on the ground.

Three-Point Plan for Blocking-In Reclining Poses

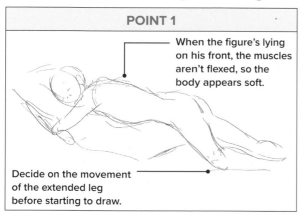

POINT 1

When the figure's lying on his front, the muscles aren't flexed, so the body appears soft.

Decide on the movement of the extended leg before starting to draw.

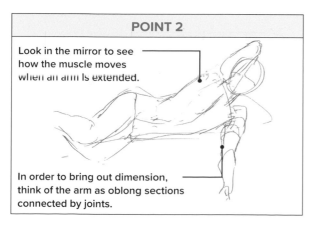

POINT 2

Look in the mirror to see how the muscle moves when an arm is extended.

In order to bring out dimension, think of the arm as oblong sections connected by joints.

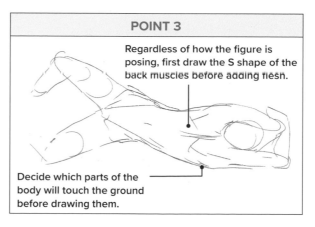

POINT 3

Regardless of how the figure is posing, first draw the S shape of the back muscles before adding flesh.

Decide which parts of the body will touch the ground before drawing them.

Drawing a Figure Lying Face Down

In a face-down pose where the back is highlighted, the shape and extent
of the back muscles can be fully rendered.

Lying Face Down

Even on a man's body that has few curves, the
line from the back down to the buttocks is a
gentle curve. This is a pose that requires a sense
of depth, so use perspective to make objects
in the foreground larger and those in the back-
ground smaller.

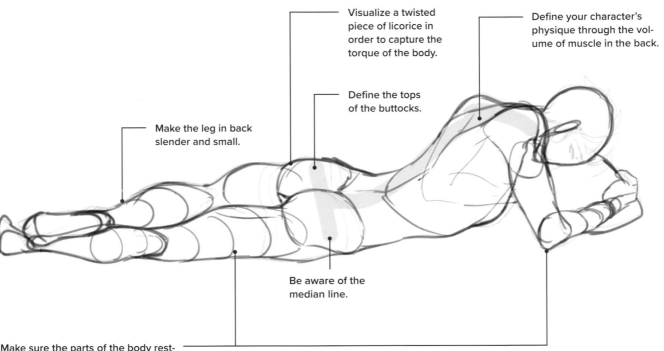

Visualize a twisted
piece of licorice in
order to capture the
torque of the body.

Define your character's
physique through the vol-
ume of muscle in the back.

Define the tops
of the buttocks.

Make the leg in back
slender and small.

Be aware of the
median line.

Make sure the parts of the body rest-
ing on the ground, such as the knee
and the thigh, align.

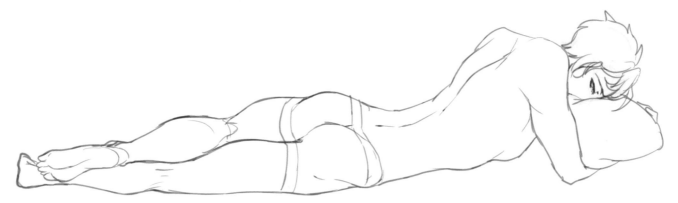

Holding a Pillow While Sleeping

When a figure is holding onto something while lying face down, be aware that the upper body rises slightly. Letting the body sink into the cushion brings out an air of relaxation.

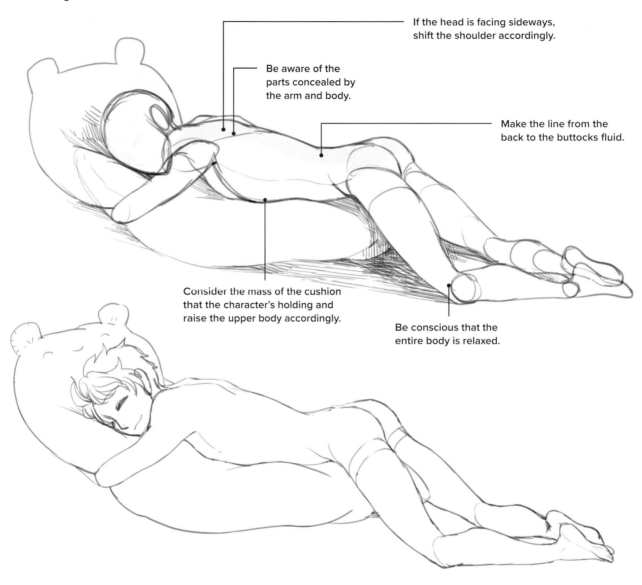

If the head is facing sideways, shift the shoulder accordingly.

Be aware of the parts concealed by the arm and body.

Make the line from the back to the buttocks fluid.

Consider the mass of the cushion that the character's holding and raise the upper body accordingly.

Be conscious that the entire body is relaxed.

A Bit of Advice

Make sure to create a relaxed air when a figure is lying face down.

In a pose where the figure's lying face down, gravity makes the entire body sink downward, and there's no tension in the muscles, unlike in standing poses. This doesn't mean the back and limbs are devoid of expression. Even when a figure's relaxed, make sure to properly represent the muscles.

Other Poses

When drawing a figure lying face down from various angles, it's necessary to use perspective to achieve a sense of depth. In a pose where the figure's pulling himself up from a face-down position, keep in mind the presence and role of the muscles.

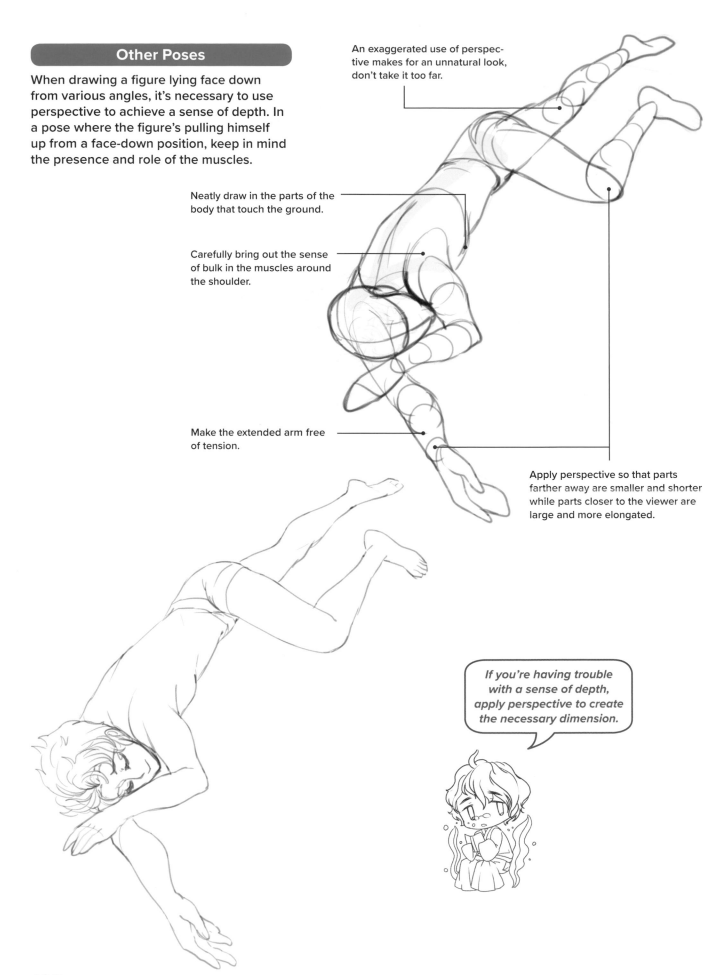

An exaggerated use of perspective makes for an unnatural look, don't take it too far.

Neatly draw in the parts of the body that touch the ground.

Carefully bring out the sense of bulk in the muscles around the shoulder.

Make the extended arm free of tension.

Apply perspective so that parts farther away are smaller and shorter while parts closer to the viewer are large and more elongated.

If you're having trouble with a sense of depth, apply perspective to create the necessary dimension.

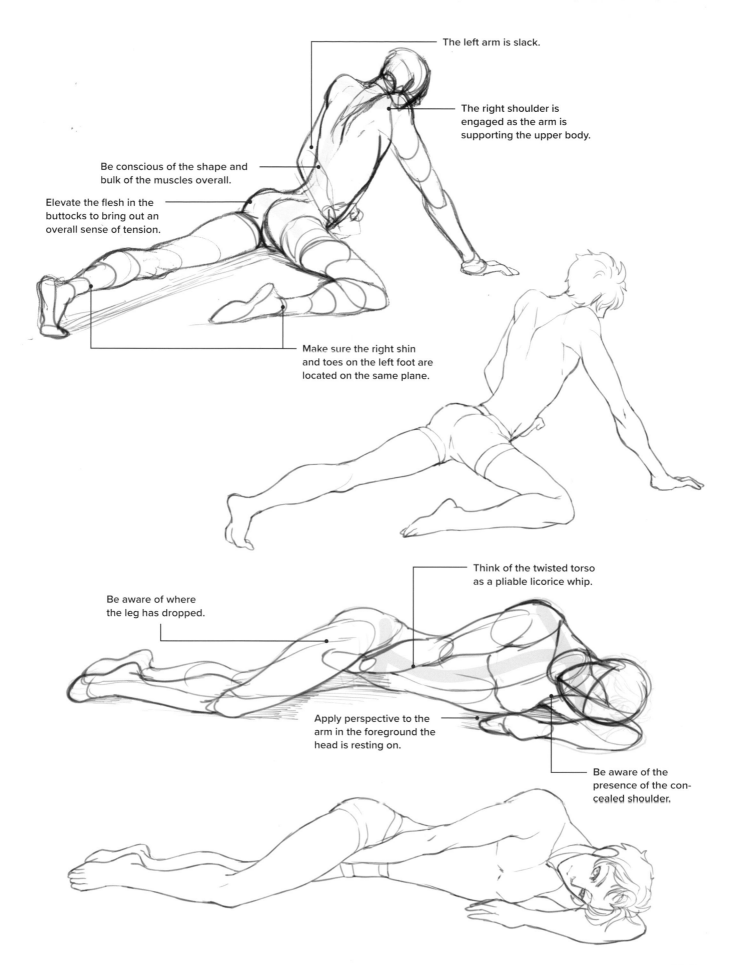

The left arm is slack.

The right shoulder is engaged as the arm is supporting the upper body.

Be conscious of the shape and bulk of the muscles overall.

Elevate the flesh in the buttocks to bring out an overall sense of tension.

Make sure the right shin and toes on the left foot are located on the same plane.

Think of the twisted torso as a pliable licorice whip.

Be aware of where the leg has dropped.

Apply perspective to the arm in the foreground the head is resting on.

Be aware of the presence of the concealed shoulder.

103

02

Drawing a Figure Lying on His Side

In a pose where your charcter's lying on his side, capturing the twist in the body and the character's expression are key.

Reclining on One Side

When lying on one side, the sides of the elbow and hip facing down engage the surface. Raising the upper body naturally causes the hips to lift and makes for a relaxed air. The direction of the legs changes depending on the direction of the pelvis, so care is needed when drawing them.

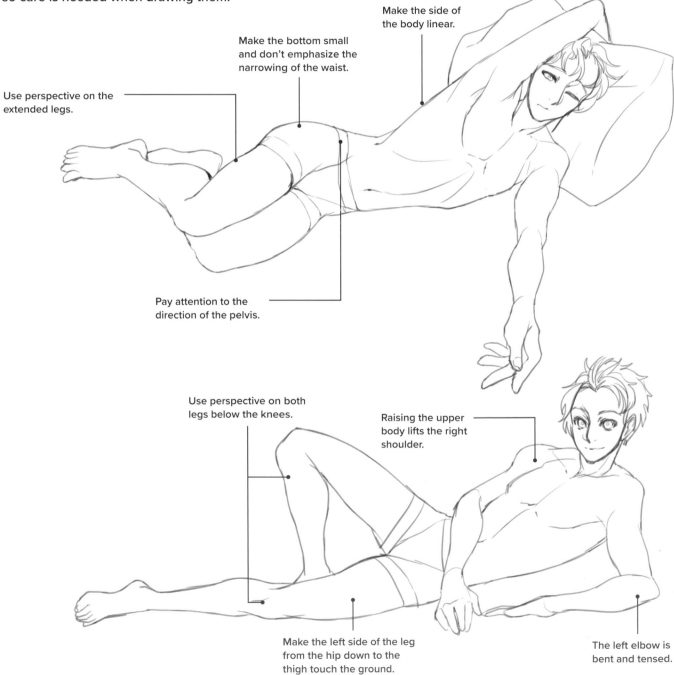

Make the side of the body linear.

Make the bottom small and don't emphasize the narrowing of the waist.

Use perspective on the extended legs.

Pay attention to the direction of the pelvis.

Use perspective on both legs below the knees.

Raising the upper body lifts the right shoulder.

Make the left side of the leg from the hip down to the thigh touch the ground.

The left elbow is bent and tensed.

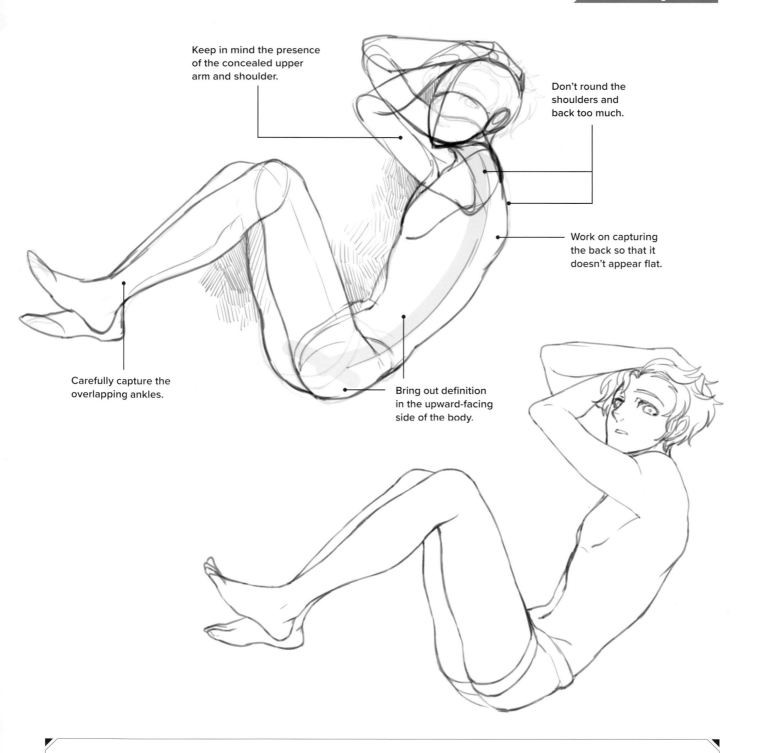

Keep in mind the presence of the concealed upper arm and shoulder.

Don't round the shoulders and back too much.

Work on capturing the back so that it doesn't appear flat.

Carefully capture the overlapping ankles.

Bring out definition in the upward-facing side of the body.

A Bit of Advice

Adding background details is a good option when drawing reclining poses.

Reclining poses have a tendency to appear flat. Apart from slightly shifting the parts touching the ground away from the parts facing upward to create depth, tweaks such as drawing in wrinkles in the sheets in the background are necessary.

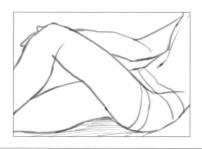

Drawing a Figure Lying on His Back

Make the back, buttocks and other parts touching the ground look natural, aiming for a relaxed, lackadaisical pose.

Lying Face Up

As a man's body is linear, the back doesn't have much of an arch to it. When showing a figure lying face up, draw it so that the body's twisted slightly, angled to make the front visible.

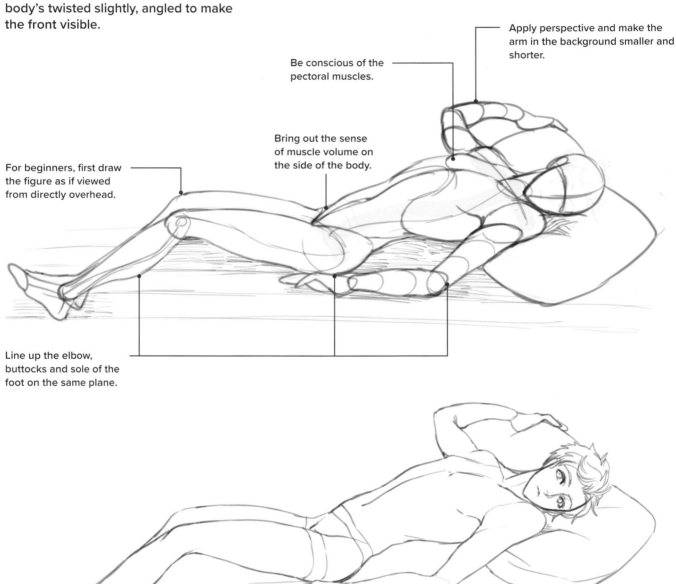

Apply perspective and make the arm in the background smaller and shorter.

Be conscious of the pectoral muscles.

Bring out the sense of muscle volume on the side of the body.

For beginners, first draw the figure as if viewed from directly overhead.

Line up the elbow, buttocks and sole of the foot on the same plane.

Raising the Upper Body

In contrast to a pose where the figure's lying on his back and it's completely flat against the ground, raising the upper body slightly brings out the muscles in the torso.

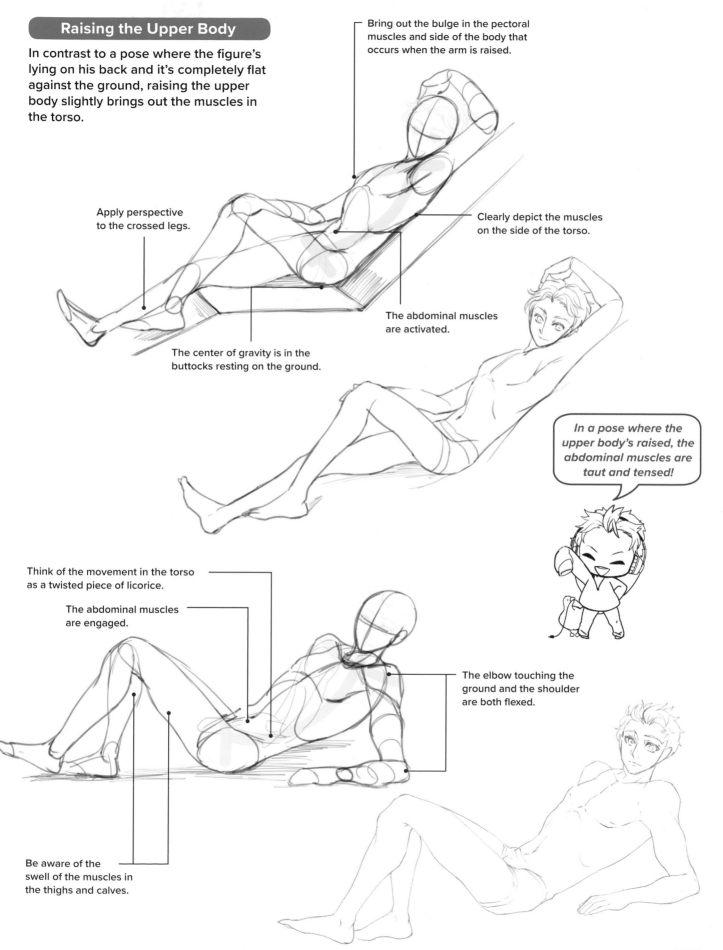

Bring out the bulge in the pectoral muscles and side of the body that occurs when the arm is raised.

Apply perspective to the crossed legs.

Clearly depict the muscles on the side of the torso.

The abdominal muscles are activated.

The center of gravity is in the buttocks resting on the ground.

In a pose where the upper body's raised, the abdominal muscles are taut and tensed!

Think of the movement in the torso as a twisted piece of licorice.

The abdominal muscles are engaged.

The elbow touching the ground and the shoulder are both flexed.

Be aware of the swell of the muscles in the thighs and calves.

Seen from Above

Viewing a reclining figure from directly overhead gives your illustration a unique angle and dynamic dimension. Take care with the sense of distance and the balance of the body to create an appealingly memorable result.

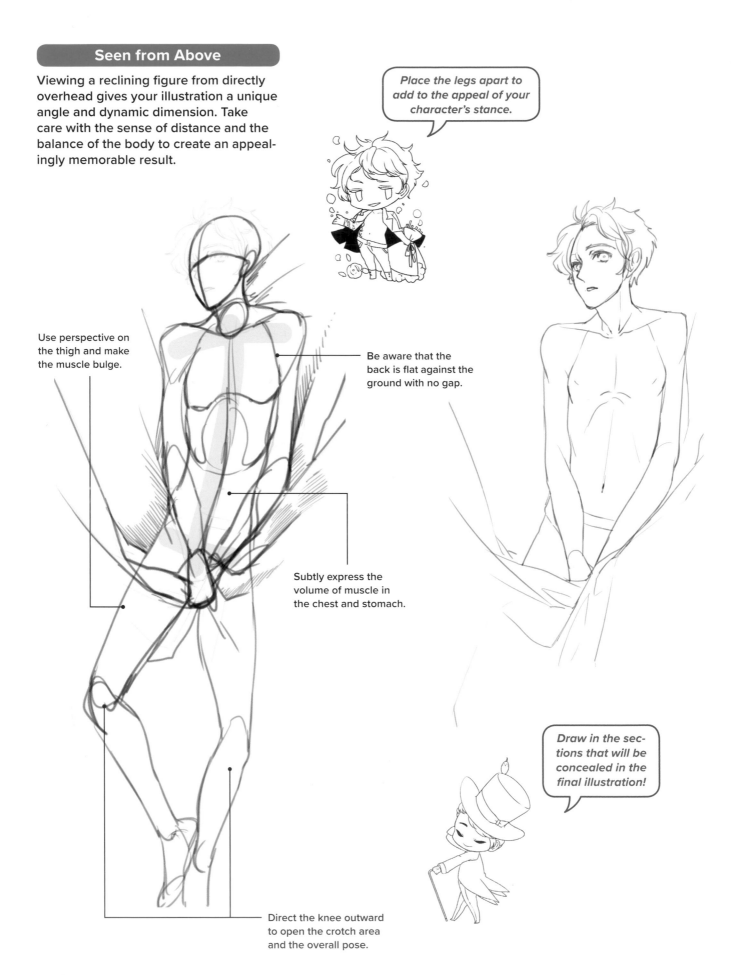

Place the legs apart to add to the appeal of your character's stance.

Use perspective on the thigh and make the muscle bulge.

Be aware that the back is flat against the ground with no gap.

Subtly express the volume of muscle in the chest and stomach.

Direct the knee outward to open the crotch area and the overall pose.

Draw in the sections that will be concealed in the final illustration!

Imagining the figure as seen from above makes it easier to draw. It's also a good idea to actually draw the figure from a bird's-eye view in order to check the perspective.

Be aware of the sense of volume in the muscles running through the entire body.

Make the thighs thick and large to enhance your character's presence on the page or screen.

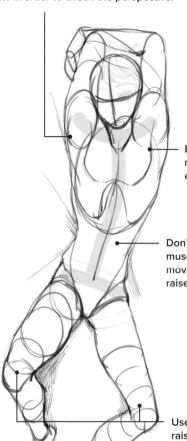

Be aware of the movement of muscles in the extended arms.

Don't forget about the chest muscles and underarms that move in the direction of the raised arms.

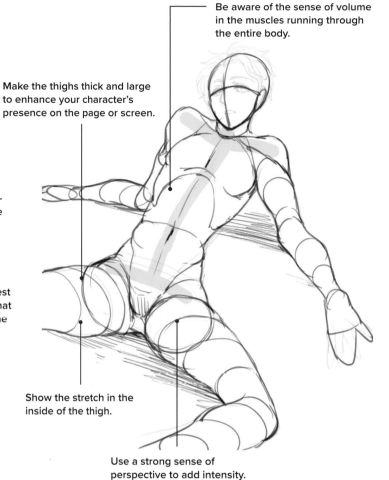

Show the stretch in the inside of the thigh.

Use perspective on the raised knees to express dimension and depth.

Use a strong sense of perspective to add intensity.

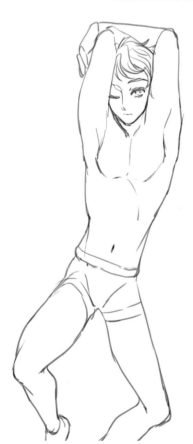

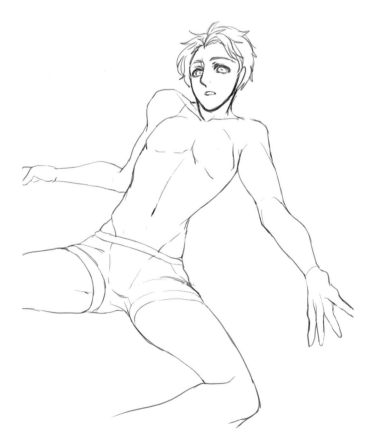

109

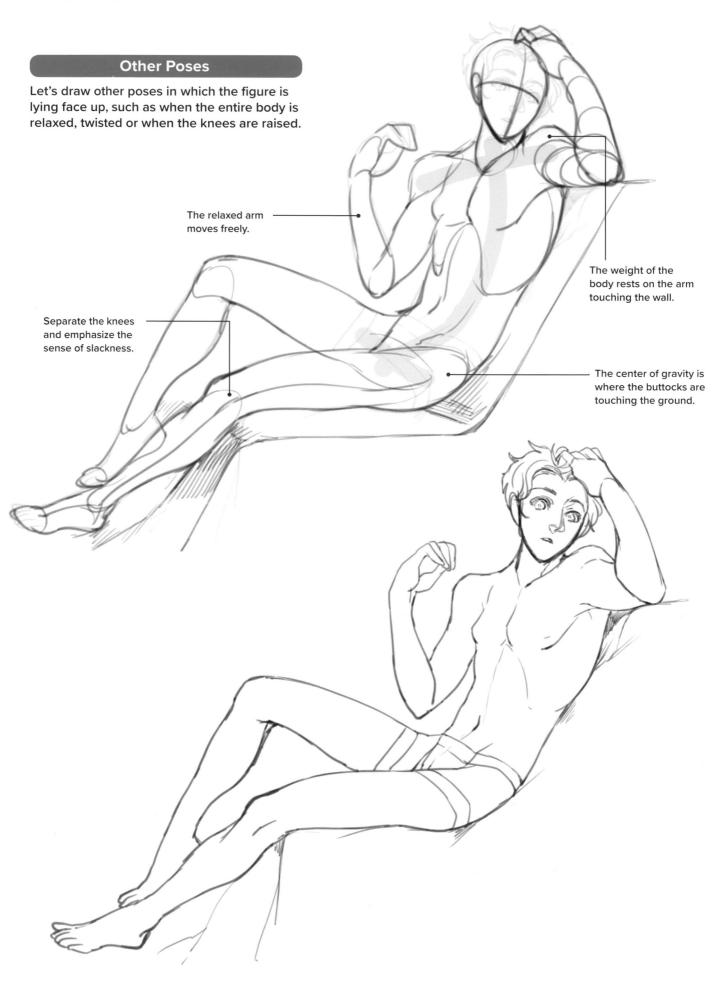

Other Poses

Let's draw other poses in which the figure is lying face up, such as when the entire body is relaxed, twisted or when the knees are raised.

The relaxed arm moves freely.

The weight of the body rests on the arm touching the wall.

Separate the knees and emphasize the sense of slackness.

The center of gravity is where the buttocks are touching the ground.

110

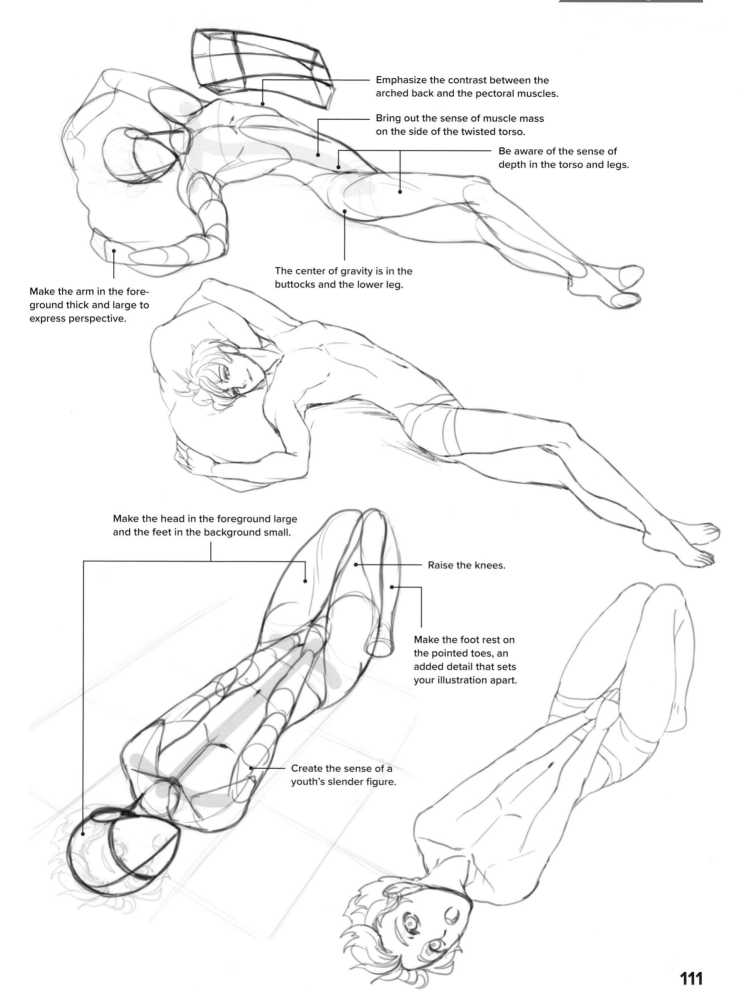

Emphasize the contrast between the arched back and the pectoral muscles.

Bring out the sense of muscle mass on the side of the twisted torso.

Be aware of the sense of depth in the torso and legs.

Make the arm in the foreground thick and large to express perspective.

The center of gravity is in the buttocks and the lower leg.

Make the head in the foreground large and the feet in the background small.

Raise the knees.

Make the foot rest on the pointed toes, an added detail that sets your illustration apart.

Create the sense of a youth's slender figure.

Drawing Two Reclining Figures

When drawing two figures interacting with each other while reclining, the positioning of the limbs and other parts in contact is key.

Lying Face Up While Another's Bending Over

This pose involves one figure lying face up and the other bending over him. The figure on his back has his leg on the other figure's neck in an acrobatic posture. The bending figure's center of gravity tilts forward.

Make sure the figures' bodies and eye lines are directed toward each other!

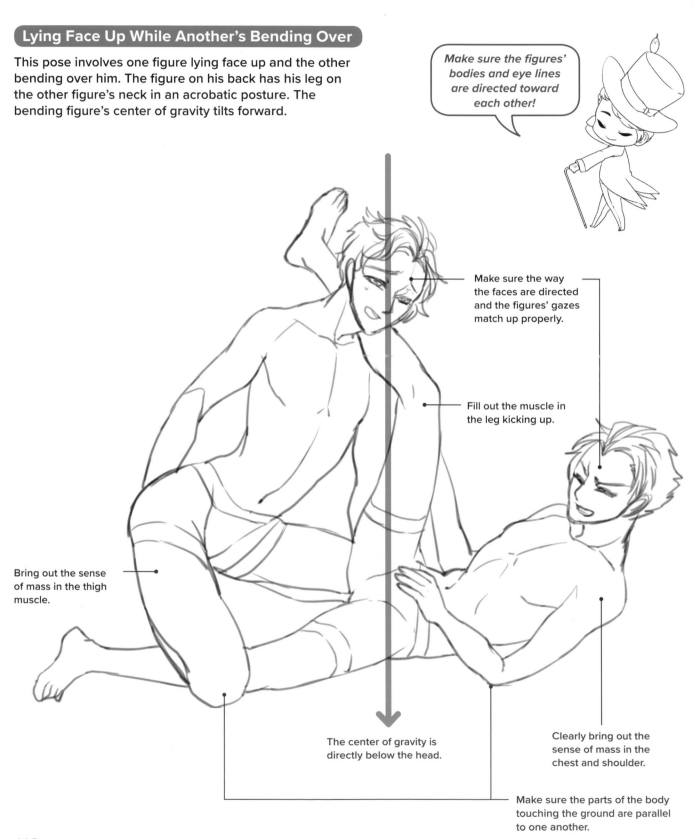

Make sure the way the faces are directed and the figures' gazes match up properly.

Fill out the muscle in the leg kicking up.

Bring out the sense of mass in the thigh muscle.

The center of gravity is directly below the head.

Clearly bring out the sense of mass in the chest and shoulder.

Make sure the parts of the body touching the ground are parallel to one another.

One Figure Lying on Top of the Other

In this scene, one figure lies on his back while the other lies on top of him facing to the side. The center of gravity is distributed over the parts in close contact. Use the movement in the arms and the sense of bulk on the side of the body to add expressiveness to the scene.

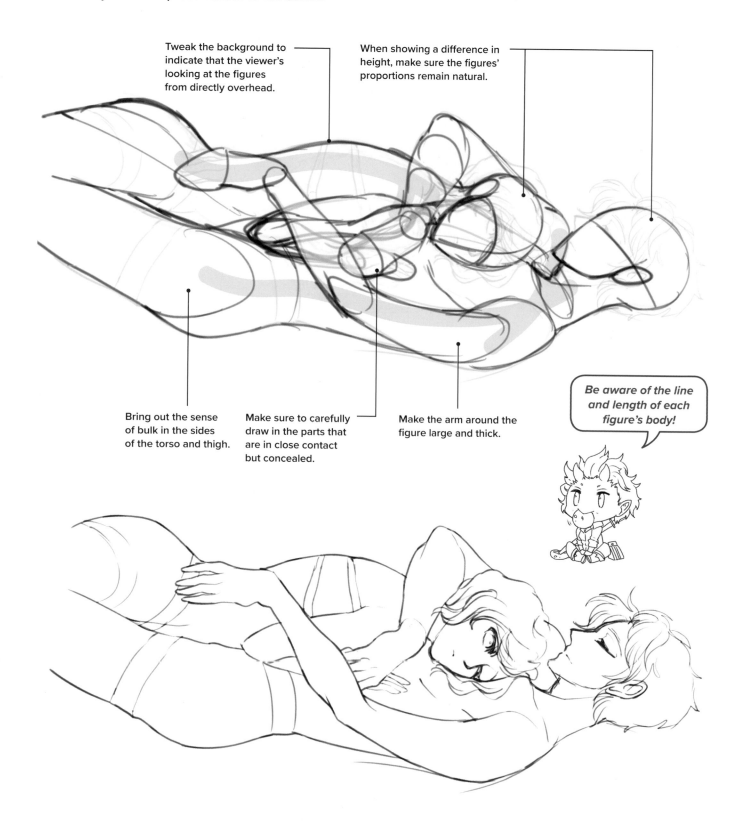

Tweak the background to indicate that the viewer's looking at the figures from directly overhead.

When showing a difference in height, make sure the figures' proportions remain natural.

Bring out the sense of bulk in the sides of the torso and thigh.

Make sure to carefully draw in the parts that are in close contact but concealed.

Make the arm around the figure large and thick.

Be aware of the line and length of each figure's body!

In this pose, a woman lies over the top of a man who's lying face down. Bring out the differences in the man and woman's physiques, at the same time making sure to carefully express the parts in close contact.

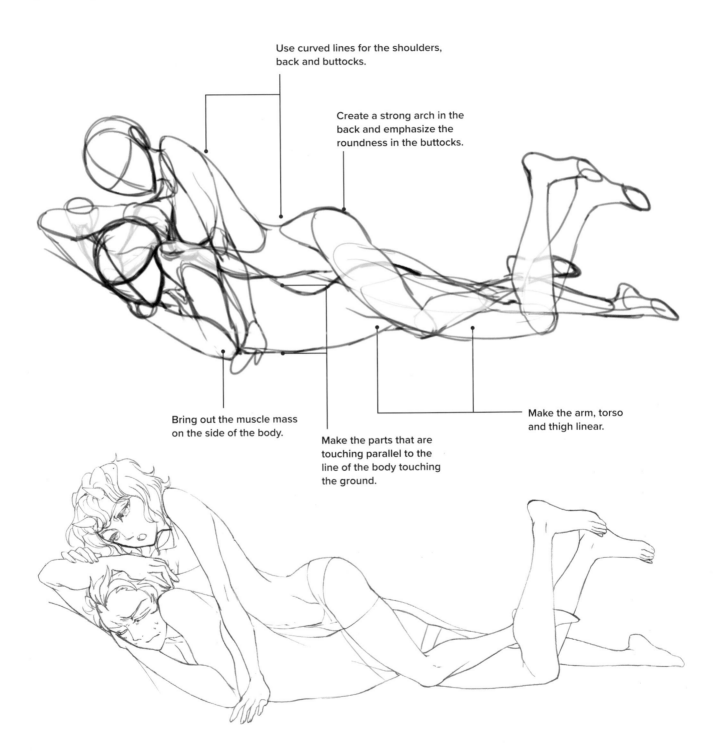

Use curved lines for the shoulders, back and buttocks.

Create a strong arch in the back and emphasize the roundness in the buttocks.

Bring out the muscle mass on the side of the body.

Make the parts that are touching parallel to the line of the body touching the ground.

Make the arm, torso and thigh linear.

An Adult with a Child

In this pose, a father roughhouses with his daughter. The father lies on his back while the daughter crouches over him. Pay attention to the differences in their physiques to create a natural, balanced look.

Make the legs small and the head large to re-create a child's physique.

The head and shoulders are resting on the arm of the sofa.

The center of gravity's in the buttocks.

Be conscious of how the buttocks come in contact with the sofa.

There's a gap behind the father's back, and the muscles of the back and stomach are tightened.

Make sure the difference in size between the adult and child remains proportional and natural!

Drawing a Rough Sketch

Once you've decided on the pose and the overall look of the illustration you want to produce, begin with the line drawing. Make sure that the body's movement looks natural.

Process on Paper
When drawing a figure making large movements, the initial blocking-in is vital. Make sure the size of the upper and lower body is in balance with the head. It's a rough drawing to start the illustration, but take care with the composition.

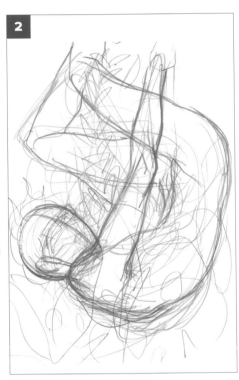

Process on a Computer
Scan the drawing into the computer, and once the rough composition is complete, carefully flesh out the figure, being conscious of how the muscles move. Capture the outline of the back that's determined by the size of the back muscles, along with the thigh muscles and the line of the outstretched arm.

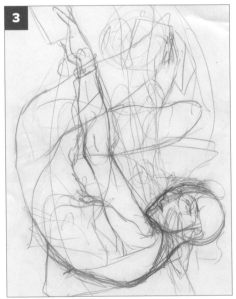

Process on Paper
Here, I wasn't satisfied with the composition so reversed the image that had been printed on paper. Add in details such as the clothing, face and fingers over the fleshed-out lines.

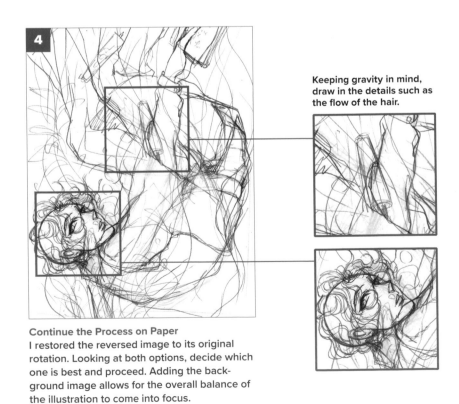

Keeping gravity in mind, draw in the details such as the flow of the hair.

Continue the Process on Paper
I restored the reversed image to its original rotation. Looking at both options, decide which one is best and proceed. Adding the background image allows for the overall balance of the illustration to come into focus.

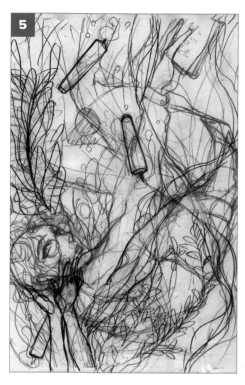

5

Drawing on separate layers makes it easy to correct any mistakes later.

Process on a Computer
At this point, scan the illustration into the computer. Add elements to the background and the character's surroundings to build the sense of the world he inhabits. If you haven't decided on the overall feel of the picture, take a step back or put it away for a while then look at it again to get a better sense of it as a whole before proceeding.

A Bit of Advice

Separate layers to draw.

It may feel like a bit of a chore, but drawing each body part on a separate layer is an option. It's time consuming, but think of it as insurance against any alterations and corrections you may need to make later.

6

Leave only the outline and erase unnecessary lines to complete the work!

Process on a Computer
Erase unnecessary lines to complete the line drawing. Applying color follows this process, so at this stage it's fine not to erase the sections where the figure and other elements overlap. Use the brush on the computer to finish off the illustration.

A Bit of Advice

Create a brush.

Once you're able to use the various existing brush tools for specific purposes, you'll want thicknesses and effects to suit your own tastes. When you reach this stage, you can make your own brush.

Applying Color

As the task of applying color tends to result in many layers, be sure to keep them under control. Try expressing shadow and conveying a sense of translucency.

Adjust the color scheme by using the color slider on your digital-design software.

Color Slider	
C	65%
M	30%
Y	54%
K	46%

Use your preferred digital-design software to add color to the illustration. Keep in mind the finished result and any other treatments you may want to apply later as you add the base colors.

When you want to bring out translucency, such as in the candles, use pale colors to distribute the tone and allow the base colors to show through.

If the picture seems to be lacking in punch, you'll want to add texture. Use Photoshop to layer texture you've created yourself and infuse the illustration with a sense of the character's world.

A Bit of Advice
Creating texture

Have a go at making your own texture in Photoshop. Use a photo or other image that suggests the look you have in mind and use the cutout function to easily create texture like that of a paper cutout. You can use the brush tool to do this.

4

Place textures one on top of the other and use design software to add contrast to the cover of the book the character is holding and the seaweed along with details such as glasses.

See page 92 to get an understanding of the shape of the glasses and to learn the key points for drawing them before you start.

Alter the transparency of the glasses in the regular layers as you proceed with the drawing.

Finally, add in the inner corners of the eyes to complete the drawing.

5

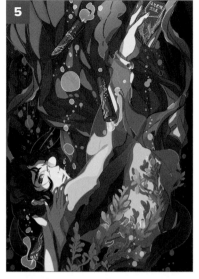

Make adjustments using your preferred design software while checking the color scheme of the detailed sections, the depth and the overall balance. Alternate between the finer details and the illustration as a whole to check the work in different ways.

6

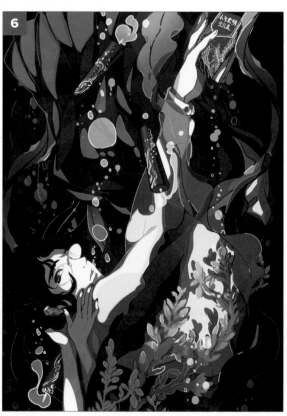

The tone curve in Photoshop allows for visual correction when adjusting the tone gradation.

Integrate all the layers and use Photoshop to correct the tone to complete the work. It's a good idea to replicate the integrated layers just in case.

119

Drawing Various Athletes

Rather than just dressing figures in uniforms to distinguish what sport they play, learn to draw muscles differently depending on the kind of sport the character plays.

▶ How to Draw a Soccer Player

Imagine the moves used in soccer. As playing the sport relies heavily on the torso, the muscles tend to be developed around the waist. Because endurance and sudden bursts of agility are needed, the muscles in the lower body are also developed, while the pectorals and arms tend to be relatively slender. Before drawing the uniform, watch motion footage or look at photos to consciously research soccer players' physiques. It's also a good idea to compare them with other athletes.

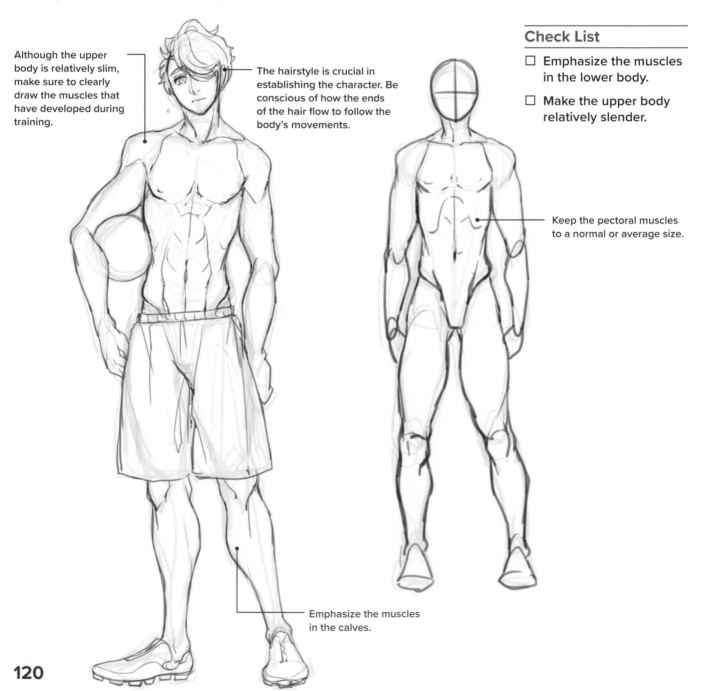

Although the upper body is relatively slim, make sure to clearly draw the muscles that have developed during training.

The hairstyle is crucial in establishing the character. Be conscious of how the ends of the hair flow to follow the body's movements.

Check List

☐ Emphasize the muscles in the lower body.

☐ Make the upper body relatively slender.

Keep the pectoral muscles to a normal or average size.

Emphasize the muscles in the calves.

▶ How to Draw a Baseball Player

Although it's a sport that tends to develop the muscles of the entire body, the muscles around the shoulders and in the buttocks are characteristic of the sport's players. When emphasizing the well-defined muscles of the back and buttocks, it's easiest to display their characteristics in a profile drawing. As for the soccer player, drawing attention to the muscles beneath the uniform will allow you to create a more realistic athlete.

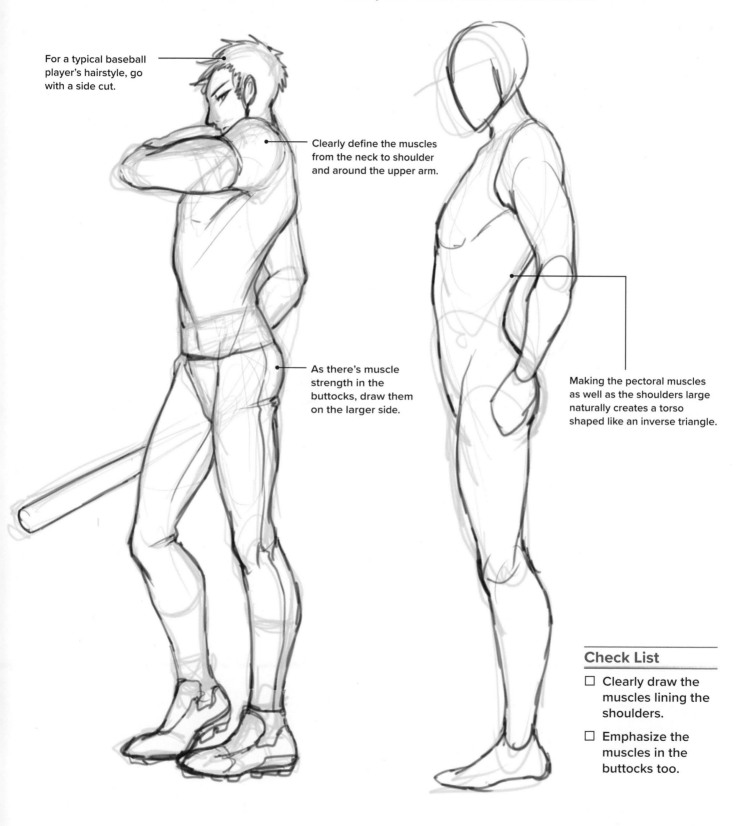

For a typical baseball player's hairstyle, go with a side cut.

Clearly define the muscles from the neck to shoulder and around the upper arm.

As there's muscle strength in the buttocks, draw them on the larger side.

Making the pectoral muscles as well as the shoulders large naturally creates a torso shaped like an inverse triangle.

Check List

- ☐ Clearly draw the muscles lining the shoulders.
- ☐ Emphasize the muscles in the buttocks too.

▶ How to Draw a Swimmer

Competitive swimmers wear only bathing suits, drawing all the more attention to the body's various muscles. Although there's a range of events in swimming, in general swimmers have broad shoulders and small buttocks, so their upper body resembles an inverse triangle. As they typically have slim legs, it's easy to capture the characteristics of these athletes. It's fine to focus on the formation of the muscles in the upper body.

Check List

- ☐ Depict the upper body as an inverse triangle.
- ☐ Make the bottom small and the legs slender.

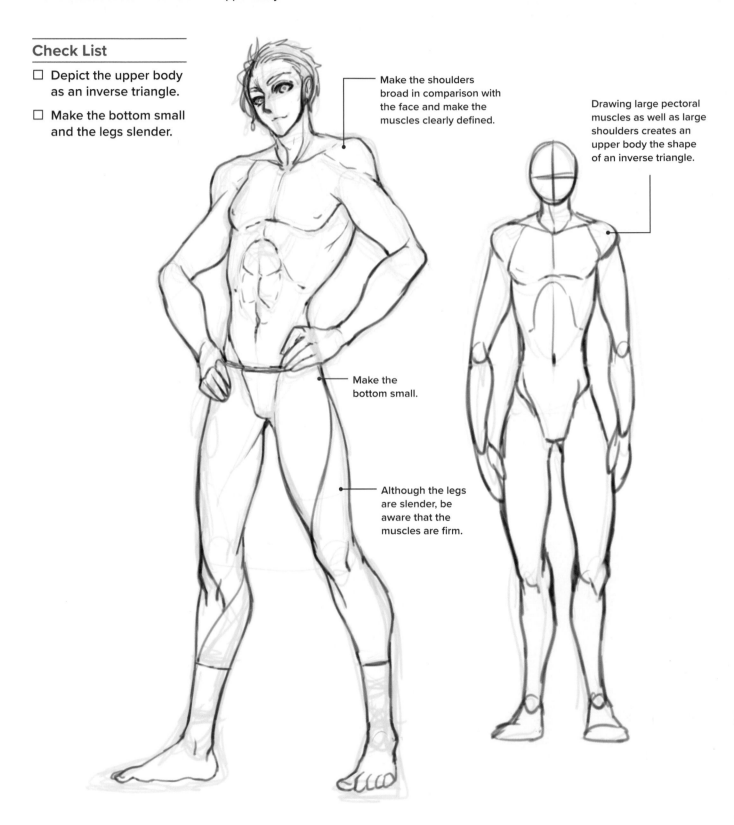

Make the shoulders broad in comparison with the face and make the muscles clearly defined.

Drawing large pectoral muscles as well as large shoulders creates an upper body the shape of an inverse triangle.

Make the bottom small.

Although the legs are slender, be aware that the muscles are firm.

Poses in Motion

Here, we look at poses that can be incorporated into sports or battle scenes. As you draw, be aware of how the body's balanced and how the muscles move.

Drawing a Figure Playing Sports

In a scene involving a sport with bold, large movements, capture not only the muscle mass involved but also the creases in clothing and the hair's movement.

Playing Soccer

When running after a ball in soccer, the most vigorous, powerful movements are centered on the legs. As the uniform is made of a light, thin fabric, it easily catches the breeze, creating long creases.

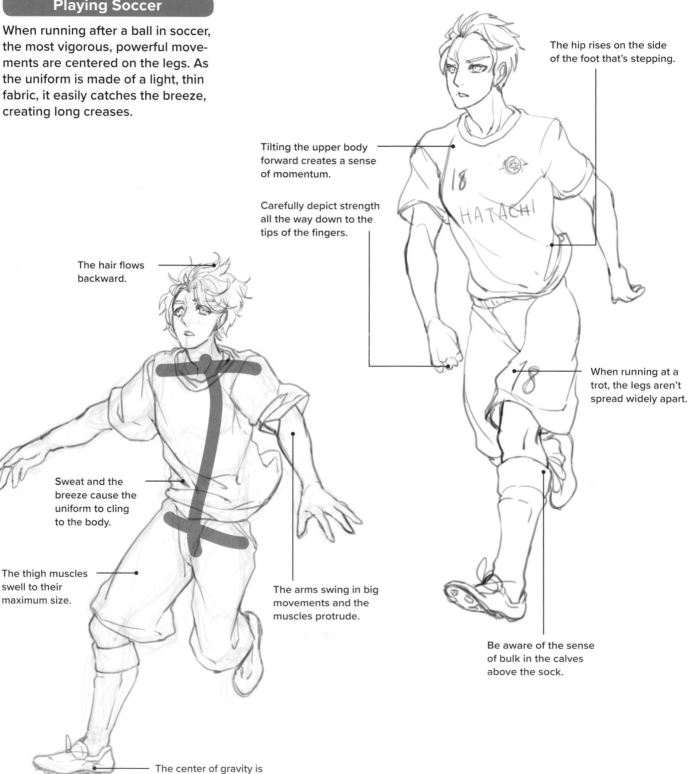

The hip rises on the side of the foot that's stepping.

Tilting the upper body forward creates a sense of momentum.

Carefully depict strength all the way down to the tips of the fingers.

The hair flows backward.

When running at a trot, the legs aren't spread widely apart.

Sweat and the breeze cause the uniform to cling to the body.

The thigh muscles swell to their maximum size.

The arms swing in big movements and the muscles protrude.

Be aware of the sense of bulk in the calves above the sock.

The center of gravity is in the planted foot.

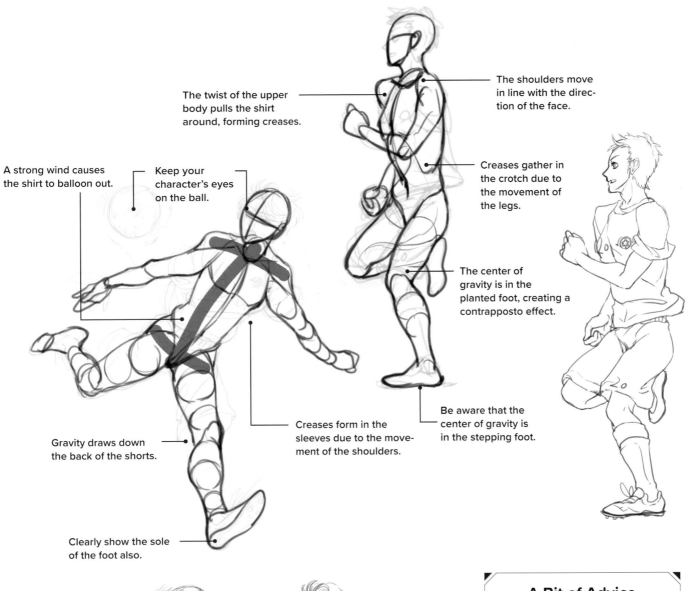

The twist of the upper body pulls the shirt around, forming creases.

The shoulders move in line with the direction of the face.

A strong wind causes the shirt to balloon out.

Keep your character's eyes on the ball.

Creases gather in the crotch due to the movement of the legs.

The center of gravity is in the planted foot, creating a contrapposto effect.

Gravity draws down the back of the shorts.

Creases form in the sleeves due to the movement of the shoulders.

Be aware that the center of gravity is in the stepping foot.

Clearly show the sole of the foot also.

A Bit of Advice

Find a place to add in wrinkles.

As the fabric used in a soccer uniform is light and thin, many wrinkles form. Drawing every single wrinkle would create an overly busy illustration, so fill in only the most prominent or necessary ones.

Playing Baseball

For baseball players, attention is drawn to the movements of the upper half of the body. As the uniform is made from a stretchy fabric that fits closely to the body, creases are formed in conjunction with the way the body moves.

Showing the sole of the foot creates a sense of instability, adding reality to the throwing movement.

Several long creases form from the chest to the hips.

Use a strong curved line for the back and a smooth line for the buttocks.

Use perspective on the leg swinging up.

The deltoid muscle in the shoulder swells.

All the muscles in the body work to form the massive twist in the waist.

Bring out the sense of bulk in the thigh and the calf of the planted foot.

A pitcher centers gravity on one leg.

The fabric pulls at the back of the knees, forming wrinkles.

The center of gravity is on the side of the planted foot.

A vigorous movement creates a surprisingly natural curved line.

126

Swimming

As swimming is an exercise that involves the whole body, use the muscles to express dynamic movement. Be conscious not only of the sense of speed but of the shift in buoyant force.

There is no gravitational pull, but make sure to depict the movement of a solid form!

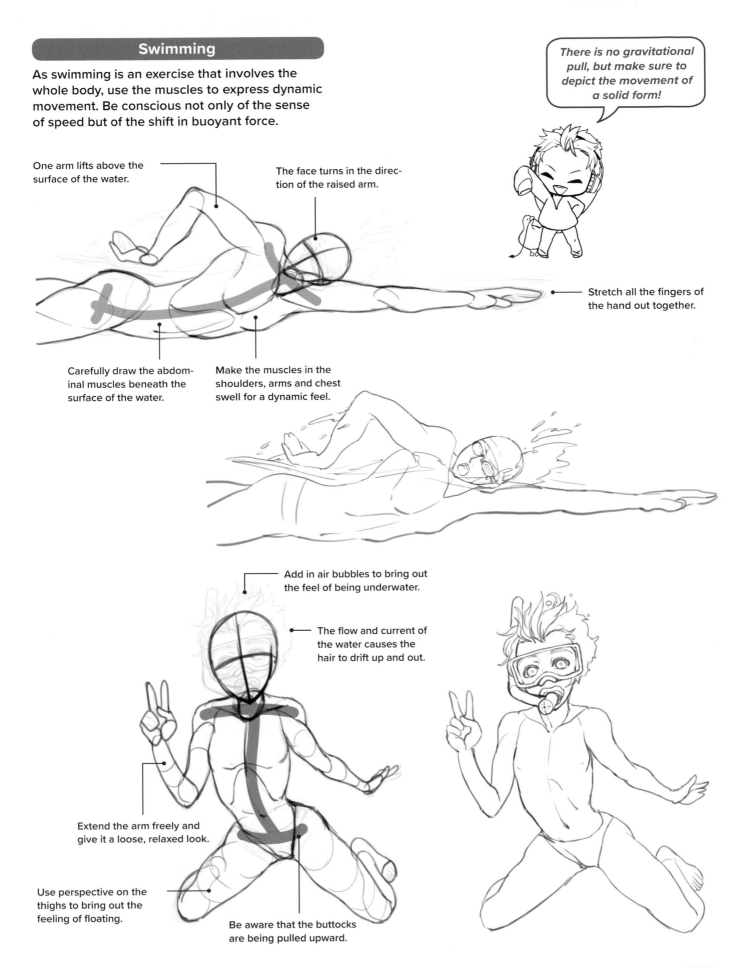

One arm lifts above the surface of the water.

The face turns in the direction of the raised arm.

Stretch all the fingers of the hand out together.

Carefully draw the abdominal muscles beneath the surface of the water.

Make the muscles in the shoulders, arms and chest swell for a dynamic feel.

Add in air bubbles to bring out the feel of being underwater.

The flow and current of the water causes the hair to drift up and out.

Extend the arm freely and give it a loose, relaxed look.

Use perspective on the thighs to bring out the feeling of floating.

Be aware that the buttocks are being pulled upward.

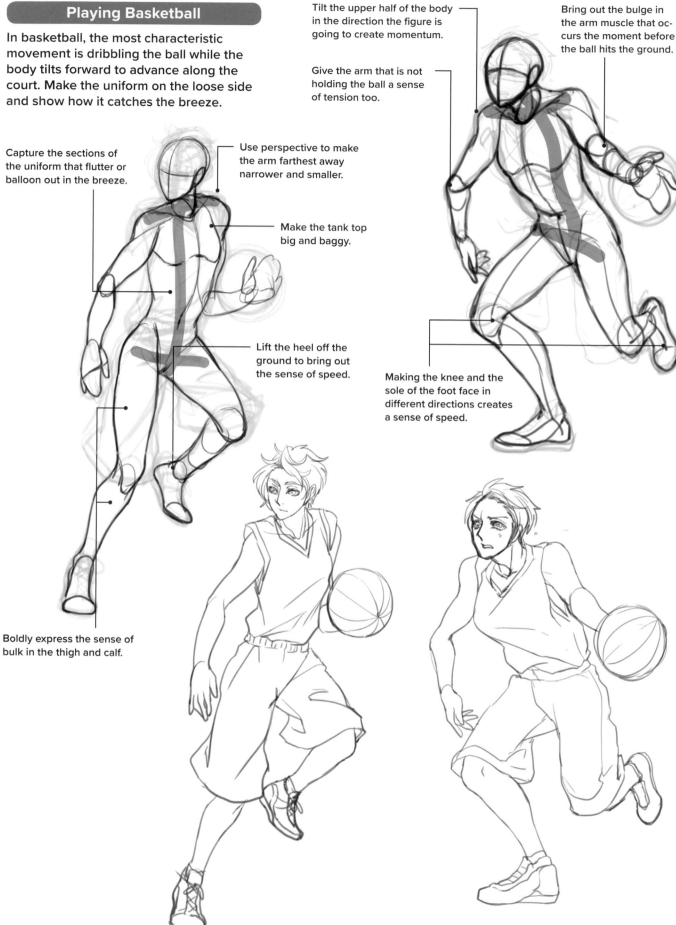

Playing Basketball

In basketball, the most characteristic movement is dribbling the ball while the body tilts forward to advance along the court. Make the uniform on the loose side and show how it catches the breeze.

Tilt the upper half of the body in the direction the figure is going to create momentum.

Give the arm that is not holding the ball a sense of tension too.

Bring out the bulge in the arm muscle that occurs the moment before the ball hits the ground.

Capture the sections of the uniform that flutter or balloon out in the breeze.

Use perspective to make the arm farthest away narrower and smaller.

Make the tank top big and baggy.

Lift the heel off the ground to bring out the sense of speed.

Making the knee and the sole of the foot face in different directions creates a sense of speed.

Boldly express the sense of bulk in the thigh and calf.

128

Doing Gymnastics

The swell of muscles is conspicuous in gymnastic poses. Refer to the body's structure to faithfully represent how particular muscles move. On top of this, it's also key to create a sleek, light look.

Take care that the twisted torso does not face in an unnatural direction.

Bring out the texture of the muscles in the upper half of the body at the same time as creating a supple curve.

Draw in even the tips of the toes carefully, engendering them with a sense of tension.

Boldly bring out the momentum in the rotating leg.

Show the swell of the supporting arm.

Tighten the vertical muscles of the extended legs.

Be conscious of the power in the abdominal muscles.

The strength of the shoulders and arms supports the entire body.

Use perspective on the closest leg, making it large and thick.

Boldly stretch the limbs to convey the poses extending all the way to the fingertips!

Steady the position of the wrists, making sure not to neglect the ends of the fingers.

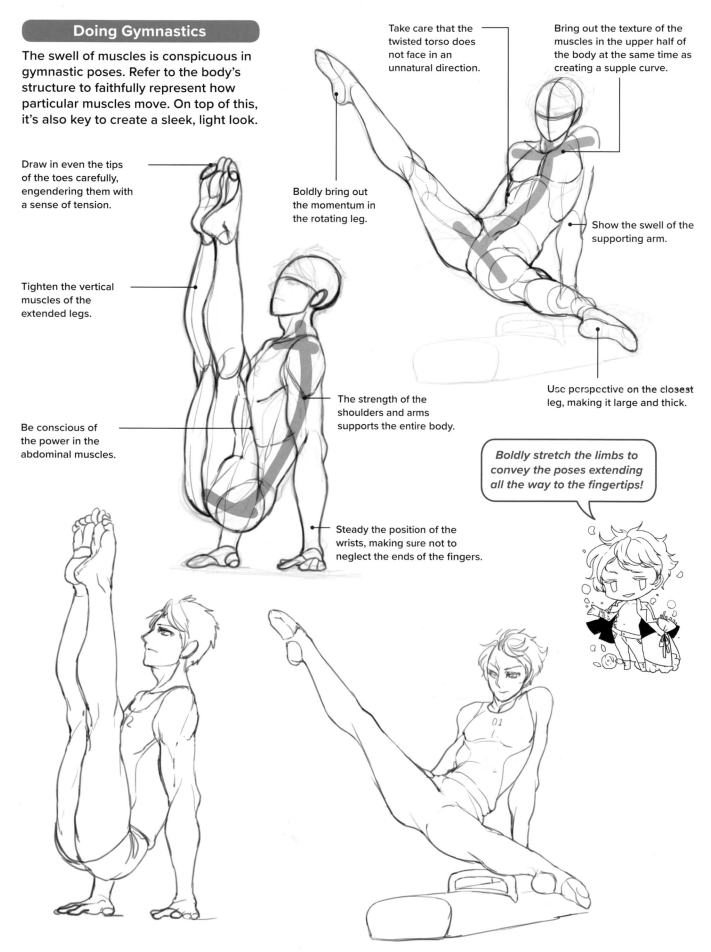

Drawing a Fighting Figure

Unless you have a firm understanding of the body's structure,
it won't be possible to create a realistic fighting scene.

Punching and Kicking

In addition to making sure each body part is in proportion, apply basic movements such as supporting weight on one leg or standing on one leg. Create a pose that allows the viewer to imagine the presence of an opponent.

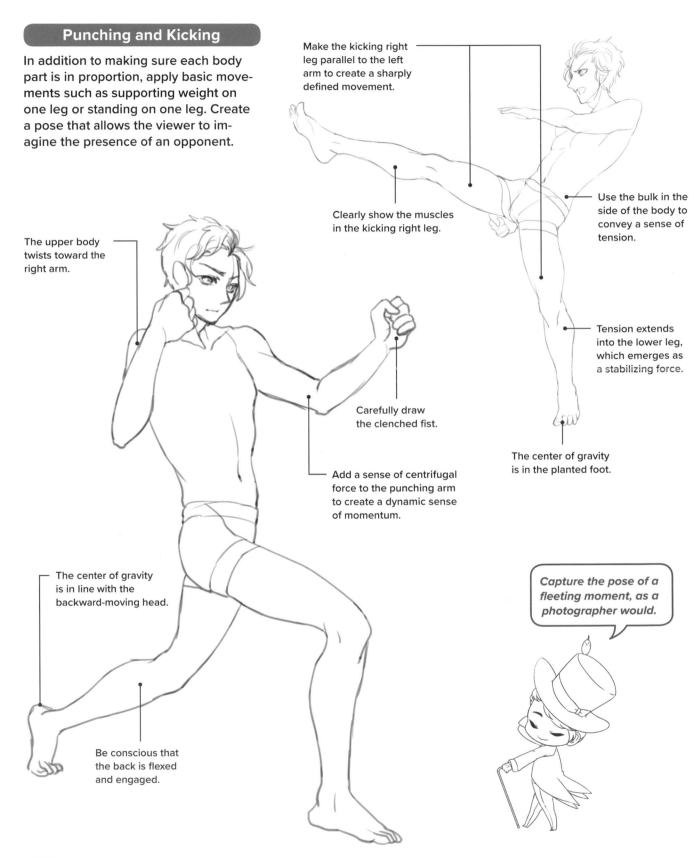

Make the kicking right leg parallel to the left arm to create a sharply defined movement.

Clearly show the muscles in the kicking right leg.

Use the bulk in the side of the body to convey a sense of tension.

Tension extends into the lower leg, which emerges as a stabilizing force.

The upper body twists toward the right arm.

Carefully draw the clenched fist.

Add a sense of centrifugal force to the punching arm to create a dynamic sense of momentum.

The center of gravity is in the planted foot.

The center of gravity is in line with the backward-moving head.

Be conscious that the back is flexed and engaged.

Capture the pose of a fleeting moment, as a photographer would.

Raising a Leg High

Rather than having the back completely flat against the ground in a pose where the character is lying face up, a posture where the upper body is slightly raised shows off the muscles of the torso.

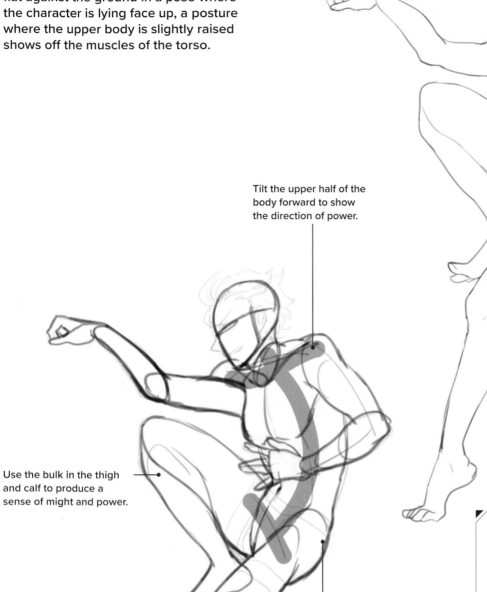

Tilt the upper half of the body forward to show the direction of power.

Use the bulk in the thigh and calf to produce a sense of might and power.

Extend strength and power down to the tip of the kicking foot.

Express the moment of instability that appears when the center of gravity shifts.

A Bit of Advice

Direct your awareness to the tips of the toes for an attractive result.

When standing on one foot, the depiction of the tips of the toes is important. Capture the movement of the thighs, calves, ankles and toes to achieve the look of quick motions in a fighting pose.

Fighting with a Sword

In a combat pose where the figure's holding a sword, the movement of the upper half of the body stabilizes in the same way as when the arms are folded. As the movement in the upper half of the body is restricted, use the lower half of the body to create variation.

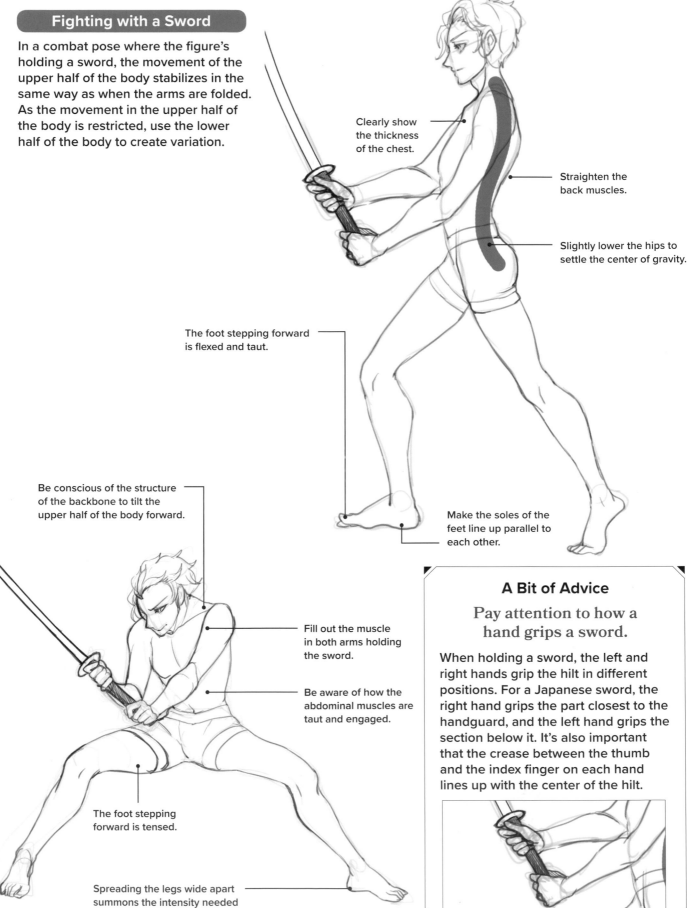

Clearly show the thickness of the chest.

Straighten the back muscles.

Slightly lower the hips to settle the center of gravity.

The foot stepping forward is flexed and taut.

Be conscious of the structure of the backbone to tilt the upper half of the body forward.

Make the soles of the feet line up parallel to each other.

Fill out the muscle in both arms holding the sword.

Be aware of how the abdominal muscles are taut and engaged.

The foot stepping forward is tensed.

Spreading the legs wide apart summons the intensity needed for a combat scene.

A Bit of Advice

Pay attention to how a hand grips a sword.

When holding a sword, the left and right hands grip the hilt in different positions. For a Japanese sword, the right hand grips the part closest to the handguard, and the left hand grips the section below it. It's also important that the crease between the thumb and the index finger on each hand lines up with the center of the hilt.

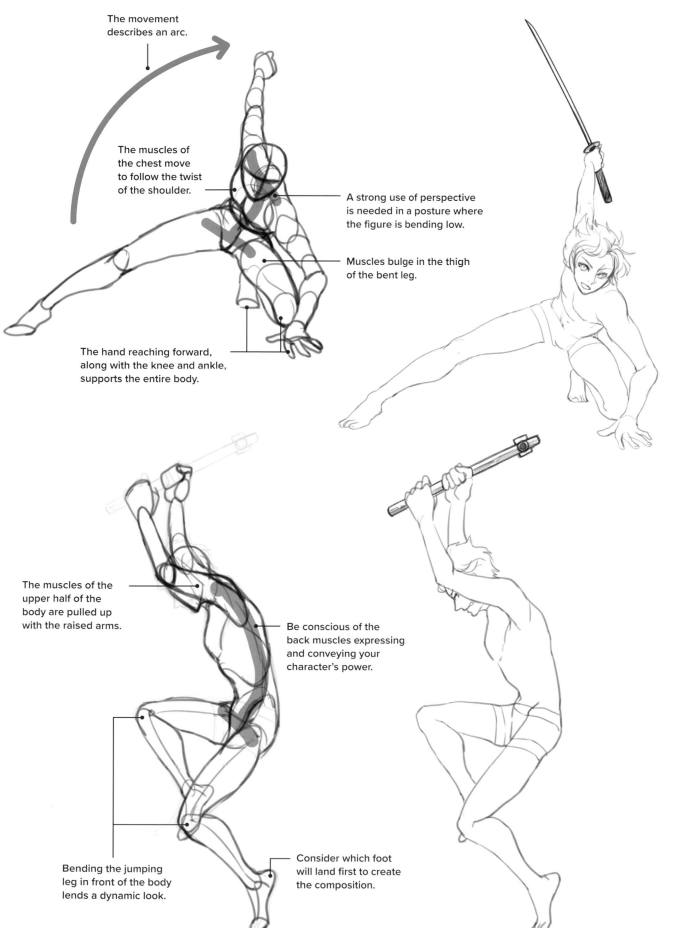

The movement describes an arc.

The muscles of the chest move to follow the twist of the shoulder.

A strong use of perspective is needed in a posture where the figure is bending low.

Muscles bulge in the thigh of the bent leg.

The hand reaching forward, along with the knee and ankle, supports the entire body.

The muscles of the upper half of the body are pulled up with the raised arms.

Be conscious of the back muscles expressing and conveying your character's power.

Bending the jumping leg in front of the body lends a dynamic look.

Consider which foot will land first to create the composition.

133

Holding a Gun

In action scenes that involve guns, it's important that the barrel and the eye line are pointing in precisely the same direction and that the grip's correct. These two key points create a sense of reality, much less adding drama and action to your scene.

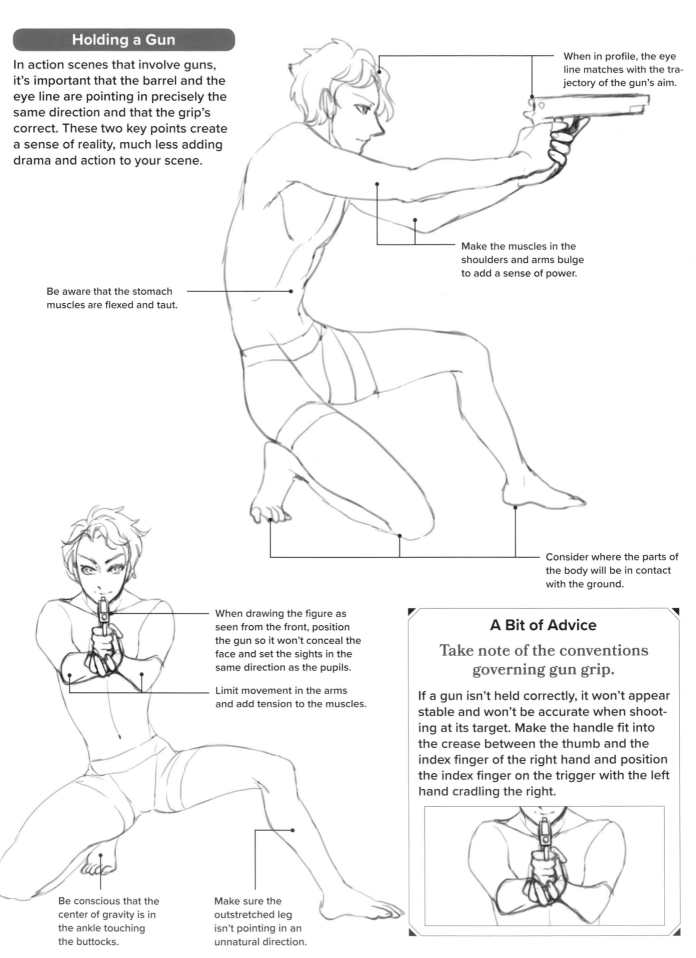

When in profile, the eye line matches with the trajectory of the gun's aim.

Make the muscles in the shoulders and arms bulge to add a sense of power.

Be aware that the stomach muscles are flexed and taut.

Consider where the parts of the body will be in contact with the ground.

When drawing the figure as seen from the front, position the gun so it won't conceal the face and set the sights in the same direction as the pupils.

Limit movement in the arms and add tension to the muscles.

Be conscious that the center of gravity is in the ankle touching the buttocks.

Make sure the outstretched leg isn't pointing in an unnatural direction.

A Bit of Advice

Take note of the conventions governing gun grip.

If a gun isn't held correctly, it won't appear stable and won't be accurate when shooting at its target. Make the handle fit into the crease between the thumb and the index finger of the right hand and position the index finger on the trigger with the left hand cradling the right.

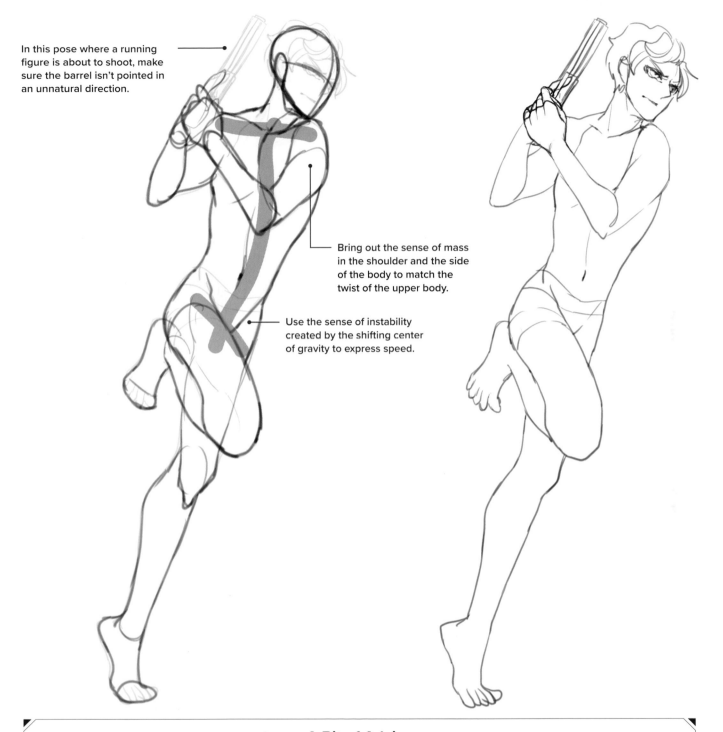

In this pose where a running figure is about to shoot, make sure the barrel isn't pointed in an unnatural direction.

Bring out the sense of mass in the shoulder and the side of the body to match the twist of the upper body.

Use the sense of instability created by the shifting center of gravity to express speed.

A Bit of Advice

Use the way the character grips the gun to control the viewer's impression.

There are two basic gun grips: the weaver and the isosceles. In contrast to the weaver, where the body twists in order to reduce the surface area of the body visible from the front, the isosceles grip involves holding the gun directly in front of the body. Consider the situation and draw depending on whether a good aim or quick, sharp movements are the priority.

Drawing Two Figures Fighting

In a fighting scene where two figures are making physical contact, it's necessary to bring out variation in each figure but at the same time create a harmonious well-balanced composition.

Punching Each Other

When characters are punching each other, the twists in the upper bodies express the intensity of the actions and the speed and power of the punches. As care is needed in the positioning and perspective applied to the arms to prevent them from appearing unnatural, this can be a difficult composition you'll need to practice to get right.

The more complicated the movement, the more difficult it becomes to draw. If you're having trouble, substitute silhouettes for the figures.

Start by drawing the parts of the two bodies that are in contact to prevent a disconnect between the figures.

Carefully draw the fist landing a punch.

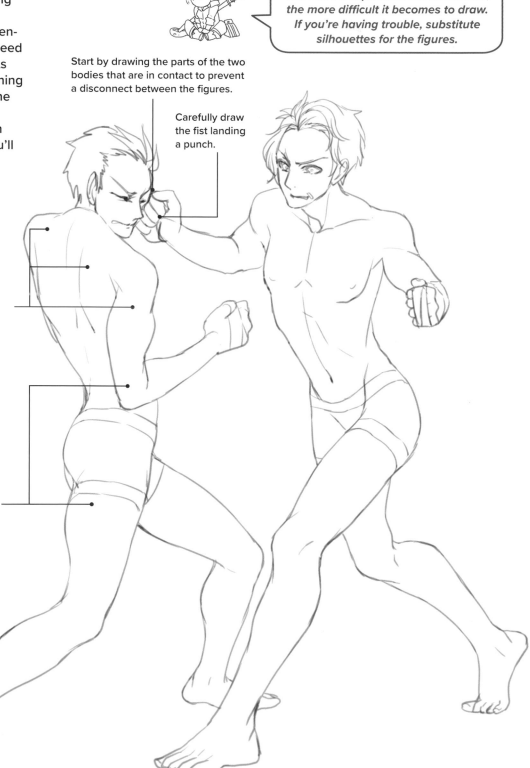

Create swelling in the muscles of the back, shoulder and arm.

Make the arms and legs in the foreground large and thick.

Defending Against a Roundhouse Kick

In order to depict the action of jumping, kicking and turning simultaneously, not only is it necessary to capture the perspective and the twisting weight centering on one leg, the figure defending must be stabilized to prevent the illustration from appearing chaotically imbalanced.

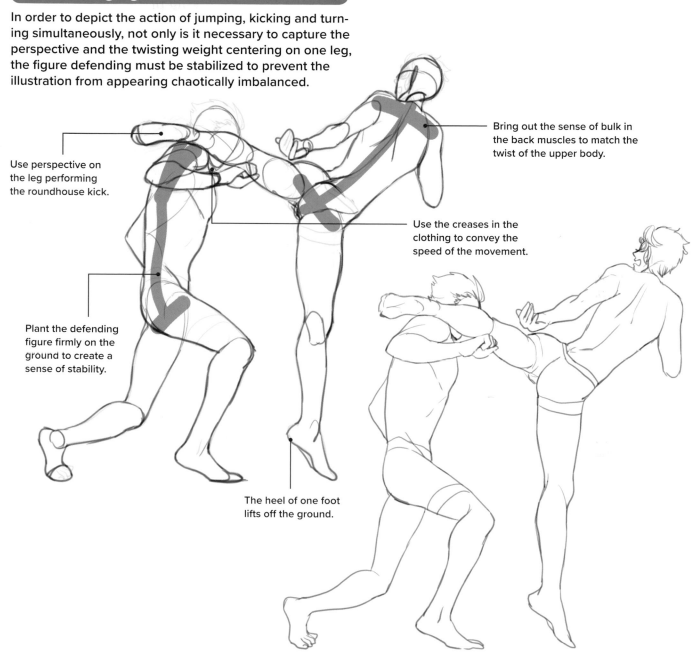

Use perspective on the leg performing the roundhouse kick.

Bring out the sense of bulk in the back muscles to match the twist of the upper body.

Use the creases in the clothing to convey the speed of the movement.

Plant the defending figure firmly on the ground to create a sense of stability.

The heel of one foot lifts off the ground.

A Bit of Advice

For fighting scenes that are hard to picture, it's a good idea to look at references before you start drawing.

For martial arts action scenes, it's important to depict the form correctly, as can be seen in fight manuals and reference books. Even just the roundhouse kick has various types such as the low kick, middle kick and high kick, so don't just rely on your memory or imagination when drawing.

In Close Contact with an Ally

When drawing a fighting scene where figures on the same side are in close contact, make sure the feeling of closeness in the midst of danger is conveyed. Position the figures close together and create a sense of unity in their outfits as well.

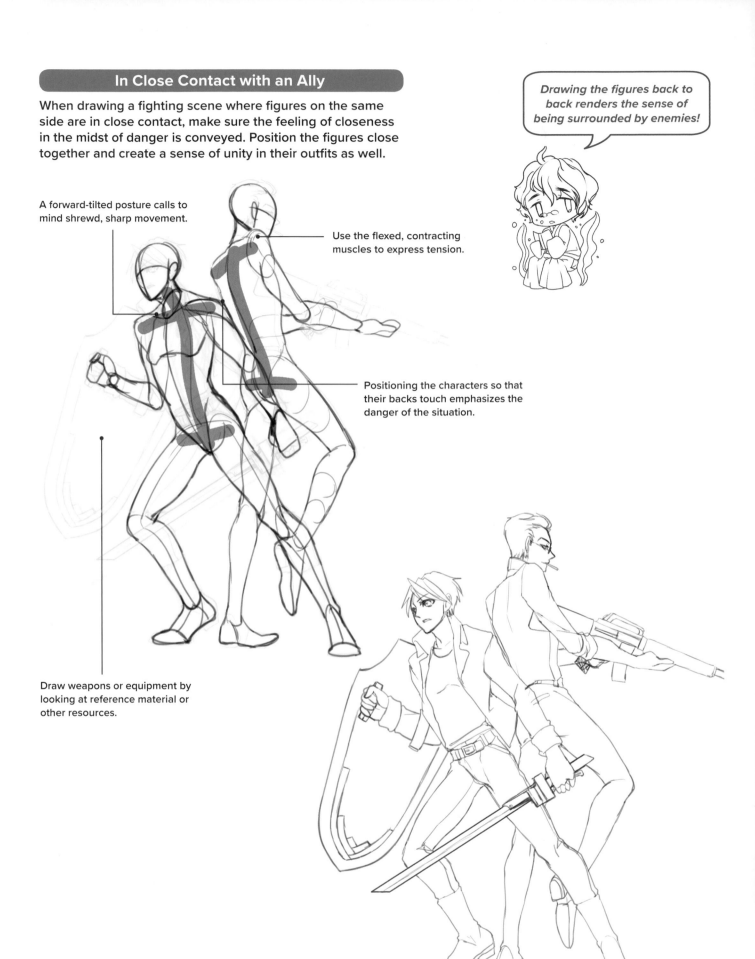

Drawing the figures back to back renders the sense of being surrounded by enemies!

A forward-tilted posture calls to mind shrewd, sharp movement.

Use the flexed, contracting muscles to express tension.

Positioning the characters so that their backs touch emphasizes the danger of the situation.

Draw weapons or equipment by looking at reference material or other resources.

In Close Contact with a Rival

In a scene with close physical contact, the increase in hostility from each side makes for a strong impact. Make sure to clearly express the burst of power in the defence and the realism in the attack.

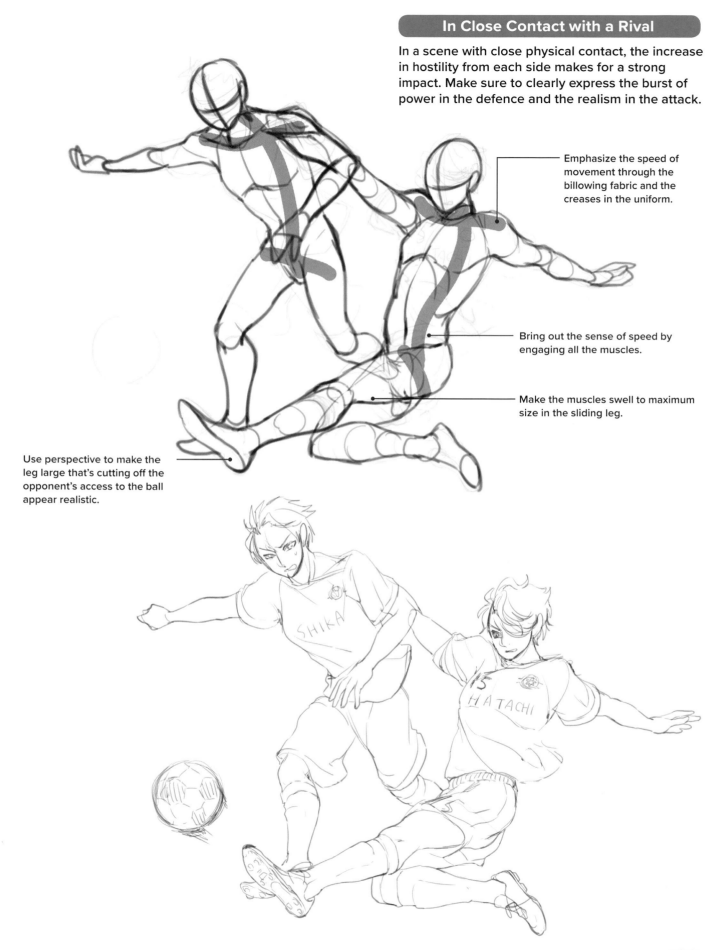

Emphasize the speed of movement through the billowing fabric and the creases in the uniform.

Bring out the sense of speed by engaging all the muscles.

Make the muscles swell to maximum size in the sliding leg.

Use perspective to make the leg large that's cutting off the opponent's access to the ball appear realistic.

139

Published by Tuttle Publishing, an imprint of Periplus Editions (HK) Ltd.

www.tuttlepublishing.com

UGOKI NO ARU POSE NO EGAKIKATA DANSEI CHARACTER HEN
© kyachi 2013
English translation rights arranged with GENKOSHA Co.
through Japan UNI Agency, Inc., Tokyo

Library of Congress Cataloging-in-Publication Data in process
ISBN 978-4-8053-1609-2

Distributed by

North America, Latin America & Europe
Tuttle Publishing
364 Innovation Drive
North Clarendon, VT 05759-9436 U.S.A.
Tel: 1 (802) 773-8930; Fax: 1 (802) 773-6993
info@tuttlepublishing.com
www.tuttlepublishing.com

Asia Pacific
Berkeley Books Pte. Ltd.
3 Kallang Sector, #04-01
Singapore 349278
Tel: (65) 67412178; Fax: (65) 67412179
inquiries@periplus.com.sg
www.tuttlepublishing.com

Japan
Tuttle Publishing
Yaekari Building, 3rd Floor
5-4-12 Osaki
Shinagawa-ku
Tokyo 141 0032
Tel: (81) 3 5437-0171; Fax: (81) 3 5437-0755
tuttle-sales@gol.com

24 23 22 21 10 9 8 7 6 5 4 3 2 1

Printed in Singapore 2101TP

TUTTLE PUBLISHING® is a registered trademark of Tuttle Publishing, a division of
Periplus Editions (HK) Ltd.

Books to Span the East and West

Our core mission at Tuttle Publishing is to create books which bring people together one page at a time. Tuttle was founded in 1832 in the small New England town of Rutland, Vermont (USA). Our fundamental values remain as strong today as they were then—to publish best-in-class books informing the English-speaking world about the countries and peoples of Asia. The world is a smaller place today and Asia's economic, cultural and political influence has expanded, yet the need for meaningful dialogue and information about this diverse region has never been greater. Since 1948, Tuttle has been a leader in publishing books on the cultures, arts, cuisines, languages and literatures of Asia. Our authors and photographers have won many awards and Tuttle has published thousands of titles on subjects ranging from martial arts to paper crafts. We welcome you to explore the wealth of information available on Asia at **www.tuttlepublishing.com**.